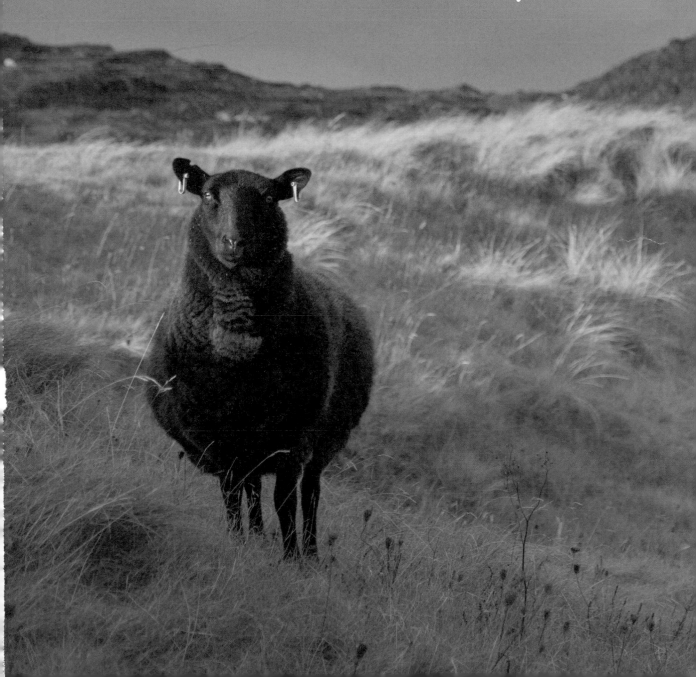

North Coast
Journey

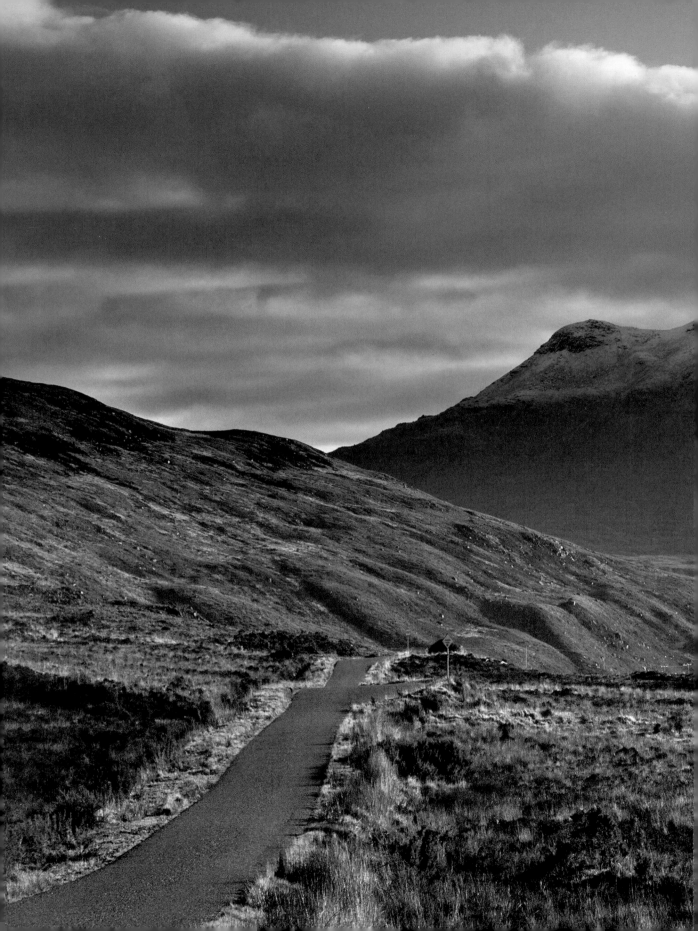

North Coast
Journey

THE MAGIC OF SCOTLAND'S NORTHERN HIGHLANDS

Brigid Benson

BIRLINN

First published in 2018 by
Birlinn Limited
West Newington House
10 Newington Road
Edinburgh
EH9 1QS

www.birlinn.co.uk

Copyright © Brigid Benson 2018

www.brigidbenson.com

All photography copyright © Brigid Benson

Maps produced by Lovell Johns Ltd.
Contain OS data. Crown copyright and
database © copyright 2018

Every effort has been made to ensure the
information in this book is as up to date as
possible. Some details, however, are liable to
change. The author and publishers cannot
accept responsibility for any consequences
arising from the use of this book, or for the
accuracy of any material which appears on
third-party websites listed in the Places to
Visit and Useful Addresses.

ISBN 978 1 78027 523 9

British Library Cataloguing-in-
Publication Data
A catalogue record for this book
is available from the British Library

Designed and typeset by Mark Blackadder

Cover photographs: Loch Lurgainn (front),
Lochinver with Canisp and Suilven (back)

Printed and bound by PNB, Latvia

Listen to the stars
They speak to your heart

BB

Contents

Acknowledgements

Much magic has gone into the making of this book. The support of family and friends who know the adventure of winding Highland roads, the wonder of a mountain's ever-changing moods, the faint rustle of deer in the woods, the song of the ocean washing remote shores and the life-affirming energy of immense starry skies has been so special!

Peter Urpeth introduced me to the great team at Birlinn and I am most grateful to him. Hugh Andrew and Neville Moir embraced my ideas and Andrew Simmons proved a thoughtful and generous managing editor. It has been an absolute pleasure working with him. The meticulous care and eagle-eyed attention of copy-editor Patricia Marshall is hugely appreciated. The ideas of designers Mark Blackadder and Jim Hutcheson have given the book shape and form, and I appreciate their creative contribution. My profound thanks go also to the marketing, publicity and sales teams at Birlinn.

Through all my travels, I have met so many open-hearted people across the northern Highlands. I feel deeply honoured to have shared their stories and I am grateful for their warmth, insight, generosity, humour and many invitations!

Finally to those whose love has been part of my personal journey, I thank you with all my heart.

BB

Introduction

Welcome!

Meaningful connections and great memories

Thanks for joining me on this adventure around the glorious coastal fringe of Scotland's far north Highlands.

Journeys are life affirming. An invitation to travel is to discover the unfamiliar, to create meaningful connections and to make memories that burn bright in the heart and mind. And so my intention is to share with you the outstanding places and vibrant communities that I know well, through my personal and family connections and through my professional work as a writer.

In recent years, the historic roads that follow the outline of the far north of Scotland have been branded and promoted with huge success as the North Coast 500 (www.northcoast500.com). Visitors are thrilled and impressed by the landscape, yet many of those that I meet feel a tinge of regret that they did not allow long for this epic experience. Looping the dramatic and characterful coast in a short period of just a week leaves many travellers feeling strangely disconnected. Though the scenery is inviting, their punishing schedule obliges them to keep moving on. I have seen visitors enchanted yet in a terrible rush to hurtle through the landscape. Leaping from their cars, campervans or motorbikes to snap a photo and maybe record a few moments of film footage before driving on to the next viewpoint.

Approaching this magnificent coastal circuit like a grand prix race creates pressure. Pit stops leave little time to paddle in the crystal-clear sea, climb a hill for panoramic views, walk among wildflowers on a

gentle coastal path, linger over a freshly landed seafood lunch and spread out a rug to watch the setting sun sink into the sea. There's little time to chat with local people and patiently observe wildlife; little time to take part in local events and festivals or discover exhibitions, museums, galleries and the work of inspirational craftspeople. While some travellers I have met relish these whistle-stop days, many wished for more time to engage with the landscape and friendly communities.

In the village stores at Bettyhill, I chatted with a woman who was travelling by motorbike with her partner. 'We're doing the whole north coast trip in a week,' she told me. 'We were under the impression it was possible. Now we are here we realise it is a rush. The scenery is fantastic. We keep seeing things and want to stop but we can't – we've got to keep moving because we haven't enough time.'

I have friends across the far north Highlands who sense this deeply from many visitors too. Travellers arrive in a whirl, stay for one night, wish they had longer and hurtle onward. And so this book is my response to requests from those guests and locals who have shared with me their feeling that so much opportunity is lost by rushing around the far north Highlands in a high-pressured week.

I am passionate about this landscape and the vibrant communities. My advice is to allow plenty of time for discovery – at least 10 days – or travel only as much of the route as is possible in a meaningful way in the time you have available. The rewards are immense and satisfying.

This journey explores the coast in sections. Each area is rich and fascinating with much to discover over a few days. Walk and cycle where you can – this appealing landscape lends itself to adventure, whether in the form of a short excursion around a dramatic headland accompanied by clamouring seabirds and curious seals or an epic quest to the heart of the mountains and the territory of golden eagles. I invite you to wander. Embrace the opportunity to connect with the magic of the scenery and the communities. Make your far north Highland experience meaningful and memorable.

Thrills, wonders and surprises await you!

Have fun!

Brigid Benson

Driving

DRIVING IN THE FAR NORTH HIGHLANDS OF SCOTLAND

The road network across the far north Highlands is limited and every route is vital to remote communities. Many of the roads are single-track carriageways with passing places designed to permit overtaking. Before setting off, please take the time to research and understand how to use these roads. This is of enormous importance because local communities depend hugely on the free flow of traffic to go about their daily business. Visitors are very welcome and local people entirely understand that, in such spectacular scenery, drivers might wish at times to crawl along. Yet slow moving vehicles that do not pull in to permit overtaking on single-track roads cause serious hold-ups and tailbacks that impact negatively on the community.

Several roads also present extreme challenges. Unfortunately, some visitors are overambitious and attempt to drive these fiendish rural routes in hire vehicles with which they are not fully familiar. When they become stuck, roads are blocked for hours and communities are cut off. Please choose your route with care. Avoid precarious roads that might cause you too much stress and seek alternatives to those that are unsuitable for your vehicle.

In remote Highland communities, ambulances may be unable to reach emergencies swiftly. Instead doctors often travel many kilometres

by car to attend a scene. To alert traffic to the emergency they use green flashing lights. If you see the green flashing lights of a doctor's car approaching, plan ahead. Look for a safe space in the road for the doctor to pass. Don't stop on corners – they are dangerous. If there is no immediate safe place, please wait until the next suitable opportunity.

Magnificent red deer and especially stags have become the iconic symbol of the Scottish Highlands. The deer population is thriving and thousands are killed or injured annually in road traffic accidents. Drivers and passengers may also be seriously injured in terrible collisions which can write off a car. It pays to be aware of the animals' habits. Deer strikes occur throughout the year but they are most frequent in May and June. Hinds and their young are particularly vulnerable to traffic in these months. Collisions peak between dusk and midnight. It is important to report any deer strike to the local police, especially when an animal is injured or has left the scene. This limits unnecessary suffering and further danger to traffic. However, do not approach an injured deer. Though usually placid, a wounded animal may be fearful and dangerous.

Be aware that deer seldom travel alone – where one animal approaches or crosses the road it is possible that there may be a herd of others waiting their turn. In this situation, be alert. Dip your vehicle's full beam headlights to avoid startling them.

GOOD TO GO!

Here's a list of some important and useful things to have with you in the wild, wonderful remote Highland landscape:

- Detailed maps of all the areas you intend to visit. Satnav systems do not work throughout the far north Highlands. The maps in this book are for general orientation only and as such do not include all the places mentioned in the text.
- Strong footwear and perhaps walking poles too – there are many wonderful paths around cliffs, through heather, along muddy tracks and into thrilling rocky places.
- Protective clothing for sun, wind and rain. The far north coast of

Scotland is renowned for four seasons in one day with good reason.

- Midge repellent, insect repellent and a tick remover – the midges, horseflies and ticks of the far north Highlands can be seriously irritating. Ticks present the serious threat of Lyme disease. While a midge head-net covering is hardly the height of glamour, it will provide some respite at particularly testing times. Swarming clouds of midges pay no respect to personal space.
- A first-aid kit – pharamacists and doctors are few and far between in remote landscapes.
- Binoculars and telescope – getting a closer look at the spectacular wildlife on land, in the sea and in the air is a huge part of the Highland experience.
- Torch and head torch – unpolluted dark skies in the mountains are magnificent yet, for safety, a torch is essential. You may also find it useful when exploring easily accessible caves.
- Phone charger – though signals are often poor, a fully charged phone is invaluable.
- Golf clubs – golfers are warmly welcome to simply turn up and play at many far north coast golf courses. Some offer club hire if booked in advance. However, if you are a keen golfer, the jaw-dropping scenery is hard to resist so you may wish to be ready to play at any moment.
- Bicycle – if you can manage to take a bike, it is well worth it. Summer morning and late evening bike rides along quiet lanes are magical. Alternatively, consider hiring a bike locally.
- Picnic rug, blanket and lantern – these creature comforts make alfresco occasions all the more romantic. A folding chair is also handy for those moments when the scenery invites you to simply sit, stop and stare.
- A flask – warming tea, coffee or soup in the wilderness is sheer luxury.
- Emergency rations, treats and water – be prepared for incidents and celebrations! You may well have both.
- Cash – there are very few banks and, while most businesses accept cards, it is useful to have a good supply of cash lest there are any difficulties.
- Eye mask and earplugs – not strictly necessary but good to have

when wild camping. Long daylight hours and rousing dawn choruses may interrupt sleep!

- Something to read – the Highland landscape has inspired many writers. Among the books mentioned on this journey are: *Highland River* by Neil M. Gunn; *Standing in Another Man's Grave* by Ian Rankin; *His Bloody Project* by Graeme Macrae Burnet; *My Friends . . .*, a series of novels by Jane Duncan; the poems of Norman MacCaig, Rob Donn and Ewen Robertson.

MAKING CONNECTIONS

Great groundwork sets up fantastic opportunities when planning an adventure. Here are some connections to bring further insight to your discovery of the magical far north Highlands.

Aurora Service Europe – www.aurora-service.eu
Caithness Broch Project – www.thebrochproject.co.uk
DeerAware – www.deeraware.com
Forestry Commission – www.forestry.gov.uk
Hostelling Scotland – www.syha.org.uk
John Muir Trust – www.johnmuirtrust.org
Mountain Weather Information Service – www.mwis.org.uk
National Trust for Scotland – www.nts.org.uk
Northwest Highlands Geopark – www.nwhgeopark.com
Royal Society for the Protection of Birds – www.rspb.org.uk
Scottish Natural Heritage – www.nature.scot
Scottish Outdoor Access Code – www.outdooraccess-scotland.scot
Scottish Wildlife Trust – www.scottishwildlifetrust.org.uk
Surf Forecasts – www.magicseaweed.com
Whale and Dolphin Conservation (WDC) – www.wdcs.org

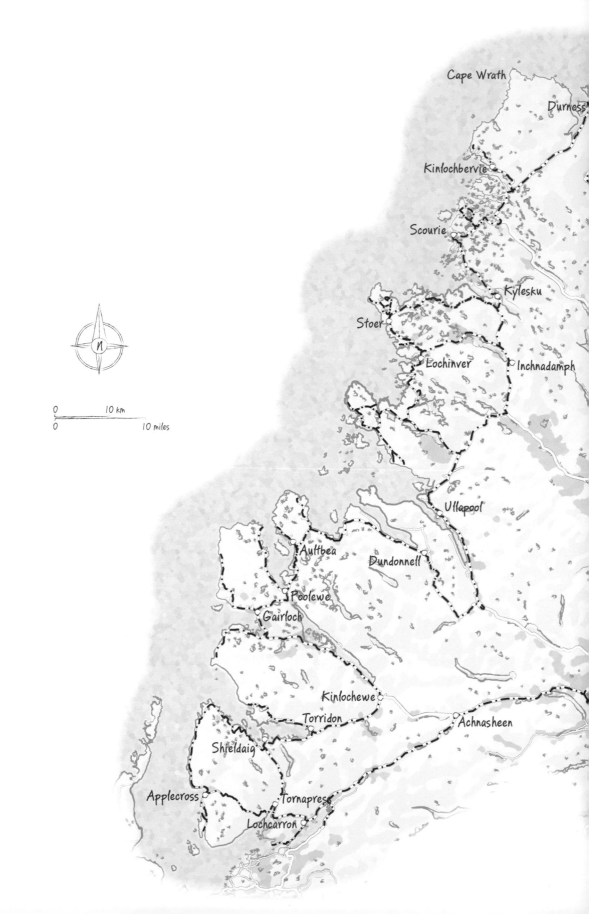

STAGE ONE
Inverness to Lochcarron

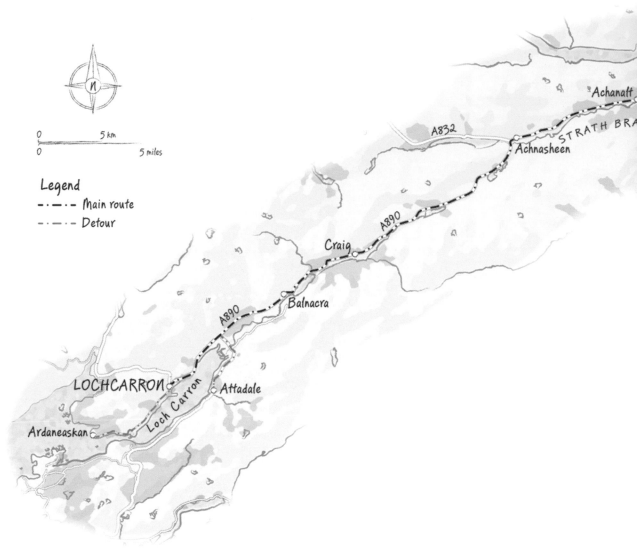

DISCOVERING INVERNESS

This magical odyssey around the far north coast of the Scottish Highlands is the journey of a lifetime. Extraordinary communities, landscapes and experiences await.

Prepare well. Don't rush. Allow yourself the gift of time to connect meaningfully with people and places. The rewards will be immense.

The adventure begins in the east-coast city of Inverness, which native Gaelic speakers know as Inbhir Nis. Discoveries made here richly inform a greater understanding and appreciation of the northernmost reaches of the British mainland.

Windswept Drumossie Moor just beyond the city centre is an important starting place. Here the Jacobite uprising that sought to oust the Hanoverian dynasty and reinstate a Stuart monarchy ended brutally at the Battle of Culloden on April 16 1746. Over 1,500 people were slain in bloody hand-to-hand combat that lasted less than an hour. Most of the dead were Jacobite supporters, vastly outnumbered by their opponents. The government troops, commanded by the Duke of Cumberland, suffered much less loss of life. The political and economic impact of this turning point in Scottish history continues to unfold. Adjacent to the battlefield is an award-winning National Trust for Scotland visitor centre. Exhibitions, living history presentations and cinema sensitively promote an understanding of events leading up the battle and explore the legacy of it through the Highlands, Scotland and the UK.

A distinctive aspect of this far north journey is a weirdly wonderful sense of time warp. In many of the remote destinations, different eras collide in an extraordinary way.

The ancient site of Clava Cairns is just 2.3 kilometres from the battlefield yet thousands of years apart. Three round Bronze Age burial

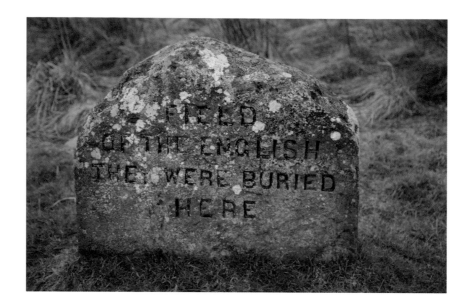

chambers, some 4,000 years old, are enclosed within circles of standing stones. Woodland protects the sacred site and the atmosphere is peaceful and mysterious. Close by the cairns is Clava Viaduct, also known as Culloden Viaduct. The imposing railway crossing is the longest masonry viaduct in Scotland. The graceful structure curves elegantly through 28 spans and is 549 metres long. Built in 1898 it remains in regular use.

The city centre of Inverness is relatively small and easily explored on foot. Inverness Museum is a great place to begin. A timeline of Highland history sets the scene for the journey ahead. Exhibitions discover the mysterious Picts and their carved stones and highlight the history and importance of Gaelic language and culture in the north of Scotland. Discover wildlife and art exhibitions too. All adds rich flavour and insight to the far north experience.

A viewing platform on the north tower of Inverness castle, situated next to the museum, offers a thrilling 360-degree view of the city. Far below, the River Ness reaches the final stage of its journey to the sea. The waters flow around the city's wooded and romantic mid-river islands, under elegant suspension footbridges, past Bught Park, Inverness Botanic Gardens, Eden Court Theatre and onward under the watchful eye of the Cathedral Church of St Andrew on one riverbank with Old

High St Stephen's Church on the other. It is believed the Irish Christian missionary St Columba converted King Brude in 565 at St Stephen's Church.

Soon, this Highland population centre will melt away. As you prepare to leave, bid farewell to Jacobite heroine Flora MacDonald. A statue of this courageous young woman stands in Castle Wynd. Flora shields her eyes from the sun and looks to the west. Her faithful collie dog accompanies her. Erected in 1899, sculptor Andrew Davidson designed the monument. On the plinth are Samuel Johnson's words of tribute:

FLORA MACDONALD
THE PRESERVER OF PRINCE CHARLES
EDWARD STUART WILL BE MENTIONED
IN HISTORY AND IF COURAGE AND
FIDELITY BE VIRTUES, MENTIONED
WITH HONOUR

JOHNSON

In July 1746, 24-year-old Flora enabled Bonnie Prince Charlie to flee Scotland after the defeat of his Jacobite supporters at the Battle of Culloden. Flora arranged for the prince, who was in hiding, to sail with her from South Uist to the Isle of Skye. To avert suspicion he was disguised as a maid. On reaching Skye, further arrangements were made for the prince to travel onward to France. After parting, Flora and the prince were never to meet again. He lived in relative obscurity; she married and left Scotland in 1750. She emigrated to America and, years later, returned to the Isle of Skye where she died in 1790. Flora is buried at Kilmuir on the Isle of Skye. She is shrouded in a sheet that Bonnie Prince Charlie slept in.

'The Skye Boat Song' is known and performed throughout the world. Usually sung to a waltz, it celebrates the extraordinary escape.

Speed, bonnie boat, like a bird on the wing,
Onward! The sailors cry;
Carry the lad that's born to be King
Over the sea to Skye.

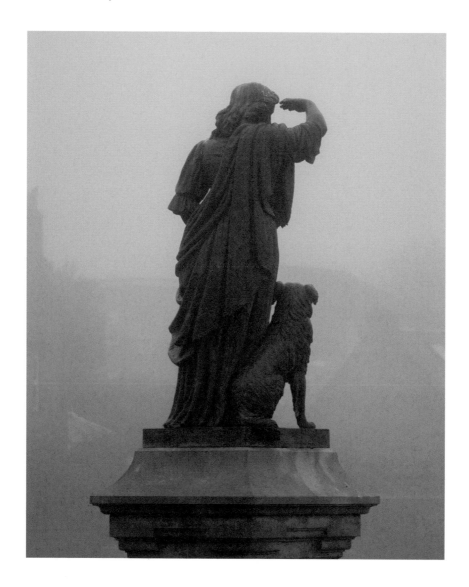

GO WEST: TOWARDS CONTIN ON THE A862

With Flora's good wishes, leave the city and head west for adventure on the A862. The route crosses the Muirtown Basin of the Caledonian Canal. This significant waterway connects the North Sea with the Irish Sea and the east coast of Scotland with the west coast. The canal, constructed by Scottish engineer Thomas Telford (1757–1834), travels

through 29 locks between Clachnaharry near Inverness and Corpach near Fort William. Muirtown was intended to be a second harbour for the merchants of Inverness. The basin was completed in 1807 but the rapidly increasing size of boats ended that ambition. However, Muirtown supported Inverness harbour during World War I. The basin served as a US naval base for ships deployed to lay mines between Orkney and Norway to restrict the movement of German submarines in the Atlantic.

Clachnaharry sea lock, just off the A862, is a famous example of Thomas Telford's ingenuity. Here the inland waterway travels through a tidal lock over shallow mudflats to the deeper seawater of the Beauly Firth. The huge lock is made of two huge parallel embankments regarded as a feat of engineering. Vessels are raised 2.4 metres from the level of the firth to the canal. The sea lock enjoys expansive views across open water to the mountains. The garden of the Clachnaharry Inn is a great vantage point too.

The sense of suburbia melting away increases as the number of houses along the route begins to dwindle and the road snakes closely by the shore. Some 12 kilometres west of Inverness, the Wardlaw Mausoleum is the burial place of the last man to be executed legally by beheading in Britain. Simon Fraser was Chief of Clan Fraser. Known as the Old Fox, he was put to death in London in 1747 for his part in supporting the Jacobite rebellion and Bonnie Prince Charlie's claim to the throne.

Local tradition claims that, when French-speaking Mary, Queen of Scots visited Beauly in the 16th century, she found it a 'beau lieu', a beautiful place, and hence the village name. Beauly has grown around the peaceful ruins of a riverside priory founded around 1230 for monks of the Valliscaulian order from France. Strict poverty, chastity and obedience are at the core of the order, which founded three abbeys in Scotland. Ardchattan Priory near Oban and Pluscarden Abbey near Elgin make up the trio. Pluscarden is notably the only medieval British monastery still being used for its original purpose.

While the name Muir of Ord strikes me as perhaps belonging to a jovial Shakespearian character, it is in fact a village. For drovers

Curiosity

Britain's shortest railway platform

Beauly station is the first stop out of Inverness on both the Kyle of Lochalsh and the Far North line. The platform is the length of a single carriage and the shortest in Britain.

hoofing herds of black cattle from the north Highlands, it was an important destination where business was done at trysts or cattle markets. The Glen Ord Distillery produces The Singleton of Glen Ord. The visitor centre offers tours of the whisky-making process, from grain to glass. The community-owned Muir Hub in the Old Tarradale School hosts a vibrant heritage centre and the cheery Cafe Artysans run by the Calman Trust. This social enterprise provides training opportunities to young people. The cafe's home baking and takeaways are much appreciated by travellers bound for the railway station. Look out too for the timber-clad community fridge beside the doorway. Here individuals and businesses share surplus food. The innovative idea prevents waste and food poverty. The contents of the fridge are freely available to all members of the community on an honesty basis.

At the junction of the A832 and the A835, the route turns towards Contin, a small village at the confluence of the rivers Black Water and Conon. Elusive Scottish wildcats live in the forest around lofty Torr Achilty.

Soon there is the opportunity of a circular detour on the A834 signposted towards Strathpeffer, returning through Contin. Alternatively continue on the A835.

DETOUR: *A circular detour to Strathpeffer, Dingwall, Tollie and Brahan*

The architecture and design of Strathpeffer is much inspired by European spa resorts. Sulphurous springs discovered in 1770 were associated with recuperative powers. It was claimed they were an aid to digestion, kidney complaints, rheumatism, heart conditions and skin disorders. By 1819 the health giving mineral water was much in demand. A timber-built pump room in the village square provided drinking jugs and baths for visitors. The village was promoted widely as a spa resort where the waters were stronger than those of any elegant rival abroad. Stylish hotels and villas welcomed British and international guests who came to drink, bathe and holiday at the Highland fountain of health.

The Countess of Cromartie commissioned a gathering place inspired by the casino at Baden-Baden spa resort. The Victorian Spa Pavilion

opened in 1881. Orchestras and string quartets entertained genteel crowds. Pleasure gardens offered elegant promenades. There were croquet lawns, bowling greens, bandstands, curling rinks and tennis courts. Royalty holidayed at the grand Spa Hotel.

When the Strathpeffer branch of the Dingwall and Skye Railway opened in 1885, tourism boomed. Across Britain, colourful railway posters promoted the Spa Express to 'Sweet Strathpeffer'. The playful pun was a nod to the sweets that were a traditional part of the sulphur spa experience – they took the nasty taste away. The fortunes of the resort declined after World War I. Yet many of the elegant buildings survive and the Spa Pavilion continues to host events. The renovated pump room houses an exhibition of popular treatments. There is an opportunity to sample the waters and be rid of the taste with a sweet. The railway station closed in 1951 although local people have ambitious plans to restore a steam train on a heritage line. The station buildings now host the Highland Museum of Childhood, a cafe, a gift shop and a bookstore.

Seventh-century artists from the mysterious Pictish tribes decorated the Eagle Stone at the east end of the village. The monument is signposted along an uphill path and, after a short walk, the large lump of blue gneiss deeply incised with enigmatic symbols is revealed. An ornamented horseshoe-like arc is visible above a powerful standing eagle with long wings, hooked beak and strong talons. The stone is cemented to the ground. According to legend, the local Brahan Seer, attributed with supernatural powers, prophesised that should it fall three times, ships will anchor on the spot. There is no evidence that the Brahan Seer existed. But you can't be too careful.

The C1071 minor road from Strathpeffer to the Heights of Brae enjoys views across the valley of the River Peffery. On the hillside at the Heights of Brae, a large modern standing stone memorial celebrates the work of Highland writer Neil M. Gunn. Between 1938 and 1950, the Caithness-born poetic novelist lived with his wife Daisy at nearby Brae Farmhouse. There he worked prolifically, writing some of Scotland's finest 20th-century literature, including *The Silver Darlings* and *Highland River*. Also on this hillside, a local crofter discovered Scotland's largest hoard of late Bronze Age gold jewellery quite by accident in 1960. Nine items around 3,000 years old were declared a treasure trove by the government.

Funded by social investors, Scotland's first community-owned distillery opened its door to visitors in 2018. Glen Wyvis produces Highland whisky and gin on the outskirts of Dingwall. Visitors booking distillery tours are taken to the hillside site by electric bus from Dingwall. The town's original distilleries, Ferintosh, Ben Wyvis and Glenskiach, closed over 90 years ago.

Before leaving Dingwall, the livestock and auction market on Bailechaul Road offer a further perspective on Highland life. The far north farming community travels considerable distances to buy and sell here. While the modern-day car park fills with tractors, trailers and pickup trucks, a fascinating exhibition within the mart celebrates the

epic journeys of Highland drovers who, for centuries, travelled on foot. From the Western Isles, Skye and throughout the Highlands they walked with hundreds of beasts bound for trysts, or sales, at Falkirk and Crieff. Many of these chaperones, skilled in animal husbandry, walked yet further on to sales in London. They followed established routes and paced their journeys to ensure animals in their care arrived at market in premium condition. Travelling across the landscape from remote settlements to towns, from grass tracks to roads, the drovers met with blacksmiths who made shoes for the beasts to wear on hard surfaces. The expertise of the Highland drovers was so greatly admired beyond Scotland that many emigrated to work in America, Canada and Australia.

One of my favourite statues is the droving scene outside Dingwall Mart. Created by sculptor Lucy Poett, the life-size bronze portrays a group. A drover is dressed traditionally with a tartan plaid slung across his shoulders. He leads a huge bull with his attentive collie dog at heel.

From Dingwall, the route follows the A835 towards Ullapool. At the RSPB Tollie Red Kites Visitor Centre there is the opportunity for close encounters with these graceful birds of prey which have a wingspan of around two metres and a haunting whistling call. They are highly protected by law yet the number of red kites in the north of Scotland is lower than expected due to ongoing persecution.

At Tollie, the partnership between RSPB Scotland and the Brahan Estate supports the reintroduction of the birds to the Black Isle area. Volunteers set out food once a day, at 14.30 in summer and 13.30 in winter. Witnessing large red kites, with distinctive forked tails and dancing flight, swoop to the feeding station is a special experience. Their penny-whistle trills fill the air. Tollie is not a commercial feeding station and facilities are basic, with a compost loo. However, the farmstead building and exhibition area have a fully glazed gable-end wall. The view of the feeding station is spectacular.

In 2014 a Black Isle wildlife crime involving red kites made national news. Over a few days 22 birds of prey were found dead within a small area around Conon Bridge – 16 red kites and 6 buzzards. The tragedy sparked outrage among many in the community. The red kites especially were well-known individuals – several, ringed as chicks, had raised young themselves, among them a 16-year-old female. Post-mortems revealed that illegal pesticides were the cause of mass poisoning. Partners

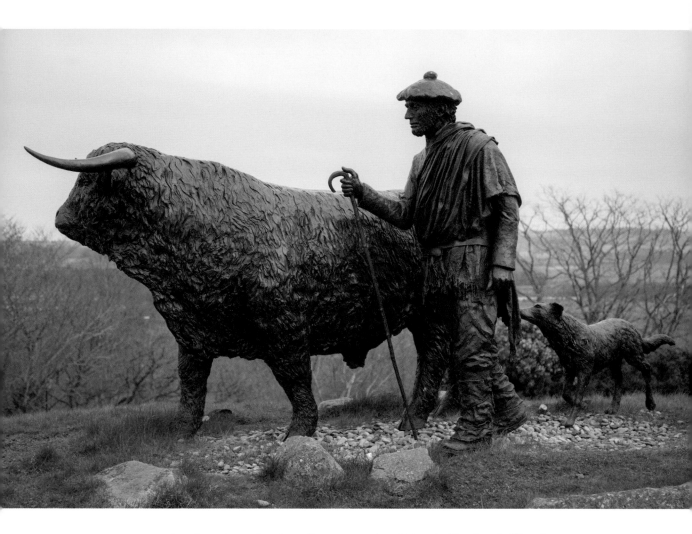

supporting the reintroduction of persecuted red kites in Scotland offered a £27,000 reward for information. Three years after the event, Police Scotland closed the case. The individual or individuals responsible for the deaths of the birds were not brought to justice. *Red Sky on the Black Isle* is a poignant, international award-winning documentary about the case and the impact of one of Britain's biggest wildlife crimes. The 12-minute film made by Lisa Marley is available on the Internet.

At Brahan Estate, just off the A835 on the return to Contin, there are gentle riverside walks, an arboretum and a curious dog cemetery. A favourite gravestone inscription reads:

In memory of Cruiser
For 15 years the faithful friend and companion of
Colonel Stewart Mackenzie
of Seaforth.
He accompanied the 9th Lancers
throughout the Afghan campaigns 1878–79–80
including the march from Kabul to Kandahar.
Born 1878, Died 1893

CONTIN TO LOCHLUICHART

In Contin, an imaginatively carved oak arch stands at the entrance to Five Acre Wood, which is owned by the community. The arch portrays woodland creatures with red squirrels, a woodpecker and an owl peeping from hollows in a tree. Five Acre Wood is awash with fragrant bluebells in spring. Along the road, just north of the village, is a car park with picnic benches and way-marked trails through Torrachilty Forest. In the depths of winter, there's an extraordinary invasion. The Strathpuffer 24-hour mountain bike endurance event challenges riders to complete circuits of the forest in freezing weather and 17 hours of darkness.

Beyond Contin village, a left turn along a minor road leads to Loch Achilty. Before the road reaches the picnic site at the far end of the loch, a forestry sign and gate welcome visitors to explore Achilty Oakwood, a peaceful sanctuary inhabited by willow warblers and pipits. From the pebble beach beside the loch there are serene reflections in calm water. By the shore is a small, tree-covered artificial island. This is an ancient crannog, the family home of lake-dwelling people. Though it was probably constructed in the Iron Age, it may have been inhabited until the 17th century.

Leaving Contin, the A835 travels towards Garve and the junction with the A832. Along the way is a classic Highland beauty spot.

Beauty Spot

Rogie Falls

The rushing waters of the Rogie Falls are reached from a car park beside the A835. A woodland path through tall pines leads to an elegant footbridge where the Black Water flows from the slopes of Ben Wyvis. After heavy rain or melting snow the torrent is deafening.

The summer spectacle of wild Atlantic salmon returning from the sea to spawn upstream at their birthplace is awesome. Their instinctive determination to hurdle obstacles in their path is powerful.

Onward, the A835 dances, twisting and turning, falling and rising through silver birch woods. In winter, Loch Garve is clearly visible. In summer, views are blocked by lush foliage. Soon the single-track railway line between Inverness and the Kyle of Lochalsh travels companionably alongside, bound for Garve's sunny yellow station buildings. From there, it crosses the road and travels west.

The road continues past the Garve Hotel, before reaching a left turn on to the A832 signed Wester Ross Coastal Route. Here there is a choice. Turn left to continue on the route or stay a while on the A835 for a beautiful riverside detour.

DETOUR: *Little Garve and the Black Water*

Remaining on the A835, pass the junction with the A832 and continue a short distance before reaching a right turn on to a minor road signposted to the Little Garve picnic site.

A scene opens up that would cause Victorian landscape painters to swoon. Splashing noisily through the forest, the Black Water negotiates large rocks midstream. The peaty river tumbles through a series of cascades to flow beneath the graceful arc of Little Garve Bridge. Major William Caulfield built this important crossing place in 1767. The bridge enabled government forces to exert control and move more freely around the Highlands in the wake of the Jacobite Rebellion of 1745. The Forestry Commission restored the bridge in 2007.

There is no vehicular access over the beautiful bridge. However, walkers are invited to cross it and follow a riverbank footpath to Silver Bridge upstream. Allow around one and a half hours for the circular stroll. For more intense walking, there is the opportunity to climb Ben Wyvis – or, in Gaelic, Beinn Uais – the 'Awesome Hill'. The mountain is climbed from Garbat, a little further north on the A835. The roadside car park on the A835 is the start of a walk of around seven kilometres through coniferous forest to the whaleback ridge of Ben Wyvis. Allow around six hours for the expedition.

Impressive Ben Wyvis dominates the skyline north of Inverness. The mountain offers spectacular views to Cairngorm. From the spur known as An t-Socach, there are views over Easter Ross and the Moray

Firth. A swathe of carpet moss and a nationally important population of rare breeding dotterels make Ben Wyvis especially significant. Though the mountain's slopes are gentle, winter walking in snow is not advised; powerful avalanches have been fatal.

Having taken the detour, double back to rejoin the route and travel west on the A832.

THROUGH STRATH BRAN TO ACHNASHEEN

At the gateway of Strath Bran, the white turbines of Corriemoillie wind farm spike the sky. Roadside silver birches hide remote railway stations from view. Beyond Lochluichart, the scene opens up. The road and

Curiosity

The Achnasheen Terraces

Before taking the A890 towards Lochcarron, there is the opportunity for a geology stop to see the famous Achnasheen Terraces.

Formed by glacial melt waters, these flat-topped features dominate the junction of the heads of Strath Bran, Glen Docharty and Glen Carron. Rising up to 30 metres high they are renowned textbook examples of outwash and delta terraces.

railway line journey more closely together. The River Bran snakes alongside. Grudie Bridge hydroelectric power station is a distinctive landmark. Around the modernist building, a series of decorative plaques suggests the meeting of Scotland's ancient culture with 1950s technology. Sculptor Thomas Whalen took inspiration from the Picts. His elegantly simple designs include a bear, a goose and an eagle eating a fish. The red sandstone building forms part of the Conon Hydro-Electric Power Scheme, among the first to harness waterpower to generate electricity. A tunnel channels water from Loch Fannich. Passing through turbines in the powerhouse, the flow is discharged into Loch Luichart.

Just past the power station there's a roadside car park with a secluded picnic site beside the River Bran. On the hill above, the Forestry Commission is working with the charity Trees for Life to restore one of the most northerly oakwoods in Britain

Immediately after Achanalt station is the grave of Captain Bertram Dickson (1873–1913), a pioneer of military aviation. His resting place is the steeply sloping Cnoc na Bhain burial ground, which overlooks a more recent graveyard below. Dickson was the first British serviceman to qualify as a pilot. In 1910 his biplane was involved in the world's first midair collision, which occurred over Milan. Both airmen survived, though Dickson's injuries prevented him from flying again. His headstone reads:

> No danger found him hesitant
> No suffering found him feeble.

There's an air of loneliness in this strath. A handful of homes constitute a township. Achnasheen station is a relative hub. There is a public loo and picnic table. Numbers are swelled by the occasional gatherings of deer on the small village green. Achnasheen is the historic junction of two routes used by drovers. The 19th-century roads built by Thomas Telford largely follow their path. While the A832 travels to Gairloch, this adventure continues on the A890 towards Lochcarron.

TO THE SHORES OF LOCH CARRON ON THE A890

From Achnasheen junction, the A890 passes Ledgowan Lodge Hotel, a former shooting lodge built in 1904. The small settlement of Craig is a hub for walkers exploring the vast network of surrounding paths at high and low level. Routes extend deep into nearby mountain ranges, through Achnashellach Forest and to a hill by the name of Wellington's Nose.

The oldest independent hostel in Scotland is beside Craig level crossing. Originally built as two cottages to house the families of railway workers, the accommodation at Gerry's Hostel is plain and simple. The roaring log fire and efficient drying room are welcome after a day on the hills. Easy access to 20 mountain peaks has made this quirky place a legend among climbers and hillwalkers since 1968.

Between Balnacra and Strathcarron, the A890 is mostly single track with passing places, though there are plans to widen it. Red squirrels have been reintroduced to this area to support the regrowth of the native trees. Many seeds buried by squirrels are forgotten and take root to become part of the forest.

Near the junction of the roads that skirt Loch Carron is The Smithy, a community hub that serves as an information point and a gallery for local artists and craft workers. Pop-up Pottery is the studio of Vicky Stonebridge, who offers occasional one-day workshops. Behind the hub is a secret picnic spot with a magical tree house. Designed by Alex Shirley Smith, this hideout and meeting place was built in just a few days by the resourceful community.

From The Smithy, continue towards Lochcarron Golf Club and village or take a detour along the A890 to the lush gardens of Attadale.

DETOUR: *Peaceful Attadale Gardens*

The fierce storms of 1980 forced an imaginative rethink of the Attadale garden, begun in Victorian times by Baron Schroder. Upturned roots of mature trees created deep hollows, which inspired artist Nicky Macpherson to create a series of new water gardens criss-crossed by attractive bridges.

The result is a journey. Artfully placed sculptures surprise and delight. The Japanese garden represents a land of myths and legends. Quarries host old rhododendron varieties. There is a fernery, and the kitchen garden produces seasonal fruit and vegetables for local restaurants. In the tearoom, you are encouraged to browse gardening books while taking refreshment.

From the gardens, return to the route, passing Lochcarron Golf Club on approach to the village.

AROUND LOCHCARRON

The Tee-Off Cafe in the pavilion of Lochcarron Golf Club is a friendly stopping place for home-made 'wicked whisky cake'. A vintage 'mashie' golf club is on display near the kitchen. Bookcases heave with an eclectic range of second-hand reads. Donations go to animal charities. Large windows offer views of the nine-hole course, established in 1908. A lovely outdoor terrace overlooks the shore of the loch and the peak of Wellington's Nose.

Lochcarron village has gone by several names including Janetown and Jeantown. In this linear community, hamlets are threaded cosily beside each other on the shore of the fjord-like sea loch. Established as a small settlement, the Lochcarron community expanded during the controversial Highland Clearances which occurred largely from the 1770s to the 1850s. The value of wool, prized by mills in Britain's booming industrial cities, prompted estate owners to clear tenant farmers from their land in favour of more profitable sheep farming. Change came swiftly. Evictions often took place at short notice or without any notice all. Buildings and dwellings were destroyed to prevent the tenants returning. Highland communities broke up. Many families scrambled to the margins – to the poor land around the rugged coast. People whose only experience was cultivating the land for generations had to learn quickly how to handle boats and harvest the sea, with inevitable loss of life. Others who had been cleared from their homes migrated south to the Lowlands and to Britain's developing industrial cities or responded to enticing advertisements placed by land speculators on the eastern shores of America and Canada. Settlers were invited to make new lives in the New World. Across the Highlands, traditional communities underwent seismic change.

Seals and dolphins visit the briny waters of Loch Carron. Shoreline benches are good observation posts. There is rich birdlife too. Spy oyster-catchers, herons, ringed plovers, redshanks, turnstones and common sandpipers. In autumn, eider ducks, wigeons, red-throated divers, little grebes and goldeneyes come to visit. The sandy floor of the loch hosts miniature reefs built by bright orange creatures known as flame shells. These bivalve molluscs are just four centimetres long. They feed on rich nutrients carried by the powerful tide. With a hidden

flexible limb they reach out to gather shells, stones and other material. Binding this together with a sticky substance they produce, these tiny creatures create, little by little, a delicate landscape of nests. Kelp is then able to take an anchor hold and this creates a nursery bed for other creatures. Yet the legal action of scallop dredging scrapes the fragile sea floor and, in 2017, scallop dredging damaged the slowly growing Loch Carron reef. The area was designated an Urgent Nature Conservation Marine Protected Area (NCMPA) to recover the flame shell beds to a favourable condition.

The sheltered harbour at Slumbay was traditionally an anchorage for boats sailing to the Western Isles. It remains popular. Sailing events take place throughout the season.

Lochcarron Food Centre is a thriving trading post, which meets the needs of the local community and visitors alike. Shelves are well stocked

with essentials including groceries, midge repellent, maps, reading glasses, fly fishing kits, fairy lights and stationery. There is a post office counter and a cash machine. Tea towels with charming illustrations by the local schoolchildren make great souvenirs.

Before leaving Lochcarron there is the opportunity of a detour to romantic ruins on the minor road past Slumbay crofting township. Otherwise, continue to Kishorn and Applecross.

DETOUR: *Tartan cloth and romantic ruins*

The road to Strome Castle passes the Highland sales room of Lochcarron Weavers, the world's leading manufacturer of tartan. There is no weaving on site. Lochcarron Weavers employs skilled craftspeople to design, dye, warp, weave, mend and tailor over 700 authentic Scottish tartans at a Selkirk mill. The iconic woollen cloth is used traditionally for kilts in clan colours. The *feileadh mor* or 'great kilt' was a single piece of cloth, around 10 metres long, worn wrapped around the body and gathered at the waist, with the end of the piece thrown over the shoulder, as seen on the drover in the sculpture outside Dingwall Mart.

A way-marked path opposite the weavers' store climbs half a kilometre through birch woodland to the remains of 28 buildings of Stromemeanach township. Crofters here voluntarily abandoned the site to move to more fertile land. From the hill there are expansive views to Creag Dubh Mor and the opposite shore of Loch Carron.

The minor road continues to the scenic ruins of Strome Castle, a 15th-century stronghold at the narrow entrance of the sea loch. On a clear day, the views to the Isle of Skye are dreamy. Until 1970 the Strome ferry service operated from here. Occasionally it was revived, especially when rock falls blocked local roads. From the hamlet of Ardaneaskan a little further along the road, cottages tucked into the shore enjoy yet more wonderful views to Skye, the mainland village of Plockton and small islands beyond. Sunsets here are magical. Romantic strolls along the lane reach the sheltered bay and secluded shingle beach at Reraig.

Continuing to Kishorn and Applecross on the main route requires doubling back along the minor road and rejoining the A896.

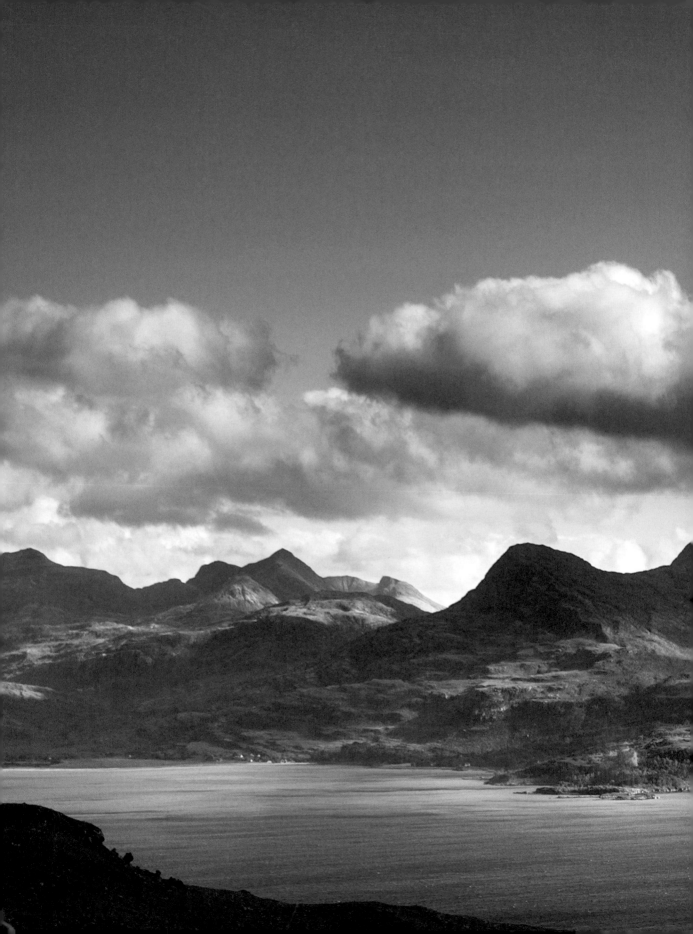

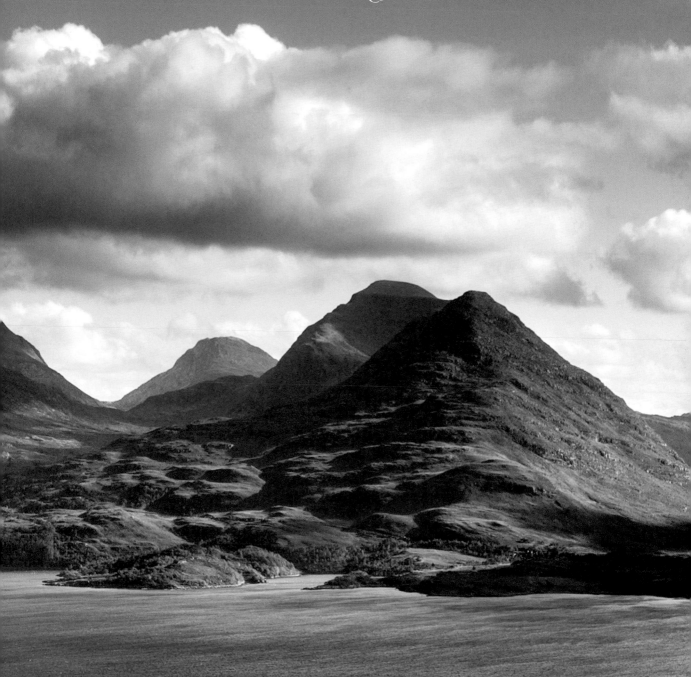

STAGE TWO

Lochcarron to Kinlochewe

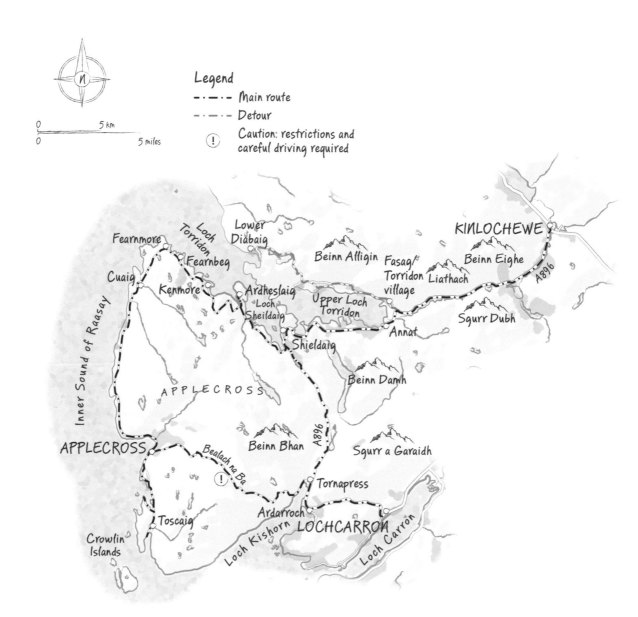

N

0 — 5 km
0 — 5 miles

Fearnmore
Loch Torridon
Fearnbeg
Cuaig
Kenmore
Lower Diabaig
Ardheslaig
Loch Sheildaig
Beinn Alligin
Fasag/ Torridon village
Liathach
Beinn Eighe
KINLOCHEWE
A896
Upper Loch Torridon
Sgurr Dubh
Shieldaig
Annat
Inner Sound of Raasay
APPLECROSS
Beinn Damh
Beinn Bhan
A896
Sgurr a Garaidh
APPLECROSS
Bealach na Ba
(!)
Tornapress
Ardarroch
LOCHCARRON
Toscaig
Loch Kishorn
Loch Carron
Crowlin Islands

KISHORN AND TORNAPRESS

From the gentle shore and shelter of Loch Carron, the route rises towards the beckoning summits of the Applecross peninsula. As the landscape changes so does the road, narrowing to a single-track carriageway with passing places along the way, as if commanded by the mountains. The peaks of Beinn Damh, Sgurr a Garaidh and Beinn Bhan await.

The community of Kishorn is the gatehouse to the Applecross peninsula. A minor road reaches the beautiful bay where Ardarroch and Achintraid meet on the sandy shore. A quiet congregation of cottages enjoys magical views to distant mountains on the Isle of Skye, the summits of mystical Applecross and islets around the coast. The scene inspires local and visiting artists, often working with sketchbooks and easels *en plein air*.

A favourite attraction of Kishorn is the cheery telephone box beside the A896. Destined for demolition, the kiosk was rescued by local young people. Catapulted into a brave new world of communication, it emerged as the Kishorn Selfie Box, the first of its kind in the UK. Visitors are invited to enter, snap a picture and send it to the kiosk's online sites at Facebook and Instagram. A gallery of images reveals the wonderfully diverse group of global travellers who have all giggled and posed in Kishorn. Charmingly, the decor of the iconic K6 model kiosk rings the changes through the seasons: summer blooms are followed by festive fairy lights and tinsel.

Across the road from the berry-red kiosk is the sky-blue chalet of the award-winning Kishorn Seafood Bar. This outpost of fine food serves locally sourced and sustainable oysters, mussels, prawns, scallops, crabs and lobster. Squat lobsters, known as 'spinies', are a west coast delicacy with a flavour like prawns, yet sweeter. Outdoor seating at the Seafood Bar makes it possible to feast with mountain views.

Just a little further along the road towards Tornapress and Applecross, a colourful Scottish Episcopal Church sign peeps from the hedge. This

is an invitation to visit Courthill Chapel, hidden from view down an estate track. While the small chapel remains in service, the estate's mansion is derelict. This is the first hint of tragedy surrounding the Murray family dynasty.

In 1835 Charles Augustus Murray travelled to America and fell in love with Elise Wadsworth, a New York heiress. Her father refused permission for them to marry. Fourteen years later and still in love, they met again and were married in 1850. They had a son, Charles James. Tragically Elise died soon after the birth having first asked her husband to promise to remarry.

Edythe Fitzpatrick became the second wife of Charles Augustus. They had a son, Cecil. When his father died Cecil was inconsolable and he took his own life one year later, aged just 20. Edythe was bereft and founded the chapel. A commemorative plaque on the wall poignantly describes her as 'a sorrowing widow and mother of an only child'.

Yet more tragedy struck the Murray family. Charles James married Lady Anne Finch and together they had four children. Their son Alasdair died of his wounds in the Boer War in 1900. Their daughter Elspeth died aged four. A stained-glass window in the chapel is dedicated to St George. The knight has the face of Alasdair, the Grenadier Guard who died in the Boer War, and, on the west wall of the sanctuary, a window remembers his sister Elspeth.

The Courthill Estate was passed on through the family and sold in 1945, though the chapel was excluded from the sale. In 1979 Elizabeth Murray gave the chapel to the local diocese. Sunday services take place at 10.30 a.m., and the congregation of this extraordinary chapel welcomes visitors to join them for coffee afterwards.

Onward towards Applecross the A896 reaches Tornapress, where a single-span bridge and sections of the old road engineered by Thomas Telford are still visible. The 1802 Parliamentary Commission for Roads and Bridges created more than 1,900 kilometres of road through the Highlands in a period of 20 years. Tornapress junction is an important landmark on this journey. Here drivers have a choice of routes to Apple-cross – either a challenging mountain pass or a coastal road. For some drivers, the option of the Bealach na Ba mountain pass does not apply. The route is not suitable for learners, caravans and large vehicles. Road signs at the start of the route make this very clear. Inexperienced

motorhome drivers and anyone driving a larger-than-standard motorhome should take the alternative coastal route rather than risk the stress of blocking the pass completely. The negative impact of this on the local community is immense. The pass demands the respect of car drivers too. A series of formidable hairpin bends and passing places makes it necessary to be adept at reversing along narrow ledges when meeting oncoming traffic. The pass is the longest steep hill of any classified road in the UK. If in doubt, take the coast road.

The coastal route to Applecross is a continuation of the A896 followed by the minor road through Kenmore, Fearnmore, Cuaig and Callekille. This journey involves driving in and out of Applecross on the same stretch of road, which is no hardship due to the spectacular scenery. Some may wish to bypass Applecross completely and continue directly to Shieldaig.

The weather conditions are another factor in this important decision. In low cloud, mist and fog, the views are obliterated, and even on a clear day, high winds can make it dangerous to get out of the car. For refreshment and serious decision-making, the cheery Bealach na Ba cafe and gallery are conveniently situated at Tornapress junction.

TO APPLECROSS AVOIDING THE BEALACH NA BA

The road that skirts the Applecross peninsula, avoiding the Bealach na Ba, continues north from Tornapress on the A896. Soon Rassal Ashwood National Nature Reserve beckons. Here a rare outcrop of ash trees stands apart from surrounding moorland. Vikings may have begun the plantation as a supply of timber, leaf mould for fertiliser and shelter for livestock. The peaceful woods are under the management of Scottish Natural Heritage.

The journey continues through more typical Highland moorland to arrive at Glen Shieldaig Forest, where red squirrels are being reintroduced. At Shieldaig junction, the route passes a large boulder at the edge of woodland on the right-hand side. This commemorates the opening of the new stretch of road by Princess Margaret, Countess of Snowdon, in May 1970. From here, the coast road journeys to Applecross. Turn to page 54 to discover this enchanting shore.

THE BEALACH NA BA ROUTE TO APPLECROSS

From Tornapress, drivers, cyclists and walkers bound for the mountain pass cross the Kishorn River. The route, which is extremely steep and narrow with passing places and restrictions, soon begins to climb. There are views to a lower road that serves a coastal quarry and the Port of Kishorn where an immense dry dock –160 metres in diameter – has been excavated from the rock. This enormous construction site was designed to meet the needs of the North Sea gas and oil industry. In the 1970s the dock was used for the casting of the 600,000-tonne Ninian Central platform, the world's largest man-made movable object before it was fixed to the sea floor. In 1992 the dry dock was used in the construction of the supports for the Skye Bridge. Now it bids to

construct floating turbines for offshore wind farms.

The gate-keeping cliffs of imposing Meall Gorm welcome Bealach na Ba travellers to the mountain amphitheatre. The heart-stopping drama becomes intense. The road snatches and propels all-comers swiftly upward. The steepest climb is in the first third of the journey. There is no turning back from the white-knuckle ride once the fierce and narrow ascent has begun. The higher the road reaches, the more jaw dropping the views. It is dizzying to check the rear-view mirror. Goodbye, Loch Kishorn! So long, Loch Carron and Plockton! As the world below shrinks, the mountains exert their power. They command the road to shimmy across the slopes. The experience is wonderful.

The Bealach na Ba was used by drovers from the islands destined for trysts, or markets, in the south. The Gaelic Bealach na Ba translates as 'Pass of the Cattle'. Imagine the spectacular scene of Highland beasts hoofing this route. Mountain walls would resound to their lowing, the whistles and shouts of drovers and the obedient barking of herding dogs. The cattle, descended from Celtic oxen, were driven in groups of at least 100 animals and sometimes up to 2,000. It is a procession I would love to have witnessed.

Yet the pass is no place for the imagination to wander too far because, just as the climb seems less frantic, there are four formidable hairpin bends to negotiate. The first is the worst – or the best – depending on your appetite for danger. Once through the switchbacks, the plateau on the crest of the road feels like the top of the world, especially if you have arrived on foot or bike, as many people do. The popular Bealach Mor Cycle Sportive is the UK's biggest road climb for cyclists inspired by the ascent of 626 metres from sea level in just 10 kilometres.

On a clear day, mountain ranges, shimmering sea lochs and islands crowd the staggering vista from the plateau viewpoint. There is even more awesome scenery from the track to a nearby transmitter. But in high winds and poor visibility do not get out of your vehicle. People have lost their lives wandering and falling from the hill.

The mountain pass delivers the road back down to earth beside Applecross Bay. The leafy lanes and sandy shore are an extraordinarily soft landing after the high-altitude drama. Fittingly, the peninsula goes by the Gaelic name of A' Chomraich meaning the 'Sanctuary'. Taking time to slow down and be restored in the embrace of Applecross is a joy.

Curiosity

A' Chomraich, the Sanctuary of Applecross

For many centuries, this remote peninsula was accessible only by the sea or by the Bealach na Ba. This imbued the scattered settlements with an air of isolation and enchantment that lingers on.

The Applecross Heritage Centre is a great resource of local culture. A collection of vintage photographs is especially intriguing. The heritage centre traces the journey of St Maelrubha, the Irish monk who rowed his *curragh* from Bangor to Applecross where he established a monastic settlement second only to Iona. It is believed that the boundary of his religious sanctuary extended around four kilometres in all directions and was marked by stone crosses. In the eighth century, Norse invaders destroyed most of the holy site. A few remnants remain visible, including a stone cross and what is believed to be a holy well, in the woods between the pier and Applecross House.

Woodland and coastal trails around the peninsula are well signposted. Many follow historic routes that served to connect isolated communities. Among my favourites is the heather moorland path between Applecross and Kenmore. This was a coffin route taken for burials at Clachan Church.

There's good living in Applecross. The Walled Garden established to feed the Victorian residents of Applecross House is a special place. I first visited some years ago when the restoration project was just beginning. Now the lush and productive oasis thrives. The Potting Shed within the garden walls serves delicious fresh food, much of it home-grown. Mounds of fresh kelp from the shore nourish the vegetable beds. Scrambling roses and wandering vines climb the walls. Lavender edges the paths. On a clear and still autumn night, stepping into the chill garden air after dinner is fantastic. The humungous canopy of twinkling stars is an astonishing sight never to be forgotten. Go with someone you love!

The ever-popular Applecross Inn is renowned for the quality of its seafood. Meals and snacks are served from lunchtime until evening. Tables are unreserved and peak times are always busy, especially in summer. Applecross Inn-side Out is an offshoot of the famous hostelry. An incongruous and dazzling Airstream trailer at the water's edge is transformed into a fish-and-chips takeaway. The home-made ice cream is especially delicious.

ALONG THE SHORE FROM APPLECROSS TO TOSCAIG

The Coalshed Gallery at the junction of the Bealach na Ba and Shore Street in Applecross was formerly the village coal shed. The stone building stands close by the bay where flat-bottomed Clyde steamers, or puffers, were beached on a falling tide. Their cargo of fuel was loaded directly on to horse-drawn carts waiting on the sand.

Opposite the Coalshed is the community-owned, volunteer-run filling station. Established on a not-for-profit basis, the facility is decorated with colourful flowering pots and vintage photos of vehicles on the Bealach na Ba. Fuel is available 24 hours with payment by card only. The ambitious filling station is part of a long-term vision to provide charging for electric cars, powered by the community's micro-hydro scheme.

Applecross consists of seashore townships that are especially lovely

to explore on foot or bike. Meandering in the company of free-range cattle, sheep and hens is a delight.

From the Bealach na Ba junction on Applecross Bay, the narrow shore road passes the inn and a parade of low stone cottages to arrive at Milltown where the dammed Loch a Mhuilinn served a now-defunct meal mill. The loch is rich in wildlife and is visited by mute and whooper swans. They can be observed easily from the road or, more closely, from the bird hide on the shore.

An uphill path leads to a rare Atlantic rainforest at Carnach. High rainfall and stable mild temperatures create ideal conditions for more than 140 varieties of lichen and over 100 varieties of moss. Highland communities traditionally put these natural resources to practical use. Lichens served as dye for wool, including Harris tweed. Moss was used for bedding, wound dressing and as a natural nappy. It also served as packing to keep boats watertight.

Before the completion of the coast road in 1976, the sea was the highway that connected Applecross to the world. West coast lobsters, fished from the Inner Sound of Raasay, were packed in sawdust, loaded on boats and sent from Strathcarron railway station to Billingsgate market in east London. Mail boats called at Milltown Pier. Travellers for destinations beyond the peninsula were rowed out to climb aboard the passing Kyle of Lochalsh and Stornoway ferry.

The well-stocked village shop, post office and cottages of Camusteel meld into the township of Camusterrach on the shore of Poll Creadha, a natural harbour with a rubble pier.

In these seashore hamlets a Gaelic-speaking community of crofters, butchers, tailors, weavers, shopkeepers and a blacksmith lived largely self-sufficient lives. Times have changed. Many of the homes are now holiday cottages yet the community still supports a doctor's surgery, two churches, a shop and a primary school renowned for a stag's head on the wall and a wildcat with a rabbit under its paw in a glass case.

From Culduie, sunset views of the Isle of Skye are especially romantic. Along the shore stand tall wooden poles where local fishers hung their washed cotton and linen nets to dry. The hamlet is the setting for Graeme Macrae Burnet's acclaimed novel *His Bloody Project*, published in 2015. The story unfolds around the arrest of 17-year-old Roderick Macrae for a triple murder. Though the novel is a work of fiction, the

burn at the north end of the township is known as Allt nan Corp or 'the Burn of the Body'.

Ard Dhubh is a community of traditional houses and ruins crammed cheek by jowl on to a headland with yet more inspirational views. A small island off the headland is the favourite basking place of common seals. Along the shore, a walk of two kilometres follows a clear footpath to Ard Ban and Coille Ghillie. These largely deserted townships have tropical white sand beaches and heavenly views to Skye, Raasay, Eilean na Ba – 'the Island of the Cattle' – and the Crowlin Islands.

Toscaig is at the road end. A lonely concrete landing stage is the only trace of the motorboat ferry service that once sailed from here to the Kyle of Lochalsh. This sleepy spot is where you might quietly catch sight of an otter. Traditionally, fisher families sold catches of herring from Loch Toscaig all around the peninsula.

A detailed map is required for the strenuous walk from Toscaig to the crumbling remains of Airigh Drishaig township. From here, there are views to Plockton and the Skye Bridge.

APPLECROSS TO SHIELDAIG

Leaving Applecross for Shieldaig, the coastal road passes many signs of early settlers around the peninsula. At the Mains of Applecross, above Applecross Bay, there are remains of an Iron Age broch tower. To demonstrate how people might have lived over 2,000 years ago, the community has built an extraordinary thatched roundhouse building at the edge of Carnach woods.

The simply named Sand is an expansive bay with a vast beach. Rock shelters have revealed traces of Mesolithic activity. Stone Age people worked here with antlers. They made tools and ate limpets, casting the waste shells on midden mounds. In later years, traditional Highland travellers used the same spaces as temporary homes. Among the many sea chambers and cave systems around this coast are the enigmatic Cave of the Liar and the Cave of True Wonders. Adjoining Sand Beach is the British Underwater Test and Evaluation Centre (BUTEC). Just a limpet shell's throw from the dwellings of Stone Age people, nuclear

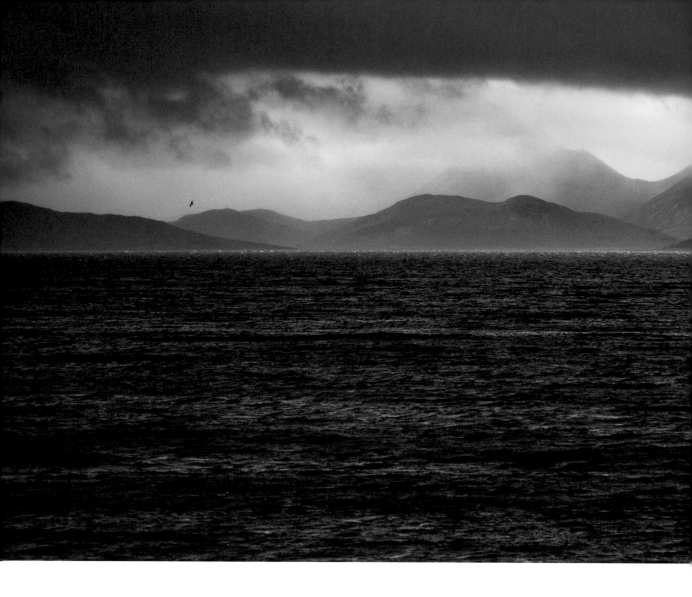

submarines and torpedoes are put through their paces in the clear and quiet waters of the Inner Sound of Raasay.

At Lonbain, a former schoolhouse and a row of deserted homes overlook raised beaches. It's easy to imagine the songs and chatter of the community at the edge of the sea. A traditional heather-thatched blackhouse, owned by the National Trust for Scotland, is due for restoration.

Callakille is another deliciously isolated outpost, with views on a clear day to Harris and the Outer Hebrides.

Beauty Spot

Stepping stones to Cuaig beach

The shore at Cuaig is a perfect picnic spot although the secluded sands are exposed only at low tide. From Cuaig Bridge a sometimes-squelchy footpath along the bank of the river nearest Applecross reaches stepping stones and then the beach.

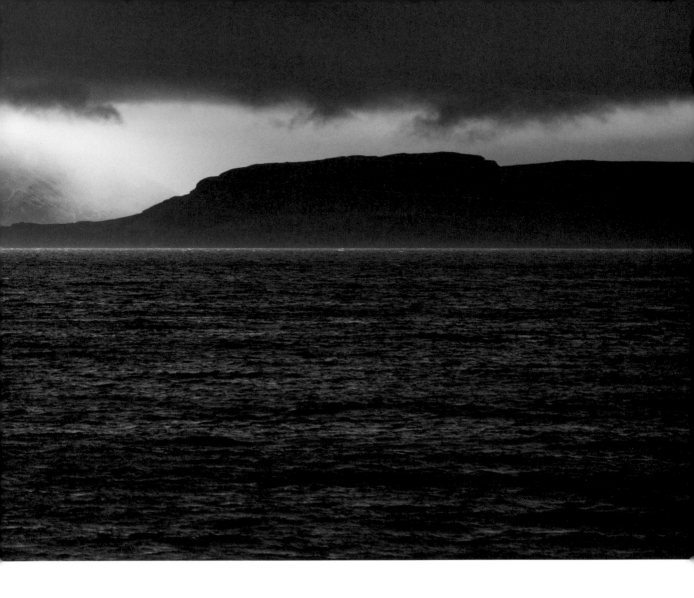

At Cuaig Croft Wools and Weavers, Lesley and Thomas Kilbride keep a small flock of grey Gotland sheep. Using traditional skills, the crofters dye, hand spin and hand weave their wool. Observe them at work in the studio, where their beautiful goods are on sale. For those who feel inspired, they also offer workshops.

The hamlets of Fearnmore and Fearnbeg provide a language lesson. Though Gaelic spellings may vary, *mor* means 'great' and *beg* means 'small'. At Fearnbeg, a track around a rocky headland leads to the sheltered natural harbour at Camas na Caillich. The view is stupendous. Across the Sound of Torridon, Beinn Alligin rises above whitewashed cottages beside the pier at Lower Diabaig. Mighty Liathach, a mountain range of eight summits, extends eight kilometres to the east.

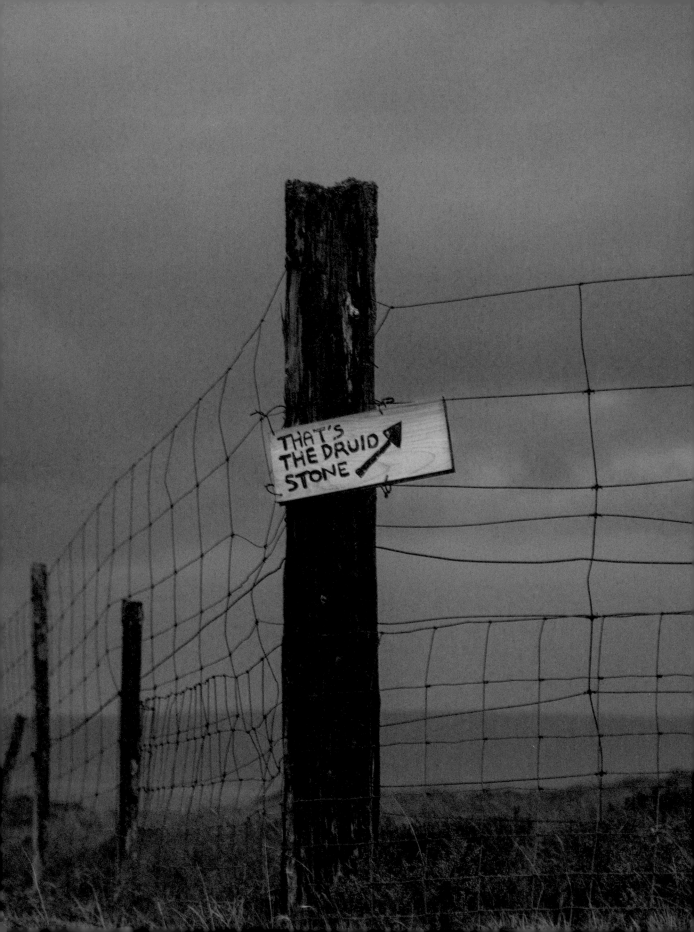

Continuing towards Shieldaig a raised section of fence runs alongside the road near the settlement of Arinacrinachd, in the area known as Arrina. A small sign points uphill to the Druid's Stone. My thanks go to Muirne Buchanan, a local artist working in glass, for explaining that her niece made the sign in response to wandering travellers seeking out the spot.

A side road dips into communal grazing pasture at Kenmore. From this township, villagers carried their dead in coffins over heather moorland for burial at Clachan. The way-marked 14-kilometre heritage path is a great walk. The scenery is rugged. At small cairns along the way, mourners traditionally rested a while and toasted their loved one. The funeral bier used to carry the coffins is on display at Applecross Heritage Centre.

Beauty Spot

Ardheslaig headland

Local fishers land shellfish at Loch Beag on the Ardheslaig headland. Some is sold around the area; much is exported to France and Spain.

There are views across the Minch to the Hebrides and over Loch Shieldaig to the massed ranks of the Torridon mountains. This is a great spot to launch a kayak, potter about or picnic on treats from the Applecross Smokehouse, near Kenmore.

SHIELDAIG TO TORRIDON AND ON TO KINLOCHEWE

The sense of leaving behind the Applecross sanctuary to enter the mountain kingdom of Torridon is thrilling. The famous peaks of Beinn Alligin, Liathach and Beinn Eighe rise up in force. The trio are among the most vertical mountains in Scotland. On a clear day, they are spectacular. In low thick cloud and driving rain, they are almost invisible.

On the approach to Shieldaig, there are glimpses through woodland to Sild-vik or 'Herring Bay' as it was known by Norse settlers. The Applecross coastal route rejoins the A896, which skirts around the back of Shieldaig village. To visit the waterfront community take the minor road.

Shieldaig was founded in 1800 at the behest of King George III. The intention was to develop a fishing community that might provide sailors for the Royal Navy during the Napoleonic Wars. Though the war was over by the time the village was built, the new community received government support. Fishers enjoyed duty-free salt for their catch, among other benefits. There's an air of refinement about Shieldaig. Picnic benches sit on immaculate greens by the shore. Attractive cast-iron

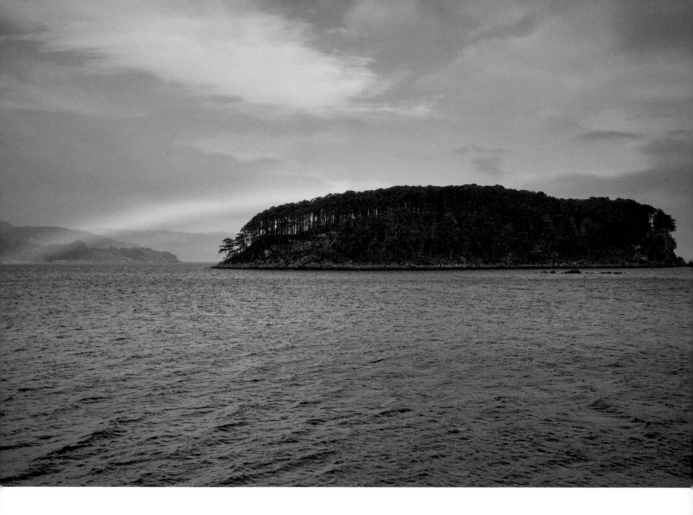

lampposts light the night. In the bay, Shieldaig Island is a giant pincushion bristling with tall Scots pines. With support from the RSPB, local people have designed a shorefront information board about the sea eagles that nest in this protected sanctuary.

Through the 1950s, Anne Grant owned the Shieldaig stores, which were situated in a corrugated iron building. She was much respected by the community, who knew her as Nanny Grant. Following the demolition of the landmark, the replacement village shop and cafe is named Nanny's in honour of her. On the menu at Nanny's is porridge with cream and honey, langoustine salad landed by the local fisherman and hot-smoked salmon salad from the Torridon Smokehouse, which is tucked away in the back garden of Rosebank cottage in the village.

The minor road through Shieldaig rejoins the A896 at the far end of the village. The route follows the shore of Upper Loch Torridon. Views of massed mountains are spectacular, especially when daubed white with snow. The peaks of Beinn Alligin and Liathach look across

the salt marsh of Annat. They dwarf the township of Fasag, or Fasaig, which has been known also as Torridon village from the 1950s onwards.

The district of Torridon encompasses 17 Munros. They are summits surveyed in the 1890s and catalogued as over 3,000 ft by Sir Hugh Munro. Many mountain-hungry climbers and walkers have ambitions to 'bag' every peak on Sir Hugh's list.

The physical structure of mountains affects the way air flows around them. As a result, they have their own weather systems and a day on high slopes can be dramatically different to a day down in the glen. Accidents happen in dramatically changing mountain weather. In March 1951, an Avro Lancaster TX264 bomber from RAF Kinloss crashed into the Triple Buttress within the seven peaks that constitute the massif of Beinn Eighe. In severe weather, the plane had gone off course. Deep snow and high winds delayed location of the wreckage. However, a young boy in Kinlochewe reported seeing a red flare of light on the mountaintop and a rescue mission began in earnest. Hampered by fierce weather and poor equipment, the task of retrieving the bodies

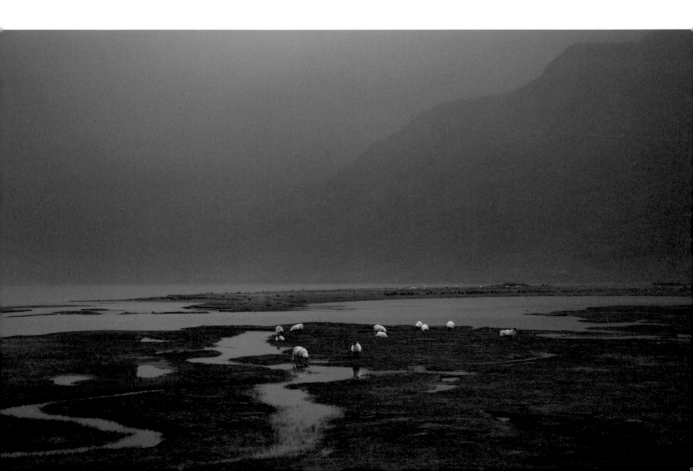

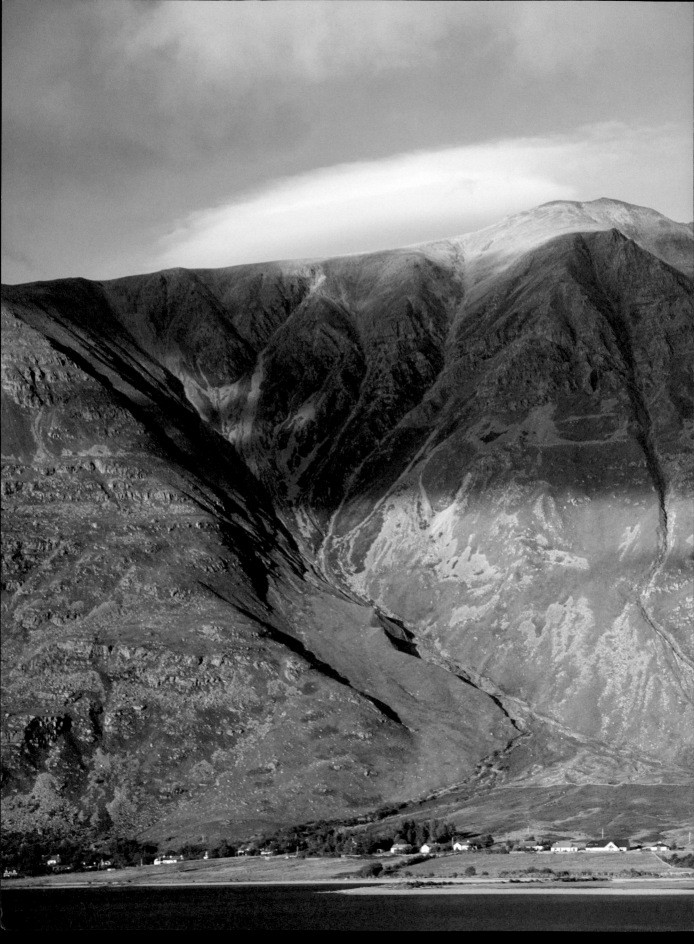

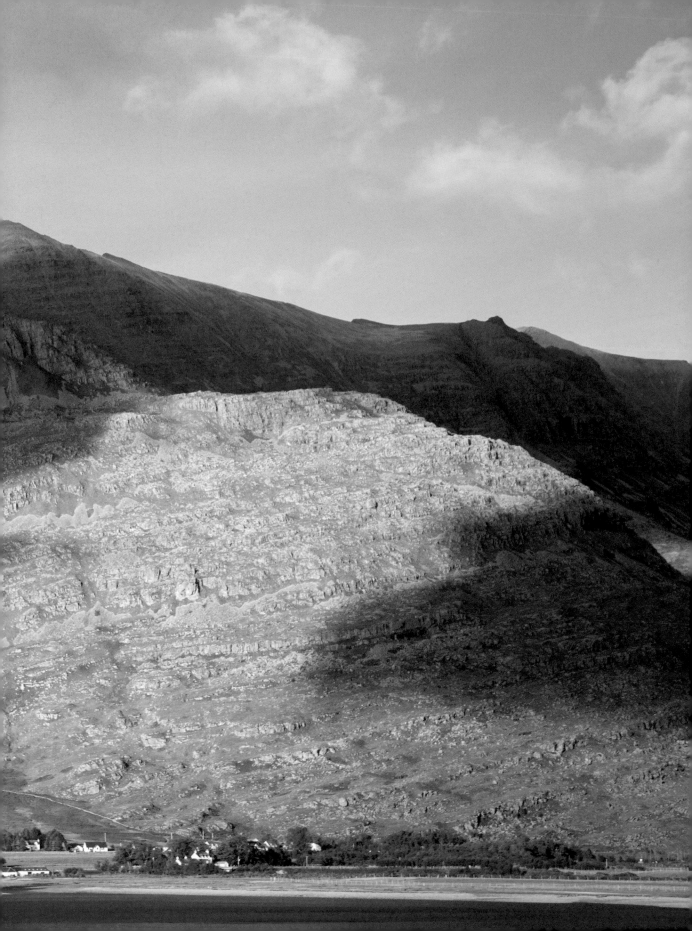

Curiosity

The Deer Museum

The wildlife of Torridon is exhibited at the Countryside Centre managed by the National Trust for Scotland, the major local landowner. Nearby is the Deer Museum, a project begun in 1971 by NTS ranger and naturalist Seamus McNally. The small exhibition at Torridon Mains is an intriguing cabinet of deer-related curiosities and wall-to-wall antlers.

An enclosure near the museum offers the opportunity to encounter live deer. From here, a short walk reaches a wildlife hide on the shore of Upper Loch Torridon.

of the eight aircrew from the remote and snow-bound crash site took almost six months. At first, the RAF declined the assistance of experienced local civilian climbers. Ultimately, it became apparent that the courageous, dedicated RAF rescue crews required better equipment and training. Following the tragedy, both were improved.

Another outcome was the eventual formation of Torridon Mountain Rescue Team in 1971. Among the first volunteers were crofters, deerstalkers, foresters and experienced local climbers with intimate knowledge of the terrain. For many years, the Torridon Mountain Rescue Team met at Torridon Youth Hostel. Their new base is at the foot of Liathach beside Loch Torridon Community Centre and Torridon Medical Centre.

The Torridon Stores and Cafe is a great place to replenish supplies. If the weather is kind, there is the opportunity to sit outside. The menu is properly Scottish – Loch Torridon salmon sandwiches, haggis rolls and Stornoway black pudding rolls. The home-made soup and cakes are good too. From the cafe there's a view of nearby Am Ploc, a small headland where community groups, in need of a church building, gathered for open-air services beside the sea loch. Still visible are the tidy rows of boulders they used for seats.

DETOUR: *The hideaway serenity of Lower Diabaig*

Lower Diabaig – simply the name makes me smile.

The memory of my first visit to this heavenly spot is crystal clear thanks to the shock of jaw-dropping views on a nerve-jangling drive. The road soars to the Bealach na Gaoithe or 'Pass of the Winds'. The vista across Upper Loch Torridon to the assembled summits of Glen Torridon, Glen Shieldaig and Applecross is breathtaking. The road is precarious and entirely unsuitable for inexperienced or nervous drivers. But all is not lost – an alternative approach to the sleepy shore of Lower

Diabaig is possible by Torridon RIB water taxi service. If the views were not enough to entice you to this serene bay, then the waterfront cafe and restaurant of Gille Brighde offers yet more temptation.

For fleeting visits, the pier and pebbly foreshore are happy places to mooch before girding the loins for the steep drive out of the village back through the spectacular pass. For longer visits, an 11-kilometre walk from Lower Diabaig reaches the sands of Red Point. The coastal views to the isles of Skye and Raasay are magical.

Leaving behind the settlements of Upper Loch Torridon, the A896 travels directly towards Kinlochewe through the mountains in the company of the River Torridon. Imposing Liathach and Beinn Eighe are to the left. To the right is Sgurr Dubh and paths into the Corrie of a Hundred Hills. Here, the last Ice Age created masses of curious smooth mounds or drumlins. Car parks along the road are well used by walkers, climbers and cyclists.

Beside the road at Kinlochewe, the cheerily painted Whistle Stop Cafe is the starting point of the annual Bealach Mor Cycle Sportive race to Applecross. The September event is regarded as an ultimate test of alpine fitness.

STAGE THREE
Kinlochewe to Ullapool

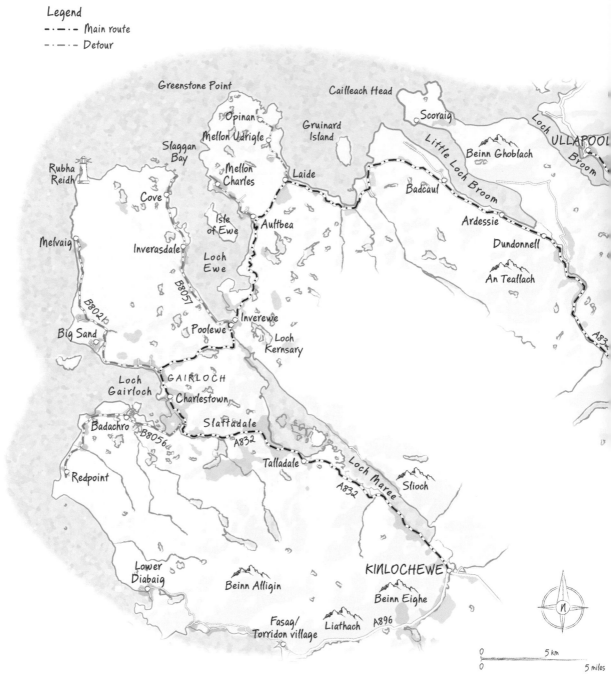

Greenstone Point

Cailleach Head

Opinan

Scoraig

Mellon Udrigle

Gruinard
Island

Little Loch Broom

ULLAPOOL

Slaggan
Bay

Mellon
Charles

Beinn Ghoblach

Loch Broom

Rubha
Reidh

Laide

Badcaul

Cove

Ardessie

Iste
of Ewe

Aultbea

Dundonnell

Melvaig

Inverasdale

Loch
Ewe

An Teallach

B8057

B8021

Big Sand

Poolewe

Inverewe

Loch
Kernsary

A832

GAIRLOCH

Loch
Gairloch

Charlestown

Badachro

B8056

Slattadale

Redpoint

A832

Talladale

Loch Maree

Slioch

A832

Lower
Diabaig

Beinn Alligin

Beinn Eighe

KINLOCHEWE

Fasag/
Torridon village

Liathach

A896

0 5 km

0 5 miles

N

KINLOCHEWE AND THE ISLANDS OF LOCH MAREE

The community of Kinlochewe lies at the foot of Glen Docherty on the shores of Loch Maree. This deep pool of freshwater, some 30 kilometres long, is sprinkled with wooded islands. Overlooking the romantic scene is the mountain hulk of Slioch, from the Gaelic *Sleagh*, 'The Spear'.

The Kinlochewe Hotel is a former coaching inn where Sir Hugh Munro resided while completing his mission to survey and categorise Scottish mountains over 3,000 feet. His legacy lives on as the hotel hosts the annual meeting of the Scottish Mountaineering Club.

Nearby Incheril car park is the gateway to slopes of Slioch and lower-level walks around Loch Maree. For campers seeking mountain views from the tent and a short, free stay of no more than two nights, the basic facilities at Taagan farm, managed by Scottish Natural Heritage, make a good stopping place.

It is thought that Loch Maree takes its name from St Maelrubha, who founded not only the monastery at Applecross but also a hermitage on Isle Maree. He was clearly a soul with excellent taste in romantic settings.

The ancient great forest that clothed the hills around the loch is largely gone – the massive supply of timber readily fuelled several 17th-century iron furnaces in the area. On the north bank of the Furnace burn at Letterewe, there are visible remains of this industry. Although Scottish iron production was rare, swords produced at Highland furnaces or 'bloomeries' were considered to be among the finest in Europe.

When a new railway line reached Achnasheen in 1870, the opportunity of Highland tourism arrived too. Deerstalking and salmon and trout fishing were major attractions, along with appreciation of the natural landscape.

Intrigued by the rare habitats of the temperate oceanic 'rainforest' at Coille na Glas Leitir on the south bank of Loch Maree, botanists were also among the new Highland tourists. Ultimately, their passion

for the ancient trees, mossy mounds and deep heather in this magical place led to the establishment of Britain's first National Nature Reserve in 1951. The historic purchase of this patch of rainforest included Beinn Eighe, the mountain known as 'The File'. Beinn Eighe, the most inland of the Torridon mountains, has since been a revelation to botanists and geologists. The dramatic heights have steeply plunging vertical slopes with seven peaks and a series of spectacular corries of white quartzite formed from sand laid down by seas that flooded the landscape around 540 million years ago. Within this massif are many rare species of flora and fauna.

Beinn Eighe National Nature Reserve hosts more than 100 different bird species, among them iconic golden eagles. The UK's only endemic bird lives here too – Scottish crossbills are not found in any other country. The award-winning visitor centre in Aultroy provides information about wildlife, walks and trails in this special landscape.

A walk of six kilometres along the east bank of the River Talladale, which flows into Loch Maree, leads through more ancient woodland to a deep gorge. This opens up to the relatively little known Talladale Falls. The pools of this magnificent cascade are wild swimming spots well off the beaten track. The path can be boggy and slippery – a detailed map and appropriate walking gear are essential, as ever when venturing into wild Highland scenery.

Between Talladale and Slattadale, the grand Loch Maree Hotel is a landmark in a landscape where buildings are few. Queen Victoria stayed at the hotel for five nights from 12 September 1877. The monarch gave it her royal stamp of approval. She wrote in her memoirs, *More Leaves from the Journal of a Life in the Highlands*: 'The windings of the road are beautiful, and afford charming glimpses of the lake, which is quite locked in by the overlapping mountains.' A mighty boulder at the front of the hotel bears witness to her visit with a Gaelic inscription recalling her pleasure. Making the most of her approval, the hotel advertised itself as 'Lately Her Majesty's West Highland Residence'. The notice stated also that boats, fishing and hill ponies were available. Hotel guests especially enjoyed excursions afloat. Between 1882 and 1911, the ss *Mabel*, a small paddle steamer, operated a scenic ferry service around the loch and islands.

In August 1922 tragedy befell the hotel when eight guests died of food poisoning after eating sandwiches on a picnic lunch. Traces of botulism were found in the wild

Curiosity

Mystical Isle Maree

Five large islands and many smaller islets stud Loch Maree. Curiously, some of the islands have their own islets in freshwater pools.

St Maelrubha built his hermitage on Isle Maree where druids erected a stone circle that is surrounded by groves of birch and sacred holly. Over the centuries, the isle has been a destination for spiritual pilgrims. The water of a well was believed to cure lunacy, and Queen Victoria was among many hundreds of people to hammer a coin into the bark of a tree believed to have healing powers. The tree has since died. Copper poisoning is believed to be the cause of death.

duck paste the hotel's kitchen had used in some of the sandwiches but
a public inquiry ruled that no fault was attributable to any particular
person.

SLATTADALE TO THE SHORES OF GAIRLOCH

Slattadale car park gives access to a lochside picnic area. From here, it
is possible to visit the Victoria Falls named in honour of the monarch's
visit. Though not the Highlands' most spectacular cascade, the falls
improve after heavy rain. From the car park, a popular scenic walk of
around eight kilometres follows an old path over the moor to Tollie
Pier. Allow around four hours for the return journey. The island and
mountain views across Loch Maree on the return to Slattadale are
especially lovely.

Leaving Loch Maree, the A832 journeys towards Loch Gairloch,
becoming single track for a while. A local landmark on the right-hand
side is the Red Barn parking place, which is actually beside a green

shed. From here, there are walks around Loch Bad an Sgalaig into a recently planted native pinewood forest of over a million trees. Not yet full height, they are the promise of things to come. Around the shore of the loch, exposed stumps are the petrified remnants of the former great Caledonian Forest.

Continuing towards Gairloch the road passes the Eas na Gaibhre, 'Waterfall of the Goat', and travels with the River Kerry, renowned for Atlantic salmon, sea trout and an internationally important population of freshwater pearl mussels. At the junction with the B8056, there is the opportunity of a romantic detour.

DETOUR: *The romantic magic of the B8056*

Among my favourite roads is the B8056. This single-track carriageway boldly announces itself with an enormous sign at the modest junction with the A832. It proclaims a delicious invitation to discover idyllic inlets, romantic islands, crofting townships with sea views and spectacular beaches at Red Point.

The road passes the wooded grounds of Shieldaig Lodge, a former Victorian hunting lodge gloriously situated on Loch Gairloch. The handsome mansion is now a comfortable country hotel where guests enjoy archery and falconry along with traditional Highland pursuits. Travellers should be wary of confusing this Shieldaig, on Loch Gairloch, with Shieldaig on Loch Torridon. It is an easy mistake to make and many have fallen foul of it.

Beyond the lodge, on the south side of the road, a way-marked path leads to the Fairy Lochs and the site of a war grave. In June 1945 a US Air Force B-24 Liberator aircraft, *Sleepy Time Gal*, crashed into the hillside and 15 young Americans lost their lives. The flight was bound for the USA at the end of hostilities. Tragically the plane collided with the summit of Slioch and struggled on before crash-landing beside the Fairy Lochs. Wreckage remains strewn around the site, in the heather and in the water. The atmosphere is deeply moving and those who visit the scene should respect the war grave. A memorial plaque lists the names and ages of those who died. Most were under 30.

Lovely Badachro is an anchorage in the shelter of Eilean Horrisdale,

the largest of the islands in Loch Gairloch. This privately owned inhabited idyll is connected to the mainland by a floating bridge that rises and falls with the tide. Hideaway cabins offer guest accommodation with the opportunity to catch crab, langoustine or squat lobster on the owner's boat. Eilean Horrisdale and Eilean Tioram, known as 'Dry Island', are the sites of former fishing stations.

The Laird of Gairloch, Sir Hector Mackenzie (1758–1826), established a fish curing business to export dried cod from the Highlands to Bilbao. The unassuming pier and store on Badachro Bay are associated with his grand scheme. The nearby Badachro Inn serviced the workers at the fishing stations. The beautifully situated watering hole remains a favourite with sailors and landlubbers alike.

On the hill above the bay, Badachro Distillery is a cottage industry where Vanessa and Gordon Quinn handcraft small quantities of Badachro gin in a copper still known as Delilah.

Discover squeaky singing sands on the beach at Port Henderson and the crumbling remains of a fishing village around the shore. Twenty-two men who were allocated land by Sir Hector established this former boatbuilding and fishing township. An unusual Port Henderson feature is a large boulder in the front garden of a local croft. Known as the Clach an Fhuail or 'the Urine Stone', travellers used the landmark while answering the call of nature. It has since been fenced off and is no longer in use.

In the hamlet of Opinan, the conservatory of a croft house serves as the local polling station. In 1964 the closure of the village school left the community without a polling facility. Rather than travel to Gairloch, it was suggested a more accesible venue might be found. The conservatory is ideal. Voting becomes a social occasion with great views to the Isle of Skye.

At South Erradale, the River Erradale – or Abhainn Dearg, the 'Red River' – passes through an extraordinary 14-arch concrete bridge built in 1874. Curiously, North Erradale is beyond Gairloch, between the villages of Melvaig and Big Sands.

As the road travels towards Red Point, the views to the isles of Skye, Rona, Raasay and Scalpay are increasingly magnificent, especially on calm sunny days when the sea sparkles. As the tarmac warms in the heat, sleepy lambs settle down to snooze. Driving with care is essential.

Red Point is a glorious swathe of amber sand. This magical place was the setting for some of the most poignant and gripping scenes of the BBC drama *What We Did on Our Holiday*, released in 2014.

From the beach, a farm track leads to Gairloch Trekking Centre and the wonderful opportunity to discover this awesome scenery on horseback. Whether walking or riding, there is much to see – especially two bothies of a former fishing station and an ice house built into the ground. I imagine the sea breeze still carries the chatter of those who gathered here through the decades to catch wild Atlantic salmon, the king of fish.

From Red Point, a magnificent footpath skirts the coast to Lower Diabaig. Along the way, it passes a former youth hostel. This spectacularly situated building is now an atmospheric bothy.

GAIRLOCH TO POOLEWE

Doubling back to the A832, the next destination is Gairloch, a community consisting of several seashore settlements.

The historic Old Inn on the banks of the Flowerdale River is renowned for fresh local seafood. From the riverside car park, several way-marked walks discover Flowerdale Glen. The waterfall path visits a memorial to piper Iain Dall MacKay (1656–1754).

Gairloch harbour is a working port. For much of the 20th century, it supported a thriving herring and whitefish economy until stocks collapsed. Protective measures closed Loch Gairloch to trawlers and dredgers. Inshore fishing boats from the local area and the east coast continue to land their catch here. Leisure boats offer wildlife- and whale-watching trips.

The Sitooterie is a narrow community garden at the edge of the shore where benches and bird feeders overlook the sea loch. From the harbour, the coast road dips to a magnificent beach and Gairloch Golf Club. Challenges on the nine-hole course include attention-grabbing vistas over the Minch to the isles of Skye, Harris

Curiosity

The chanter of Iain Dall MacKay

Iain Dall MacKay is considered one of Scotland's finest pipe composers. The blind musician, poet and composer became the official piper to the Mackenzie lairds of Gairloch. His 17th-century bagpipe chanter, handed down through generations of his family, is exhibited at the Glasgow National Piping Centre Museum.

JUNE SUMMARY:
MINKE WHALE × 90
COMMON DOLPHIN × 687
BOTTLENOSE DOLPHINS
UNIDENTIFIED LARGE WHALES
WHITE-TAILED EAGLE × 67
ICELAND GULL

JULY SUMMARY:
MINKE WHALE × 79
COMMON DOLPHIN × 420
WHITE-TAILED EAGLE × 29
STRIPED DOLPHIN × 1!

AUGUST SUMMARY!
HUMPBACK WHALE × 2
MINKE WHALE × 70
COMMON DOLPHIN × 1161
BASKING SHARK × 4
SABINE'S GULL × 7
LONG-TAILED SKUA × 9
WHITE TAILED-EAGLE × 18
SOOTY SHEARWATERS

* HALF OF THE CRUISES LOST TO THE WEATHER IN AUGUST! ☹

JUNE 24th
KILLER WHALE ×2

SEPTEMBER SO FAR:-
KILLER WHALE × 2
MINKE WHALE × 28
RISSO'S DOLPHIN × 12
COMMON DOLPHIN × 1030
BASKING SHARK × 1
SABINE'S GULL × 7
LEACH'S STORM-PETREL × 1
LONG-TAILED SKUASLOADS
POMARINE SKUASA FEW
SOOTY SHEARWATERS......LOADS
WHITE-TAILED EAGLE × 12

PORPOISE, STORM PETRELS, SEALS ETC
* EVERY CRUISE *

14th MINKE WHALE ×6
COMMON DOLPHIN × 500 +500
+250 +10 +20 +35 +45
SABINE'S GULL × 5
LONG-TAILED SKUAS
POMARINE SKUA
15th MINKE WHALE ×3
COMMON DOLPHIN × 20+15+2
SABINE'S GULL
LONG-TAILED SKUA'S
POMARINE SKUA'S
16th MINKE WHALE ×5
COMMON DOLPHIN ×10
SABINE'S GULL ×6
LONG-TAIL & POMARINE SKUAS
WHITE-TAILED EAGLE × 3
17th
MINKE WHALE × 4+1+1
COMMON DOLPHIN × 40+80
+130+20
POMARINE SKUA'S
LONG-TAILED SKUAS
SABINE'S GULL ×5
WHITE-TAILED EAGLE×3

MINKE WHALE ×2

and Lewis. When the weather's gloomy, there's good cheer and home baking at the Links Cafe in the clubhouse. Visitors are welcome every day of the week. The road climbs to Gairloch War Memorial, where benches with huge sea views are perfect for watching harbour porpoises all year round.

In 1872 the Gairloch Estate commissioned two hotels, the Loch Maree Hotel and the Gairloch Hotel. Highland tourism was booming and summer steamers carried visitors from Portree, Tobermory, Oban and Glasgow. The Gairloch Hotel's conservatory and gardens were

much admired for their abundant fruit, flowers and vegetables. In 1878 Queen Victoria came to stay. During World War II, the accommodation served as a naval hospital.

Large raised vegetable beds and a garden of seashore cobbles surround the impressive GALE Centre. Here the Gairloch community meets for events, including a weekly Monday market. The Scandinavian-style building is constructed of locally grown, untreated timber and built to *Passivhaus* standard, which makes it exceptionally energy efficient.

Near the Shieling Restaurant, a two-storey, above-ground, blast-proof, reinforced concrete bunker is due to become the new site of Gairloch Heritage Museum. The 1950s building was one of four Anti-Aircraft Operation Rooms built across Scotland during the Cold War. The secret communications centre issued alerts from the Royal Air Force about the height and direction of possible airborne attack to gun sites around Britain. The bunker became redundant following the disbandment of the Anti-Aircraft Command in 1955. The local council later used it as a roads depot.

At the junction of the B8021 and the A832, there is an opportunity to discover more rich history. The Gairloch Heritage Museum is presently located in the more traditional rural buildings of Achtercairn steading at the junction of the B8021 and the A832. Allow plenty of time to explore the eclectic collection. A popular exhibit is the relocated old-fashioned and colourful interior of Farquhar Macrae's shop at Melvaig.

DETOUR: *To the lighthouse at Rubha Reidh*

'When you come to a fork in the road, take it,' announces the sign over the door to Buddha by the Sea, a favourite Highland shop on the Gairloch shore. The quirky words are from Yogi Berra, elected to the Baseball Hall of Fame in 1972. In the same year, the New York Yankees retired his number 8 shirt. The quote refers to directions he would give to his New Jersey home, accessible by two roads. The lovely shop sells interesting books, clothing and Fair Trade crafts from Nepal, Rajasthan and other far-away places. To visit on a grey day is pure colour therapy.

At Strath, the route passes the cottage from where Two Lochs Radio broadcasts to the Highlands. Though it is the UK's smallest radio station,

the independent broadcaster has won many awards for programming in Gaelic and English.

The seashore road climbs to a cluster of shops and cafes. Kenneth Morrison, the family butcher, sells poultry, game, fresh fish and even Christmas trees in season. A sign on the door of the Mountain Coffee Company and Hillbillies Bookstore and Trading Post reads: 'I do not agree with what you have to say, but I'll defend to the death your right to say it.' The cafe is renowned for home-baked scones – fruited mini mountains. The adjoining independent bookshop is a great den and well stocked. It is a joy to browse. Locals and visitors leave donations for the tribe of feral cats that feed regularly from dishes outside the cafe since the local fish-processing factory closed.

Gairloch Sands Youth Hostel opened to the public in 1932. The building is a former shooting lodge known as Cam Dearg. Generations of outdoor enthusiasts have made memories here. Sands Caravan and Camping Park in the dunes at Big Sand hosts the annual Gairloch Highland Gathering on the first Saturday in July. The on-site Barn Cafe offers breakfasts, lunches and evening meals. A shop supplies holiday essentials, from books to champagne. Kayaks and cycles are available to hire too. Opposite the campsite is Longa Island, where a small fishery and farm were established in the 18th century. Now the only residents are colonies of breeding seabirds.

The Sand River Archaeological Trail departs from a small car park along the road. The three-kilometre route crosses heathery moorland to discover turf dyke enclosures and Bronze Age hut circles.

As the road journeys towards the lighthouse at Rubha Reidh, there are sea views to distant mountain peaks on the Isle of Skye, the Shiant Isles and the isles of Lewis and Harris. Along the indented coast, ragged rocks snare unwary boats. Crofters once stashed illicit whisky stills in sea caves reached by ladder from the cliff. The last section of the road is private. However, a footpath from Melvaig leads to the Rubha

Curiosity

Rubha Reidh Lighthouse and the White House

Built in 1912, Rubha Reidh Lighthouse was designed to accommodate three keepers and their families. Access was largely by sea, until the arrival of the road in 1962. The light was automated in 1986 and the keepers' quarters are now guest accommodation.

The beacon's polished crystal Fresnel lens was made by Chance Brothers glassworks in the West Midlands. Among their other significant commissions were the windows for the White House in Washington DC. The original Fresnel lighthouse lens is exhibited at the Gairloch Heritage Museum.

Reidh Lighthouse and the jetty where the keepers landed their groceries and coal. The cliff path continues around the rugged headland, passing spectacular sea arches. At Camus Mor Beach, a rustic bothy is accessed by a scramble down grassy cliffs.

Rejoining the A832 towards Poolewe, there are moody views of mountain peaks in the isolated territory known as the Great Wilderness. At Loch Tollaidh, an island crannog was the defensive stronghold of the MacBeath clan. They reached their fortress by an underwater causeway.

A minor road off the A832 leads to the shore of Loch Maree, where the ss *Mabel* ferry landed at a long-gone wooden pier. The romantic view looks across Loch Maree's wooded islands to the distant slopes of Glen Docherty.

Before the A832 reaches Poolewe there is an opportunity to discover secret wartime history along the B8057 coast road.

DETOUR: *The secrets of Loch Ewe*

From the junction with the A832, the B8057 passes the Poolewe Hotel, a historic coaching inn dating back to 1570. The single-track road travels the shore of Loch Ewe through the small settlements of Boor, Naast, Brae, Midtown and Mellangaun. Much of the land is common grazing with livestock on the loose.

Inverasdale is a cluster of crofts curiously associated with the 1950 Christmas Day theft of the Stone of Destiny from Westminster Abbey. Among the four students who removed the stone from the abbey was Kay Matheson of Inverasdale. Though the stone reappeared at Arbroath Abbey in 1951 and has since been returned to Scotland to remain at Edinburgh Castle, there are suggestions that the students commissioned a replica that was successfully passed off as the original. Perhaps the true Stone of Destiny is hidden in the mountains of Wester Ross.

The road passes through scattered crofts with views to the Isle of Ewe and the distant peaks of Sutherland. Around the amber shore of Firemore Beach there's rustic camping and plenty of space to build sandcastles and fly kites. The sea is crystal clear, perfect for snorkelling.

A series of gentle bays leads to Cove, where harbour fees are collected in a post box painted sky blue. The coast is littered with sea caves – smugglers used some for illicit stash and the Free Church congregation of Gairloch used others for occasional prayer-meetings.

After scenic delights along the shore of the only north-facing sea loch in Scotland, it comes as a jolt to discover a wartime coastal battery on Rubha nan Sasan headland. Constructed in 1941, the battery protected merchant ships and Royal Navy escorts that gathered secretly in sheltered Loch Ewe before sailing in convoy to Murmansk and Archangel in Russia with vital wartime supplies. The headland bristles with former gun and searchlight emplacements, an observation post and the foundations of a long-gone accommodation camp of huts. Many of the buildings are dangerously unstable and fenced off. A memorial reads: 'In memory of our shipmates who sailed from Loch Ewe during World War II. They lost their lives in the bitter Arctic sea battles to North Russia and never returned to this tranquil anchorage. We will always remember them.'

Around the coast at Black Bay a memorial made by local crofters

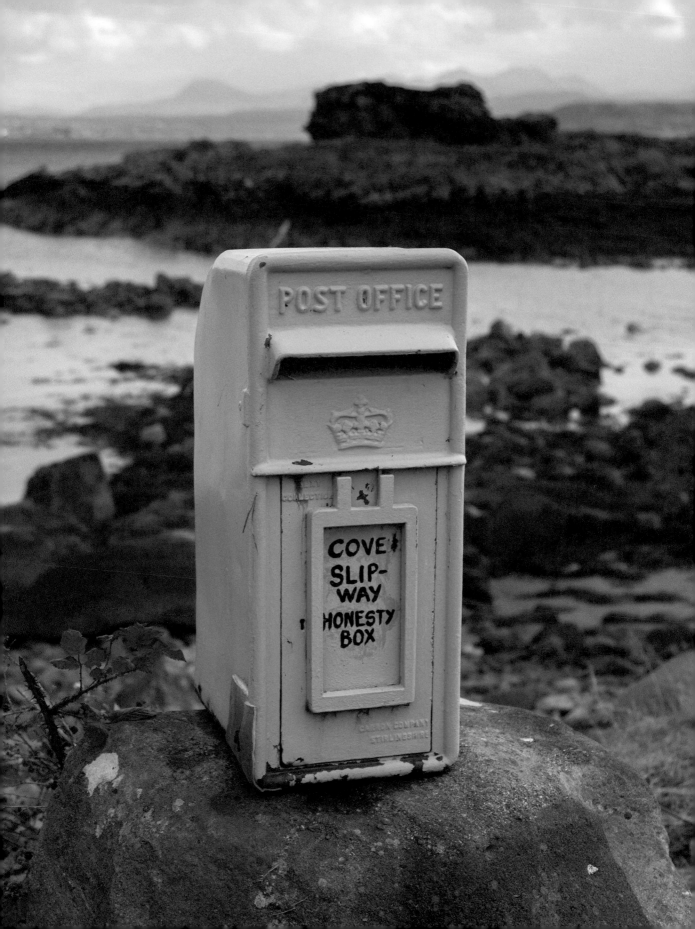

commemorates a shipwreck tragedy that impacted the local community deeply. On 26 February 1944, the American Liberty ship SS *William H. Welch*, named after the eminent physician and advisor to the US Army's medical department, was bound for Loch Ewe to join Convoy EN50 to New York. It was a wild winter night. Snow lay deep on the ground and was falling still when a savage storm blew up. Tragically, close to her destination, the ship foundered on the small island of Furadh Mor at the narrow mouth of Loch Ewe. The waves were mountainous, and before the crew could launch the lifeboats the ship broke up. Local people began a heroic rescue mission. Despite their courage, of the 74 American seamen aboard, just 12 survived.

The memorial overlooks the island and Black Bay. The inscription recalls the tragic loss of life and acknowledges the heroic rescue efforts of local people who came to help, including Mrs Katrina Kennedy, Mrs Mary Maclean and Mrs Jean Mackenzie. The determined housewives 'bravely went to the scene carrying large kettles of tea, food, blankets, cigarettes and even candles to light the fire which helped to revive survivors'.

To rejoin the A832, double back to the junction at Poolewe.

POOLEWE AND INVEREWE TO BADCAUL

In the 18th century, Poolewe was the main port serving the Outer Hebrides. Cattle and goods were sold on flat land behind the village. Now local people hold a small Tuesday market in the village hall from 10 a.m. to 2.30 p.m.

In 1922 an ancient Pictish symbol stone was discovered within the historic burial ground of Inverewe Church, or Londubh. The mysteriously carved stone lies flat in a grassy enclosure.

Curiosity

Highland Shangri-la

Osgood Mackenzie began the subtropical garden at Inverewe in 1864. Following his death in 1922 his daughter, Mairi T. Sawyer, continued his work until 1952 when she presented the garden to the National Trust for Scotland.

Surrounded by heather moorland, rocky outcrops and craggy mountains, the exotic garden, situated on a windy headland between two lochs, is an extraordinary feat. In summer, the long terraced walled garden is abundant with flowers, fruit and vegetables. Peering through the wrought iron gates to the craggy mountain scenery of Beinn Airidh Charr beyond is surreal. Much of the planting was made possible with imported rich soil that was used as ballast by ships sailing to Poolewe.

Osgood and Mairi's gracious family home is open to the public. The interior is fun and evocative of their extraordinary lifestyle. Osgood had an obsessive appetite for hunting. Mairi had a passion for shopping. Their shared pleasures were planting, entertaining and international travel.

A favourite 10-kilometre circular walk of around three hours departs from Srondudbh on the shore at Poolewe. Signposted to Loch Kernsary, the circuit explores spectacular scenery and is especially lovely when walking clockwise from Poolewe. The path is good, and the section along the River Ewe offers dreamy views of Loch Maree.

Leaving this romantic landscape and the fantasy gardens of Inverewe, the A832 climbs across heather moorland. As it descends to Aultbea, a curiously industrial-looking jetty comes into view. This is the Loch Ewe refuelling depot that serves NATO and UK naval vessels, including submarines. In connection with the coastal battery near Cove, there are further traces of the sea loch's wartime history around Mellon Charles.

DETOUR: *Mellon Charles*

From the Drumchork junction a minor coastal road passes Aultbea Hotel. In wartime, the hotel bar was a gathering place for locals and

troops who drank from jam jars. Aultbea harbour is small and sleepy and it is extraordinary to imagine how different the scene must have been when a boom net and mine defence system protected vessels in the loch from attack by German submarines. Some 481 merchant ships and 100 naval escorts sailed in convoy from Loch Ewe to Murmansk and Archangel. Near the playing field of Maclennan Park, it is possible to explore a World War II gun emplacement. The crew's shelter space and ammunition lockers are still visible. An accommodation camp of Nissen huts was situated a little further along the road.

The contemporary Isle of Ewe Smokehouse & Fine Food Emporium in Ormiscaig is just along the shore from the jetty that served the World War II boom defence depot at Mellon Charles. Into this curious time warp and mix of activity comes the Perfume Studio, the only one of its kind in Scotland. The studio's Aroma Cafe has outdoor seating with fantastic views to Torridon and the Isle of Ewe.

The white sand beach at Slaggan Bay, a little further north of Mellon Charles, is perfect for picnics on warm summer evenings. The spectacular headland of Greenstone Point is studded with sea caves and natural arches. It is possible to hike along the rugged coast to the communities at Opinan and Mellon Udrigle, though a detailed map is essential.

To continue on the main route, double back to the A832.

The Russian Arctic Convoy Museum on the A832 is fascinating. Though

the museum is small, a wealth of personal material and recollections make for a hugely rewarding and poignant visit. Arctic convoy veterans wear white berets and are nicknamed 'snowdrops'. The museum is developing a snowdrop garden to commemorate the 3,000 lives lost in merchant shipping and naval convoys to Russia during World War II.

At the community-owned Laide Wood there are annual primrose walks on the Saturday of each Spring Bank Holiday weekend. Laide Post Office is an invaluable general store and filling station at the junction of the A832 and the minor road to Achgarve, Mellon Udrigle and Opinan. Between April and September freshly landed squat lobsters, known as 'spinies', are often on sale.

DETOUR: *To the Loch of the Beast*

The footpath to the white sands of Slaggan Bay is signposted from the section of minor road between Achgarve and Mellon Udrigle. The easy walk along a five-kilometre farm track takes around three hours there and back, plus time at the beach. However, the challenge is to survive the Loch of the Beast along the way. Legend tells of a weird creature lurking in the water. Some point the finger at a mythical water cow. Others suggest a kelpie. Many traditional Scottish myths tell of lochs, streams and rivers haunted by these shape-shifting aquatic spirits that often take the form of a horse. Walking back from the beach, there are especially good views to the remote area known as the Great Wilderness.

There are more fine white sands at Camas a Charaig, a relatively sheltered and north-east-facing beach that is good for swimming and water sports. Far-reaching views to the peaks of An Teallach and Suilven are magnificent.

To return to the main route, double back and rejoin the A832 towards Dundonnell.

The coastal journey continues towards the beach campsite at Laide. When the chapel at Sand of Udrigle fell into ruin, the community used a nearby a sea cave, known as Uamh na Pollachar, for religious gatherings. A pauper woman lived in another cave nearby.

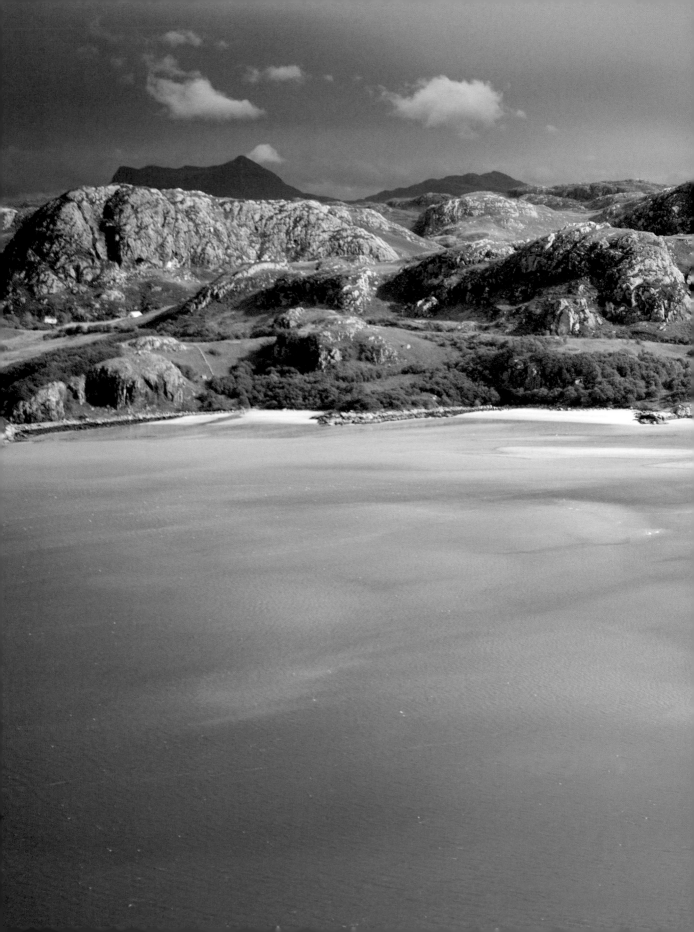

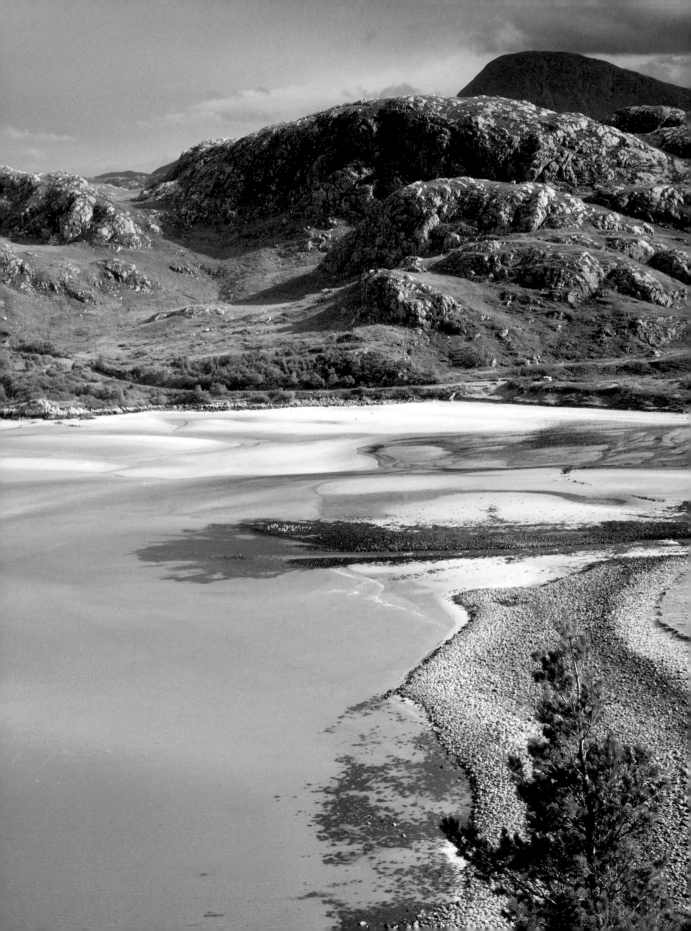

In 1942 the remote and beautiful Gruinard Bay was the scene of a deadly biological weapons experiment to test anthrax, a disease that can be transmitted to humans by contact with infected animals or their products. A flock of 60 sheep was taken to Gruinard Island and exposed to a bomb packed with anthrax spores. Three days later, the animals began to die. The island was put in quarantine for 48 years before being given the anthrax all-clear in 1990.

Through the crofts of First Coast, swiftly followed by Second Coast, the road begins the steep ascent to the crest of Cabeg Hill, where a small parking place offers views over the sands of Gruinard beach to the blue mountains of Coigach and Assynt. The scenery is truly spectacular.

The road rolls from the hilltop to a car park on the shore. A flight of wooden steps provides access to the vast sands. Inland, a footpath follows the Inverianvie River to the Eas Dubh waterfall, which is especially forceful after heavy rain.

The A832 follows the shore a little further before passing through woodland on the banks of the Gruinard River. The Highland scene of peaty water tumbling around boulders and gravelly islands is classically beautiful. Out of the woods, the road sweeps by Mungasdale beach, which is reached by footpath from a lay-by.

Curiosity

A girl called Shell and a small lighthouse

The viewpoint car park on the road to Dundonnell was a film location in 2012. *Shell*, directed by Scott Graham, explored the dilemmas of a teenage girl living in a remote filling station with her single-parent dad.

Views across Little Loch Broom look towards Scoraig, a remote community reached either by boat or a track from Badrallach. There is no access by road. At only four metres high, the Scoraig lighthouse is relatively tiny yet it was an awfully big adventure to relocate it around the coast of Cailliach Head and into the heart of the community where it now serves as an unusual exhibition space.

BADCAUL TO THE BRAEMORE JUNCTION

At Badcaul, a minor road leads to Badluarach from where the post boat to Scoraig sails. In a small field, the rustic Northern Lights Campsite offers basic facilities with the possibility of seeing the mesmerising colours of the Northern Lights, or aurora borealis, in unpolluted dark skies. The site is a favourite with hillwalkers who come to discover the heights of An Teallach, at the northern edge of the Great Wilderness.

Just beyond the township of Badbea, the Ardessie waterfall tumbles dramatically into a deep pool beside the road. The fish cages of Wester Ross salmon are clearly visible in Little Loch Broom. On a croft at Camusnagaul, David and Wilma Orr founded the An Teallach Ale Company in the shadow of the eponymous mountain. The names of their award-winning craft beers are inspired by the Highland landscape.

Sail Mhor Croft Hostel is beautifully situated on the shore of Little Loch Broom. Dormitory windows are thoughtfully fitted with midge screens. The road is surprisingly straight and flat on the approach to the Dundonnell Hotel, a former coaching inn. I've regularly seen tribes of wild goats strolling along. They have little road sense. Beware!

There is often a hub of hikers and climbers at the lay-by beyond the hotel. From here, they begin excursions to the slopes and summits of An Teallach. Just a little further along the road, on the right, is the much-photographed Smiddy bothy. A saltire is painted on the stable door. The conversion of the building into accommodation with Alpine-style bunks is dedicated to Jim Clarkson, a climber who died on Carn Mor Dearg near Fort William in 1968.

Through deep woods, the A832 enters the Gorge of Dundonnell. I have always felt strangely uneasy when travelling this section from the depths of a gloomy ravine to the windswept heights of a bleak moor. When I discovered that this is the 1851 Destitution Road, built by famine victims in return for food, the melancholy I have experienced here made sense. In the wake of a potato blight that left the population without a staple part of their basic diet, the Highland Destitution Board offered undernourished men and women oatmeal rations in return for the hard labour of road building. Many estate owners on local destitution committees commis-

Beauty Spot

The Filthy Hollow

From the Gaelic, Corrieshalloch Gorge means 'Filthy Hollow'. This doesn't sell it well but it does hint at something rather fearful in the spectacular box canyon where the River Droma tumbles through a long deep gash formed by glacial meltwater.

A roadside parking place leads to a kissing gate and a steep path that descends some way to the suspension bridge built in 1874 by Sir John Fowler. The famous Sheffield engineer, who bought land at nearby Braemore in 1857, was the creator of the iconic Forth Bridge, which opened in 1890.

Lady Fowler's Walk leads to another viewpoint and a magnificently cantilevered viewing platform across the bridge. Allow around an hour to explore it all. The Falls of Measach are especially thrilling when they surge into the ferny gorge after heavy rain or melting snow.

On gusty days the suspension bridge sways and the experience can be alarming. In strong winds and poor weather it is closed for safety.

sioned convenient routes across their land. As the A832 rises to meet the stone-faced walls of Dundonnell Gorge, it's unnerving to imagine the rock resounding to sounds of starving people at work. The Destitution Road climbs past the canyon where the Dundonnell River plunges 40 metres after a series of waterfalls that churns through chasms in the rock.

Road and river climb together to the landscape known as the Fain, a bleak and lonely scene but for mountain slopes and peaks of An Teallach, Sgurr nan Clach Geala and Beinn Dearg – the territory of golden eagles. The iconic ruin of Fain Inn stands at the roadside. Mounds of stones on the rough moor are the remains of shepherds' shielings and Fain shooting lodge.

Approaching the end of its journey, the A832 saves yet more spectacular scenery until last. A wide lay-by to the left offers a bird's eye view over the lush woodland and neat pastures of Strath More, Loch Broom and the fishing village of Ullapool. Around the hill, the dramatic Corrieshalloch Gorge National Nature Reserve, in the care of the National Trust for Scotland, is the A832's parting gift.

TOWARDS ULLAPOOL

The A832 completes its journey at the Braemore junction. From here the A835 takes over. The road travels west to Ullapool and east towards Inverness. Head west.

On the approach to Ullapool, the flow of traffic in the opposite direction can often determine whether the car ferry from Stornoway on the Isle of Lewis has recently arrived, discharging travellers with ongoing journeys across the mainland.

Passing the Braes of Ullapool, the road arrives in the village which was developed in 1788 by Thomas Telford and the British Fisheries Society.

Curiosity

A world of trees

Lael Forest Garden, owned by the Forestry Commission since 1929, is a world of exotic trees in an arboretum that formed part of Sir John Fowler's Braemore Estate. Woodland paths are easily accessed from two roadside car parks. Discover over 200 species of specimen trees including towering Giant Sequoia and Sitka Spruce. A visit to nearby Lael Crafts Gallery for coffee and home-made cake after the walk is recommended.

Around 16 kilometres further along the A835 towards Ullapool, Leckmelm Shrubbery and Arboretum is largely hidden from view behind a tall wall backing on to the road. Possibly inspired by Inverewe Garden, Leckmelm was planted to take advantage of the low rainfall and temperate climate of the west coast. The garden, undergoing restoration, features many champion trees.

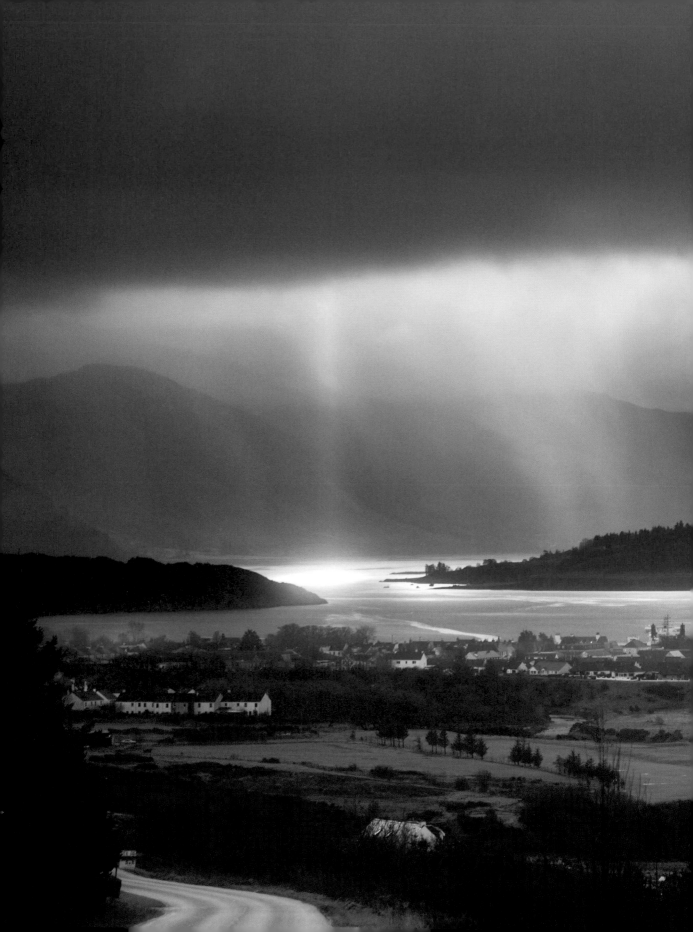

STAGE FOUR

Ullapool to Scourie

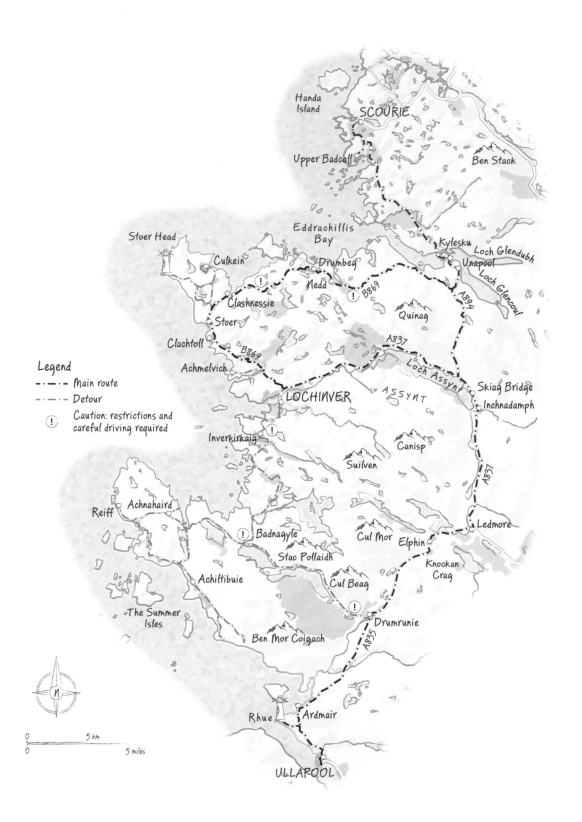

ULLAPOOL VILLAGE

With the change of scene comes the distinct sense of arriving in what is a metropolis, relative to the previous landscape of scattered communities. Things become suburban. The speed limit drops to 30 mph. There are pavements, substantial buildings, freshly painted signs advertising bed-and-breakfast accommodation and houses on both sides of the road. This is all something of a novelty after so much open space.

There is colour in Ullapool even on the greyest day. Brightly painted fishing boats, some gleaming, some rusting, gather at the pier from where Caledonian MacBrayne ferries sail to the Isle of Lewis. Passing Am Pollan Park, the road reaches the junction with Shore Street. The lovely village is best explored on foot, and Highland Council's Latheron Lane car park is situated in the heart of the community.

The village is much influenced by a historic event that took place in July 1773. Sailing from Ullapool, the *Hector* became the first ship to transport emigrants directly from Scotland to Nova Scotia. Almost 200 men, women and children made the desperate crossing cramped in the ship's hold. Eighteen children and one woman died at sea. The voyage to the New World was part of a wave of emigration around the Highland Clearances and the 1761 Burying of the Hatchet ceremony, which ended years of conflict between the forces of the British Empire and the indigenous Mi'kmaq people.

The story of the *Hector* and the complex reasons behind the mass emigration are explored at the friendly Ullapool Museum, which is a great place to start discovering the village. The museum is housed in the former church built in 1829 under the direction of Thomas Telford. The engineer was commissioned by an Act of Parliament to deliver 32 churches of the same design throughout the Highlands. Ullapool Church is believed to be the most complete example of a Parliamentary Kirk and is a Category A listed building.

In Pictou, Nova Scotia, a full-size replica of the ship welcomes visitors to the *Hector* Heritage Quay, and nearby is a replica of the Loch

Broom log church built by the Scottish immigrants. Occasional services in Gaelic are followed by tea and oatcakes.

Ullapool's fishing community began to expand rapidly in 1788, when the British Fisheries Society developed the port to exploit the herring fishing boom, and offer an alternative to mass migration in the wake of Highland Clearances.

The village was designed on a grid plan but herring stocks declined soon after it was built. Ullapool survived and developed as a port for ferries between the Scottish mainland and the Isle of Lewis.

In the 1960s and 1970s, up to 70 foreign factory ships, or klondykers, gathered annually in Loch Broom between August and January to process mackerel caught by smaller ships. Stories abound of local people making lifelong connections with crews and their families from Scandinavia, the Eastern bloc countries, Nigeria, France, Japan and Ireland. Though the factory ships are gone, Ullapool is a port of call for international cruise liners and sailing ships. Caledonian MacBrayne is the harbour's major customer, operating a daily passenger and car ferry service and an overnight freight service on the Ullapool to Stornoway route.

Vessels supplying live salmon smolts and feedstuffs to fish farms around the west coast frequently visit. The harbour supports an inshore shellfish fleet, and there are seasonal landings of haddock, squid, hake and monkfish. This diverse activity makes Ullapool especially vibrant. Ferries arrive and depart, connecting with coaches to Inverness. The inshore fleet load and unload creels. Day-trippers sail to the Summer Isles and bagpipers wearing traditional Highland dress welcome cruise ship passengers ashore.

There is a strong creative vibe around the village. The Macphail Centre and the Ceilidh Place host performing arts events. The work of local artists is exhibited at An Talla Solais gallery. At Highland Stoneware each piece of pottery is handmade and hand decorated. Village pubs often host live traditional music sessions. Vibrant annual festivals celebrate dance and books. Loopallu is an ambitious music festival with a huge Highland heart.

Curiosity

Clock and Bench

Among my favourite Ullapool curiosities is the handsome cast-iron village clock dedicated to the memory of Sir John Fowler. The famous engineer lived locally and designed the suspension bridge at Corrieshalloch Gorge. On West Terrace, look out for the beautifully sculpted cat and fiddle bench dedicated to the memory of local musician Sandy Ross. The seat enjoys spectacular sea views towards the Summer Isles.

Beauty Spot

Ullapool Hill

One of my favourite Highland viewpoints is Ullapool Hill. The vista inland to An Teallach is every bit as awesome as that across the sea to the heavenly Summer Isles archipelago. A steep circular walk of around five kilometres, signposted from Broom Park in the village, reaches the summit and explores the beautiful surrounding landscape. Allow around three hours for the full circuit. Or simply take an hour or so and climb to the hilltop where there are seats with expansive views over Loch Broom and out to sea. Return by the same route.

There are great food experiences throughout the village too. From April to September, there's an opportunity to meet local producers from the traditional smokehouse and artisan bakery at Ullapool Saturday Market near the harbour.

The Seafood Shack is a crowd-funded takeaway launched by Kirsty Scobie and Fenella Renwick, worthy winners of BBC Radio 4's Food and Farming Award for Best Street Food. Their locally sourced seafood dishes are fantastic. Strong community spirit achieves much in Ullapool. Ahead of many places in Britain, Ullapool businesses abandoned single-use plastic straws in response to the

environmental concerns of local school students. The New Broom Hub and Community Shop is a treasure trove of pre-loved books, clothing and surprises.

NORTHWARDS FROM ULLAPOOL

From Ullapool, the A835 north rises and falls and swirls dramatically through the mountain landscape. A minor road leads to Rhue Art Gallery and a stumpy white lighthouse at Rudh' Ard a' Chadail or the 'Headland of the Sleepy People'. According to legend, shipwrecked sailors were found here slumbering and unharmed on the rocks.

Back on the A835, there is a steep climb before an exhilarating descent to the pebbly shore of Ardmair Bay and sheltered Isle Martin. The island is a wildlife sanctuary in the care of the local community. Onward, the A835 soars dramatically to Strathcanaird. At Blughasary,

a minor road leads to the site of an Iron Age fort at Dun Canna headland and to the start of the Postman's Path, a precariously rocky route used to deliver mail on foot to the remote community of Coigach, some 17 kilometres away. A signpost indicating the Postman's Path cautions that the dangerous journey into remote landscape is suitable only for those who are experienced and properly equipped.

Back on the main road, an information panel at the 'Deep Freeze' lay-by explains how Ice Age glaciers sculpted this ancient landscape. The view to the dramatic sandstone massif of Ben Mor Coigach, the spiky crown of Stac Pollaidh and the slopes of Cul Beag is iconic – although, in this land of low cloud, brooding storms and swirling snow, how much you see of them is always unpredictable. On a clear day they are spectacular.

The route continues to a sign welcoming visitors into the territory of the North West Highlands Geopark. Lewisian Gneiss rocks around

this coast are a mind-boggling 3,000 million years old. Throughout the Geopark, a series of roadside information boards illustrates and highlights extraordinary features in the landscape.

The main route continues on the scenic A835 through Knockan Crag National Nature Reserve towards Lochinver, Unapool and Kylesku. Alternatively, a detour leads to the Summer Isles and the coastal route to Lochinver along a precarious single-track road unsuitable for many vehicles.

DETOUR: *Stac Pollaidh and the Summer Isles circuit*

At Drumrunie, just beyond the North West Highlands Geopark welcome sign, a single-track road with passing places slithers into the wild land-scape of Coigach. Vehicle restrictions on this narrow and winding route

are indicated at the junction and signs politely remind traffic to use passing places to permit overtaking. The importance of this cannot be over emphasised.

Remote communities have a limited network of roads. They depend heavily upon the free-flowing movement of traffic. While visitors are very welcome, slow-moving vehicles that do not use passing places to permit overtaking on single-track roads hold up local traffic with a seriously negative impact on the daily lives of the community. Responsible drivers are hugely appreciated.

The impish road dances around Cul Beag and past the walkers' car park at the foot of Stac Pollaidh. Onwards it goes, past a chain of three beautiful lochs sprinkled with islands – Loch Lurgainn, Loch Bad a Ghaill and Loch Osgaig – to reach the shore of Loch Raa.

From here it is possible to turn left or right to complete a circuit that explores the Coigach peninsula. Among the highlights are the sands and salt marsh of Achnahaird beach, backed by mountain scenery, and seasonal boat trips from Old Dornie harbour to discover the caves, seals and seabirds of the Summer Isles.

Double back along the minor road to rejoin the A835 main route towards Lochinver at Drumrunie.

Alternatively take the extremely challenging narrow minor road from Badnagyle through Inverpolly towards Lochinver. Again there are vehicle restrictions and this route is unsuitable for inexperienced or nervous drivers and those unable to reverse around tight bends into passing places. Please consider the local community and make a responsible choice.

The alternative route to Lochinver

The twists, turns, steep ascents, switchbacks and sudden drops along the fiendish minor coastal road to Lochinver are as much a part of the journey as the mountain summits, lochs, waterfalls, silver birch woods and scattered islands around the indented shore.

Discover an unexpected bookshop and tearoom in beautiful woodland at Inverkirkaig. A way-marked path follows the River Kirkaig through rowan, hazel and birch to reach peaty waterfalls. Beyond the falls are

wonderful views of Suilven, the mountain that inspired Norman MacCaig (1910–96). The poet spent much of his life in the landscape of the north-west Highlands, and a memorial to him, beside the River Kirkaig at the start of the waterfall walk, quotes his much-loved poem 'Climbing Suilven'.

If taking this route to Lochinver, please turn to page 108 to reconnect with the main route onward.

DRUMRUNNIE TO LOCHINVER VIA KNOCKAN CRAG ON THE MAIN A835 ROUTE

From Drumrunie, the smooth A835 route towards Lochinver passes through tracts of moorland with barely any buildings or trees to arrive at Knockan Crag National Nature Reserve. Here, an outdoor exhibition under a heather roof reveals why this unique landscape is the cradle of modern geology. A statue honours Benjamin Peach and his pupil John Horne. While mapping rocks for Geological Survey in Scotland between 1883 and 1897, Peach and Horne found startling evidence to confirm that older rock could be pushed over younger rock along fault lines, known as 'thrusts', and that rock could move sideways too. This discovery inspired a new understanding of geology around the world.

The Moine Thrust disruption of the earth's crust some 400 million years ago is clearly visible on the Knockan Crag hillside. Environmental artworks around the site are inspired by the drama. My favourite is a giant stone sphere perched dramatically on the hill. Created by Joe Smith, it celebrates the global significance of the site.

The top of the path that winds uphill through the geology exhibition and artworks makes a fabulous picnic spot – views across the wild landscape to the crenellated summit of Stac Pollaidh are especially inspirational. Leaving Knockan Crag, the road swirls into monumental scenery. There is a feeling of being increasingly dwarfed and humbled by the grand scale of the terrain, yet the experience is life affirming. Though the mountains are silent, their moods are expressed in ever-changing light and weather.

The road swerves spectacularly into Elphin, a crofting township with the civilised attractions of a telephone kiosk and a tearoom. The

village hall hosts a bijou market every second Wednesday in season. Talented craftspeople sell works in wool, silver, leather and silk. Jams, smoked cheeses and charcuterie are for sale. Such civilised shopping in rugged mountain grandeur seems deliciously surreal.

Elphin burial ground is a small stone-walled enclosure of yew trees and headstones, romantically situated on a hill overlooking slender Loch Veyatie between the peaks of Cul Mor and Suilven. The lovely loch is a highway to Suilven for those who paddle canoes and kayaks. Many make camp and rise early to conquer the mountain. The loch is also the haunt of anglers in pursuit of brown trout.

In any remote landscape with few roads, junctions are such a novelty that they become landmarks. The famous Ledmore junction is where the A835 ends and connects with the A837. Traffic travels onward to Lochinver on the coast or inland to Lairg along the Oykel salmon river. Our journey continues towards Lochinver, but first there are extraordinary discoveries in the wild landscape of Inchnadamph.

The church at Inchnadamph is now defunct and the attractive whitewashed building is used for community events. A memorial at the gate is dedicated to the memory of six airmen who died when their Anson bomber crashed on the slopes of Ben More Assynt in April 1941. Due to the inaccessibility of the site the men were buried on the mountain.

On the crest of a nearby hill, within sight of fantastically jumbled geology around Loch Assynt, a memorial celebrates the pioneering work of Peach and Horne. The plaque salutes the rock mappers for playing 'the foremost part in unravelling the geological structures of the north-west Highlands 1883–1897'.

It is something of a challenge to imagine fertile farms and grazing livestock in the empty land surrounding lonely Loch Assynt. Yet, in medieval times, this was a significant community and a centre of power.

In 1597, the Laird MacLeod built Ardvreck Castle on a rocky promontory reaching into

Curiosity

Caves named Badger, Reindeer and Bones

In 1889, the rock mappers Peach and Horne discovered an extraordinary variety of bones in the limestone caves of Inchnadamph valley. Among the haul were fragments of brown bears, reindeer, northern lynx and arctic fox. This remote place was the hunting ground of Upper Palaeolithic Man. From a roadside car park south of Inchnadamph, a well-worn yet narrow and steep path time-travels to the limestone caves where the bones were found.

The three caves, – Badger, Reindeer and Bones – are relatively shallow yet still they are an adventure. Allow around two hours for the walk. Go well equipped with walking boots, torch and protective clothing for sudden changes in the weather.

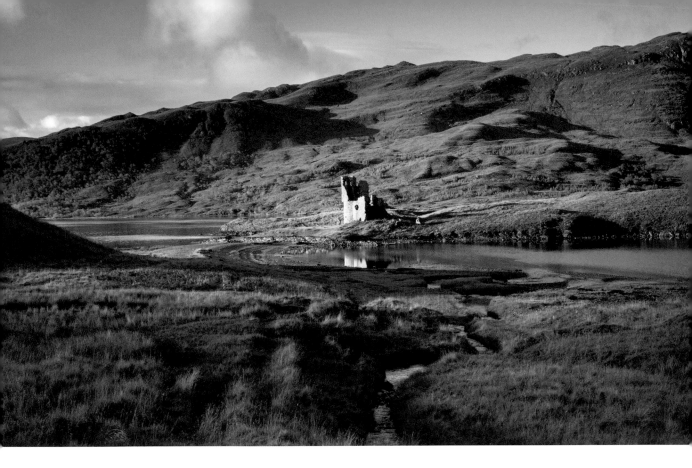

the loch. After a siege in 1691, the fortress passed to the ownership of the MacKenzies. Yet, in 1736, the Mackenzie laird was forced to sell up to pay off debts, which included the expense of building grand Calda House next door. In 1757 the castle became the property of the Earl of Sutherland and has since tumbled into romantic ruin.

The final demise of neighbouring Calda House is a Highland mystery. In 1726 Frances, the wife of Kenneth Mackenzie of Assynt, desired to escape draughty Ardvreck Castle and move to a modern home with creature comforts. Her husband commissioned Calda House. Built to a classical design, this impressive abode must have been an extraordinary sight in a community where most locals lived under heather-and-turf roofs. The Mackenzies proved unable to afford their dream home and the grand pile went up for sale, provoking a feud between would-be purchasers. Calda House burned down mysteriously in 1737.

The road follows the shore of Loch Assynt, which is speckled with wooded islands. The mountain walls of Quinag dominate the scene. The Torridonian sandstone massif takes its name from the Scots Gaelic word for a 'churn' or 'pail'. Quinag is under the stewardship of the John Muir Trust, a conservation charity dedicated to protecting and enhancing

wild places for the wellbeing of people and wildlife. Walkers and climbers are invited to access the mountain's trio of peaks on stalkers' paths. The routes traverse grassy slopes and heather moorland where toads, frogs and newts inhabit peaty lochans.

Quinag is the haunt of elusive Scottish wildcats, tragically on the edge of extinction. While it's unlikely you'll encounter one of these protected felines, there is a strong possibility of seeing red deer, golden eagles and ring ouzels – thrushes that are like small slim blackbirds with dapper bibs.

At the Skiag Bridge junction, the A894 travels north to Durness. This route will be taken later, but first the journey continues to Lochinver on the A837.

Large polytunnels set back from the road are a surprising sight on the approach to Lochinver. In this protected environment, the team at Little Assynt Tree Nursery raises future native woods and forests from specially selected seed collected in the wild.

LOCHINVER

Lochinver is a community gathered around a wide bay and harbour. The River Inver completes its journey from Loch Assynt beneath a beautiful stone bridge near the village car park. If in luck, you might catch sight of otters here. The working harbour continues to be economically important. Lochinver's proximity to all west of Scotland, Rockall and North Atlantic fishing grounds is in its favour. Whitefish is landed by the UK fishing fleet and by vessels from other European countries. Opposite the harbour's 20-tonne-per-day ice plant is the Culag Hotel. This unlikely neighbour was formerly the Duke of Sutherland's shooting lodge. The grand baronial-style building with turrets was in situ long before the ice-making machine.

Peet's Restaurant is a stone's throw from crab and lobster creels stacked on the quayside. Nearby, the former Fisherman's Mission is

Beauty Spot

Leitir Easidh

Britain's most scenic All-Abilities Path is perhaps the 1.5-kilometre route around watery landscape of Leitir Easaidh. Maintained by the Culag Community Woodland Trust for people in wheelchairs or with limited mobility, the path begins in a lay-by beside the A837 on approach to Lochinver. Allow around 45 minutes for the gentle adventure. Discover wonderful mountain views, picnic benches and even a compost toilet.

now An Cala Cafe and Bunkhouse, with a grandstand view of the harbour-side football pitch where fearless red deer graze on the penalty spot. Lochinver Larder and Pie Shop and The Caberfeidh fine-dining pub are popular places to eat. Inver Lodge Hotel enjoys floor to ceiling windows with commanding views of the harbour and the village. Albert Roux creates the restaurant menu.

The village offers the opportunity to stock up on essentials. There are a couple of grocery stores, a butcher, a post office, a chandlery and petrol station. There is also a small health centre. Colourful and witty mosaic sculptures delight in the garden of Highland Stoneware at Baddidarach. The pottery welcomes visitors and it is often possible to observe artists hand painting the famous ceramics in colours inspired by Highland landscape.

When raspberry and apricot sunset skies meet with perfectly calm waters in the bay at Lochinver, the experience of extraordinary reflections is unforgettable. As the day closes, locals and visitors are drawn to the shore where red deer graze. Equally inspirational are the dark starry skies and psychedelic colours of the Northern Lights.

A web of lovely footpaths explores community-owned Culag Wood. The wonderfully named Are You Brave Enough? path leads to the White Shore where pebbles of many colours are to be found. The woodland is rich in wildlife. Look out for grey herons, common pipistrelle bats and otters. An elusive pine marten nests here too. Throughout Scotland gamekeepers persecuted these beautiful beady-eyed creatures and their numbers declined steeply. Since 1998, they have enjoyed full legal protection in Scotland and are making a comeback. Culag Wood is approached from Lochinver on the minor road that connects with Badnagyle.

The most iconic natural feature of Lochinver is Suilven, a magical mountain that appears dramatically different depending on the aspect it is viewed from. For those arriving by sea, Suilven rises above the village in the giant form of a smooth sugar loaf. Yet this view conceals the mountain's long, serrated dragon's back ridge, which connects to further peaks at Meal Mheadhonach and Meall Beg. At 731 metres, Suilven is hardly the highest summit in Assynt – Ben More Assynt wins that title at 998 metres. Yet Suilven, the playful shape shifter, is, beyond doubt, my favourite.

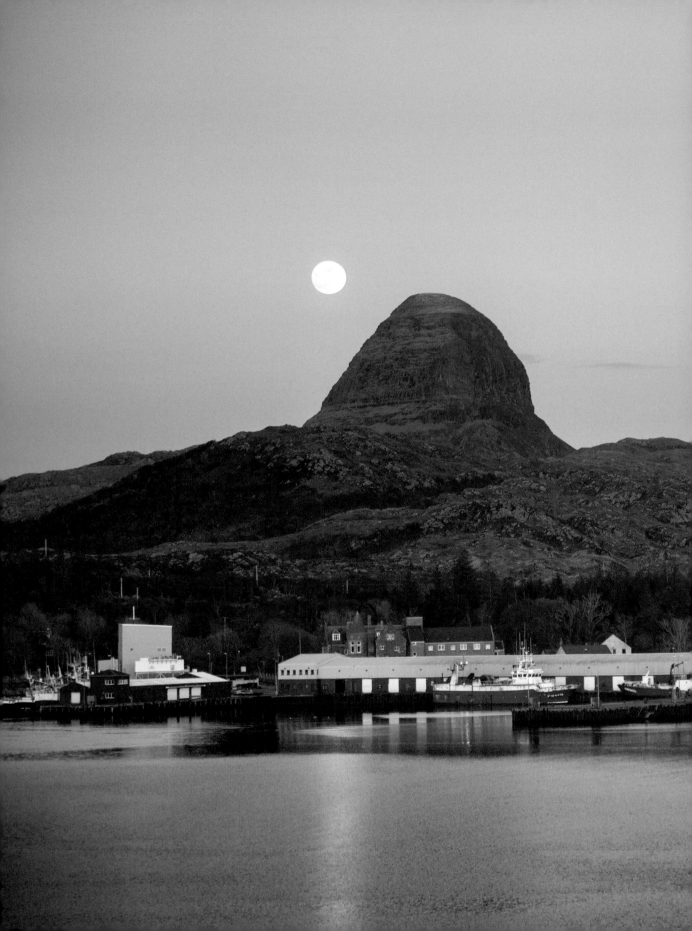

Over recent years, the fragile peat landscape around the mountain has been eroded badly and sensitive restoration is underway through the Suilven Path Project, a partnership between the local community Assynt Foundation, which owns the mountain, and the John Muir Trust, which is managing the work, as part of Coigach and Assynt Living Landscape Partnership Scheme.

The advised access route to Suilven from Lochinver is through the grounds of Glencanisp Lodge. This path limits damage by footfall to the surrounding landscape. Alternatively, walkers with canoes are invited to approach from the lochs at Elphin. This is the route taken by Edie, played by Sheila Hancock, in the beautiful 2018 film *Edie*. The quest of a redoubtable woman in her eighties to reach the peak of Suilven is remarkable.

Leaving Lochinver, the most direct route to Durness via Unapool and Kylesku is back along the A837 to the junction with the A894 at Skiag Bridge. From here, a dramatic drive unfolds between the slopes of Quinag and Ben Uidhe.

Alternatively there is the B869. This challenging single-track road with passing places is unsuitable for large vehicles, dangerously slow drivers, those of a nervous disposition and anyone unable to reverse accurately round tight bends. For over 35 kilometres, this route is a roller-coaster of seriously steep blind summits, switchbacks and sudden drops. Local people depend on the free flow of traffic along these pesky roads. Please do choose your journey to Unapool and Kylesku with care, though you may wish to explore a little of this coastal route to the beaches of Achmelvich and Clachtoll first.

THE ALTERNATIVE ROUTE TO UNAPOOL AND KYLESKU ON THE FIENDISH B869

The B869 leaves Lochinver politely and begins a gentle climb into the hills, but soon the route is narrow, with passing places, and extremely steep sections and restrictions. On arrival at the junction with the minor road to Achmelvich, there is the opportunity of a detour to discover a magical bay and a romantic rustic youth hostel.

DETOUR: *Off the B869 to Achmelvich Bay*

Sheltered Achmelvich is a paradise of soft white sand and crystal clear turquoise water. It is also the haunt of black- and red-throated divers and porpoises. For information about the local wildlife and geology, visit the imaginative displays in the ranger hut in the car park.

From the sand dunes, a way-marked walk of around five kilometres enters the surrounding hills to discover the ruins of Altanabradhan corn mill. Coastal views of the rugged shore backed by mountains are thrilling. The nearby sheltered, sandy cove is perfect for picnics.

Achmelvich conceals a magical miniature tower. Cross the beach and pass through the campsite to discover the Hermit's Castle on rocks beside the sea. Architect David Scott designed and built his diminutive fortress in 1950. The solid concrete structure encompasses just enough

space to live basically, as a hermit would. All is functional, yet the idea is beautifully romantic. Apparently David Scott stayed just one night then left his palace for others to discover.

From Achmelvich, double back to the B869 and continue towards Clachtoll. The road soon arrives at a car park on a steep hill. From here there is an iconic view that lives long in the memory, especially if you are fortunate to see it on a clear day. The sentinels of Canisp, Suilven, Cul Mor, Cul Beag and Stac Pollaidh rise from the landscape, each proud and distinct. Surrounded by purple heather, yellow gorse, red rowan and silver birch, this is the stuff of Highland dreams.

The narrow road weaves through high rocky scenery to fall swiftly into the soft sandy bay at Clachtoll. A meandering boardwalk explores grassy dunes. From the shore, there are clear views to the famous split rock on the headland. Clachtoll is a magical place to sea watch for dolphins, porpoises, minke whales and basking sharks. The ranger's hut in the beach car park provides useful wildlife identification guides. Outside the hut is the jawbone and skull of a 19-metre-long female fin whale that washed up at Stoer in 2007.

The beautifully clear, cold water of Clachtoll Bay is the first stop on a nine-destination, self-guided snorkel trail around the coast of the north-west Highlands. Information is available from the Scottish Wildlife Trust website.

Clachtoll fishing station closed in 1994. The humble bothy where salmon fishers gathered to catch the king of fish is now a tiny museum. Heavy cotton and linen fishing nets were dried on tall poles beside the sea, while the valuable catch was stored and kept fresh in an underground ice house. Slabs of ice were hacked from local lochs and pools in winter.

A large boulder on the shore bears a plaque celebrating the life of Clachtoll-born Presbyterian minister Norman McLeod (1780–1866). The charismatic leader sailed from Scotland with his followers, known as 'Normanites'. He established communities in Nova Scotia, Australia and New Zealand.

A walk north along the Clachtoll shore discovers the remains of an Iron Age broch monument that may have stood some 17 metres high on rocks beside the sea. Mystery surrounds the lives of the people who constructed these impressive towers around 2,000 years ago. Archaeological

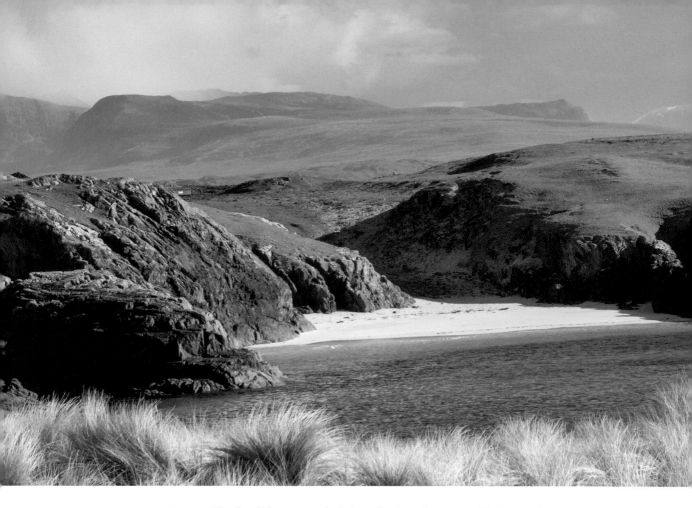

excavation at Clachtoll has revealed that the broch was badly burned, and much stonework has been lost to coastal erosion. However, some may have been recycled to build later homes too.

Flossie's of Clachtoll is a small blue beach hut of wonders. Here you will find freshly baked cakes, freshly laid eggs, freshly ground coffee, fresh local news and occasionally, Rocky the dog.

From the beaches at Clachtoll and Stoer, the road climbs inland passing Lochan Sgeireach to reach the offices of the Assynt Crofters' Trust in Rhu Stoer village hall. In 1993 the crofters of Assynt made history when they agreed a buyout of the North Lochinver Estate, a precedent that opened the way to community ownership of land in Scotland. The crofters renamed their 21,000 acres the North

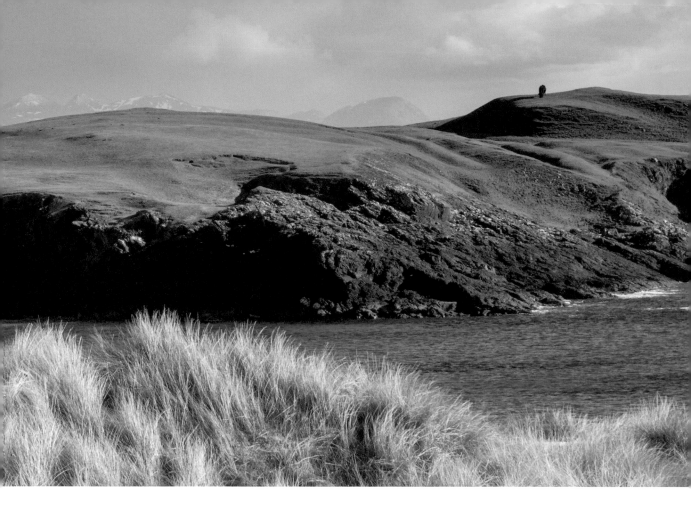

Assynt Estate. Visitors are welcome. Stalking information, fishing permits and boat hire are available from the village hall, where a memorial remembers Allan Macrae who led the crofters' historic campaign.

A minor road opposite the village hall leads to Stoer Head lighthouse.

DETOUR: *Off the B869 around the sea cliffs at Stoer Head*

The minor road weaves a web around scattered settlements on the brutally exposed Stoer peninsula. David and Thomas Stevenson engineered Rhu Stoer lighthouse to withstand ferocious winds. The beacon, built in 1870, is just 14 metres high.

Parked up beside the tower, Living the Dream tea van serves freshly baked cakes, hot filled rolls, porridge and pancakes. Recent wildlife sightings are chalked up on a board. A stack of books and leaflets helps with identification. Here you will find perhaps one of the strangest

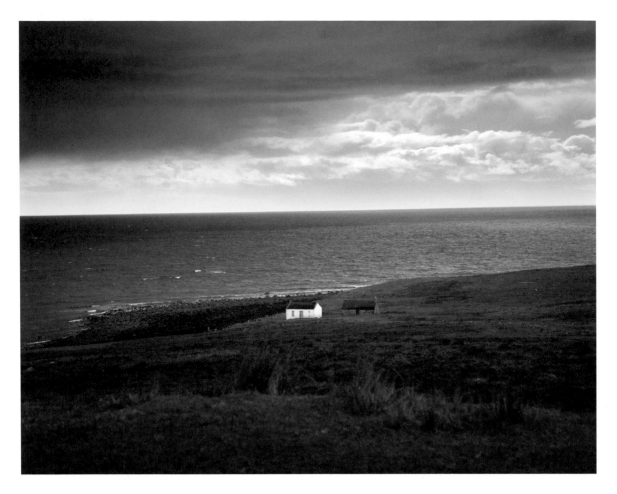

holiday souvenirs. A date-stamped card is issued in recognition of a small payment to use the far-flung composting toilet provided by the Assynt Community Association. The card reads: 'I visited the remotest public toilet on mainland Britain.' Both loo and van operate seasonally and keep the same hours. In strong wind and heavy rain they are closed.

In calm weather, this elevated headland with huge sea views is an ideal place to observe seabirds and marine life. From the lighthouse a three-kilometre cliff top walk reaches the Old Man of Stoer sandstone sea stack. At 60 metres high the Old Man is a feather in the cap of climbers who swim out to it or travel across to it by rope on a Tyrolean traverse.

Culkein crofting community is dispersed around a sandy bay renowned for bird-watching opportunities, especially in spring and autumn. In a pretty timber chalet, the Culkein Store sells jams and crafts made locally. Overlooking the township is Tigh nan Shiant or

the 'Hill of the Fairies'. The panoramic views from here to blue mountain ranges and the islands of Oldany and Handa Island are enough to make anyone believe in magic.

Back on the B869, safe swimming and a soft sandy shore make Clashnessie a favourite with young families. Inland, a short walk signposted from the beach car park reaches a waterfall. The road departs Clashnessie on the ledge of a cliff. This can seem like a Mediterranean corniche on a gloriously calm sunny day. The uninterrupted deep blue sea extends all the way to the horizon.

Drumbeg viewpoint presents a grand vista across the salmon cages and islets of Eddrachillis Bay towards Handa Island. This modest township encompasses a diverse range of commercial enterprises. Crafts on the Croft sells locally made items in a small showroom set back from the road at Culkein Drumbeg. The Drumbeg Hotel and Bar is alongside Drumbeg Stores, which sells food, crafts and the limited edition single malt Drumbeg whisky. Assynt Aromas candle store offers a lush hidden tea garden. Jewellery designer Clare Hawley hosts occasional workshops in her studio.

The road becomes more challenging towards the lovely hamlet of Nedd. Through heart-stopping switchbacks and steep ascents, it undulates wildly. Plunging into Ardvar Woods on the sheltered shore of Loch Nedd, it pushes fiercely upwards again to cross the barren moorland beyond.

With a fleeting glimpse of the Kylesku Bridge across Loch a Chairn Bhain, the lurching ride comes to a sudden halt at the junction with the A894 at Unapool. The journey north continues to Scourie and Durness.

NORTHWARD ON THE A894 FROM UNAPOOL AND KYLESKU

From the crofting hamlet of Unapool, the A894 sweeps to the North West Highlands Geopark visitor centre at the Rock Stop, a converted former schoolhouse on the shore of Loch Glencoul. A colourful exhibition explores the complex geology of the north-west Highlands. There are

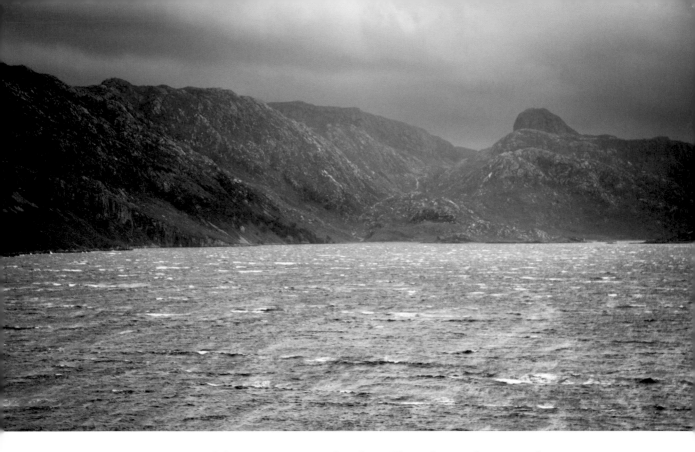

intriguing models, giant maps and a short film. The Rock Stop cafe offers home-made cake and Wi-Fi.

A little further along the road, a junction to the right dips to the shore of Loch Glencoul. The Kylesku Hotel overlooks the slipway from which a ferry service crossed the loch prior to the opening of the Kylesku Bridge in 1984. From huge picture windows, the view up the loch is atmospheric in all weathers. On sunny days and warm evenings, the outdoor deck is a great place to relax. A grassy knoll beside the slip-way and public toilets is an excellent vantage point to appreciate the impressive glacier-carved landscape where Loch Glencoul meets Loch Gleann Dubh. There's a good chance of seeing grey and common seals too.

The mountains of Quinag, Glas Bheinn, and Beinn Leoid congregate here. Golden eagles scour the ridges and red deer roam the slopes – geologists too. Kitted out in field-trip uniforms of high-visibility vests and protective helmets, they visit the Glencoul Thrust, where older Lewisian Gneiss has been carried on to younger Cambrian quartzite.

While experienced walkers may wish to follow stalkers' paths and deer tracks across peaty boggy ground to see Britain's highest single drop waterfall, Eas a Chual Aluinn, tumble 200 metres over a cliff, there is the alternative of a boat trip from the Kylesku Hotel. The

cascade is around four times higher than Niagara Falls and most spectacular after heavy rain. A dry summer can reduce it to a trickle. Unlike at Niagara, the boat cannot approach closely, and it is worth taking binoculars to see the falls in detail.

The wonderful 276-metre curve of Kylesku Bridge is one of the most important crossings in Scotland. The elegant design by Ove Arup and Partners has won many international awards. The bridge carries the roadway high above the water on a concrete box girder deck. Raking leg supports are planted on the land because strong tides and currents ruled out supports in the channel. The navigation clearance is 24 metres. Prior to the opening of the bridge, a small shuttle ferry carried cars and passengers across the narrows. The ferry did not operate at night or in bad weather, and in high summer there were often long queues of holidaymakers. The alternative route was a detour of 177 kilometres. Earlier ferries were rowing boats and drovers crossing the narrows swam the cattle behind them.

Along the route to Scourie the road passes Loch a Mhuilinn National Nature Reserve, the site of Britain's most northerly oak wood. Springtime brings carpets of native flowers, and in summer there are dragonflies. All year round there are otters. An all-ability path explores this lovely sanctuary.

A sprinkling of cottages constitutes Upper and Lower Badcall on the shore of a sheltered bay. This hideaway is the haunt of sea kayakers paddling around beautiful islets. Shafts of light playing on the water create a romantic and dreamy scene.

From the hillside there are spectacular views to the three mountain kings of the far north-west corner of Britain. The distinctive cone of Ben Stack, the whale back of Arkle and the many summits of Foinaven are magnificent.

Around the coast Scourie awaits.

Curiosity

Craft and chariots

After crossing the Kylesku Bridge, a visit to the lochside car park reveals another extraordinary secret of this wild landscape. A memorial honours civilians and service personnel involved in covert wartime training and missions between 1942 and 1945. The XIIth Submarine Flotilla operated midget submarines, known as 'X-craft', and chariots or human torpedoes in Loch a Chairn Bhain below the bridge. At the time of the secret operations, the area was known as port HHZ. The X-craft submarines were 15 metres long. They carried explosive charges and a crew of three plus a diver. Two frogmen rode the torpedo chariots. Their mission was to cut through anti-submarine and torpedo netting and place explosive charges on German battleships threatening convoys of Allied ships delivering munitions to Russia. The memorial honours 39 men who lost their lives in these extraordinary secret operations. Among the ships attacked and crippled was Hitler's flagship, *Tirpitz*. From the car park, the road crosses a causeway towards the Kylestrome viewpoint. Here there are spectacular views back to the Kylesku Bridge.

STAGE FIVE
Scourie to Tongue

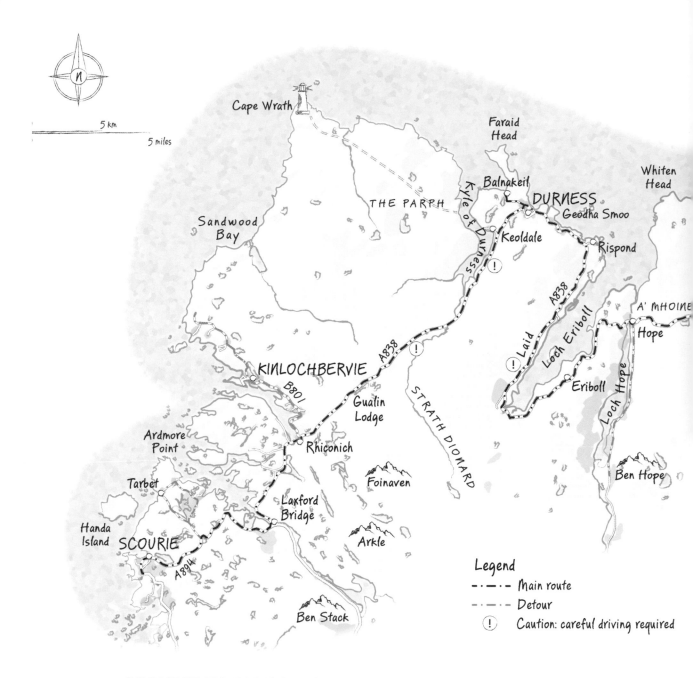

SCOURIE TO RHICONICH

Though Scourie is relatively far flung, this stronghold of Clan MacKay has a sparkling list of visitors who delighted in holidays here. Among them were the Queen Mother, Prime Minister William Gladstone and the author of *Peter Pan*, J.M. Barrie.

The A894 bisects the community. The coast is to one side and lush

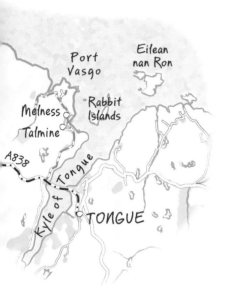

pastures backed by gnarly hills are to the other. The sandy bay and small harbour are reached by a minor road.

From Scourie burial ground a way-marked coastal ramble of around three kilometres explores the rugged landscape. On clear days, the combination of sea and mountain views is dramatic. The headland offers some of the finest scenery in the north-west Highlands. The coast is fragmented, surrounded by splinters of islets and islands. The hulks of Ben Stack, Quinag, Canisp and Suilven are distinct. Handa Island wildlife sanctuary is to the north. The Old Man of Stoer sea stack is to the south-west. Seabirds reel overhead, seals peep from the deep. Allow around an hour for this breathtaking walk.

Scourie community bird hide is a sheltered observation post. The attractive timber building is situated near the beach car park. If locked, the key is available from the village shop.

Many visitors come to Sutherland to fish, and the Scourie Hotel is hallowed ground. The decor is delightfully fishy. Discover celebrated specimens in glass cases, vintage wooden rods, fishing notice boards, fishing rosters and mountains of fishing magazines. The hotel offers fly-fishing on 300 lochs and lochans. If you are fond of fishermen's tales, you will find them here.

Scourie village football pitch is an astonishing vision of immaculate emerald green turf. A striking modern pavilion overlooks the grassy plateau surrounded by rugged rocky landscape.

Curiosity

The seeds of Scourie Lodge

A favourite Scourie story tells how exotic cabbage palm trees came to grow in the walled garden of Scourie Lodge. Around 150 years ago, the seeds were posted to a gardener at the big house by a relative in New Zealand. They flourished in the far north Scottish climate which, although brisk, is warmed by the effects of the Gulf Stream. The mature tall palms are among the township's most famous residents. I wonder if either the relative or the gardener could ever have imagined the fame brought to Scourie by a small envelope of seeds.

DETOUR: *The bird land of Handa Island*

Leaving Scourie, the A894 reaches a junction with a minor road. This is signposted to the jetty for Handa Island and a trio of townships that consist of just a few houses on the deeply indented coastline. The sense of isolation is palpable and enthralling. The hamlets are known locally as 'The Balkans'. The story goes that, prior to World War I, when unrest and crisis in the Balkans were headline news, the Scourie postman encountered men from Tarbet, Fanagamore and Foindle engaged in a whisky-fuelled dispute. On return to the village, the postman described their squabble as 'worse than the Balkans'.

In the wake of the potato famine that devastated communities across the Highlands in 1847, all 64 residents of Handa Island abandoned their community of traditional blackhouses and sailed from Scotland to begin new lives in Nova Scotia. The Duke of Sutherland paid for their passage and put sheep on the island after their departure. It was the end of an

extraordinary era. The isolated islanders traditionally regulated the community with a parliament that met every day to decide on priorities. The island queen, usually the oldest widow, presided. The largely self-sufficient population fished, dug peat for fires and planted potatoes in lazy-beds piled up with earth and seaweed. In spring, nimble climbers scaled Handa's towering sandstone cliffs to steal eggs from seabirds breeding on stacked ledges. Feathers were traded for other goods.

While Handa remains uninhabited by a permanent community, seasonal wildlife wardens protect 100,000 auks, petrels and gulls that return to breed on the vertiginous cliffs through spring and summer. A limited number of day visitors is welcome to witness the extraordinary spectacle. The island is reached by a seasonal pedestrian ferry service from Tarbet jetty. The Monday-to-Saturday sailings are weather dependent and it is not possible to pre-book. If you are in luck, take good walking boots, food and drink and protective clothing, which is necessary on the exposed island. Visitors are advised to allow three hours for the six-kilometre walking route around the sanctuary.

Handa is in the care of the Scottish Wildlife Trust. The environment is kept as natural as possible. There are no facilities other than a turfed-roof compost loo.

The small burial ground is of special interest. Here the community of Eddrachillis Bay buried their dead to avoid disturbance of graves by ravaging mountain wolves on the mainland.

At Tarbet jetty the Shorehouse Seafood Restaurant serves daily specials landed by the family boat. Island views are magical.

The A894 terminates at Laxford Bridge. Our journey north continues along the coast on the A838 towards Rhiconich. The road passes a stone pier and boathouse on the shingle shore of Laxford Bay. Surrounding islands and large shallow inlets are a Special Area of Conservation. The distinctive mountains of Arkle, Foinaven and Ben Stack overlook this beauty. Their Cambrian quartzite summits appear like glistening snow in sunshine.

The lovely lanes that weave across the beautiful Ardmore headland and around the sheltered waters of Loch a Chadh-fi are perfect for gentle strolls and picnics on sunny days. Lochs and lochans are scattered across the headland. Islands in the gentle bay are the haunt of seals

Curiosity

Racehorses inspired by mountains

Mighty mountains in the far north-west corner of Britain have inspired the names of heroic racehorses. Arkle (1957–70) earned his place in the British Steeplechasing Hall of Fame with 27 wins from 35 starts. His owner, the Duchess of Westminster, named the horse after the mountain on her Sutherland estate. Among other honours achieved by the racing legend are three consecutive Cheltenham Gold Cups from 1964 to 1966 and the 1965 King George VI Chase. Arkle's skeleton is on display at the Irish National Stud in County Kildare.

Foinavon the horse, spelled differently to Foinaven the mountain, is renowned for an unexpected Grand National win in 1967. Surviving a chaotic pile up at the 23rd fence, Foinavon won the race at odds of 100-1. The outcome was so improbable that neither his owner nor trainer attended the occasion.

Ben Stack, another horse from the Duchess of Westminster's stable, won the 1963 Cotswold Chase, now the Arkle Challenge Trophy Chase, and the Queen Mother Handicap Chase in 1964.

and kayaks. As shafts of light shift and illuminate this watery landscape, the effect is mesmerising.

The Rhiconich Hotel stands beside the River Rhiconich. The Highland water flows between the mountains Arkle and Foinaven into Loch Inchard. A lengthy detour from Rhiconich junction discovers the port of Kinlochbervie, known locally as 'KLB', and the beaches of Oldshoremore, Oldshore Beg, Sheigra and the famously remote arc of Sandwood Bay.

If considering a detour to visit Sandwood Bay, please be aware that there is no vehicular access to the remote shore. The walk to the beach from Blairmore car park is seven kilometres over a peat track across exposed moorland. Do not to underestimate the amount of daylight required to reach the isolated beach and to return safely. Allow around five hours of walking plus time to explore the vast shore. Food, drink, walking boots and protective clothing are essential.

DETOUR: *The port of Kinlochbervie and remote Sandwood Bay*

While the A838 main route continues to Durness from Rhiconich, the B801 detour follows the shore of Loch Inchard to Kinlochbervie, the most northerly port on the west coast of Scotland. There are few facilities in this wonderfully remote community. The Old School Restaurant and Rooms is a popular destination. Diners are advised to reserve a table. The Worth A Look cafe at Kinlochbervie harbour serves takeaways and all-day breakfasts.

Small boats offer day fishing trips from the harbour; larger vessels steam to fishing grounds around the north and west coasts of Scotland.

The freshly landed catch is sold at the quayside market and transported swiftly through Britain to mainland Europe by refrigerated lorries. Monkfish is especially highly prized in Italy and Spain.

For motorhome travellers, the Kinlochbervie community has created what is known abroad as an 'aire' – a place to stop overnight with the essentials of water, electricity and waste disposal. The Loch Clash Stopover is purpose built on flat land beside the pier. The relatively sheltered spot enjoys big sea views. A small grocery store is nearby. Significantly, the local community uses income generated by the site to improve local amenities further.

The beaches north of Kinlochbervie are all wildly spectacular. Oldshoremore, Oldshore Beg, also known as Polin, and Sheigra are all special yet, for many, the holy grail is the golden shore at Sandwood Bay. The trek to Sandwood begins at Blairmore, some seven kilometres from Kinlochbervie. The path is surrounded by lonely hills that were the stronghold of wolves before humans hunted them to extinction. The scenery is not especially uplifting but rewards lie ahead. When the sound of crashing North Atlantic rollers carries on the wind, the heart beats a little faster. At last, Cape Wrath lighthouse heaves into view and soon Sandwood's immense golden runway appears. The isolated shore is guarded by headlands north and south and an iconic sea stack known as Am Buachaille or 'the Herdsman'. The atmosphere is special and sometimes eerie. The lonely ruins of Sandwood cottage, crumbling beside Sandwood Loch, are said to be haunted. In 1900, a crofter was convinced he saw a mermaid on the shore.

The John Muir Trust owns the Sandwood Estate and protects the beaches, sea cliffs and precious machair by low-intensity farming methods. Volunteers repair erosion on the paths so that others may enjoy this rugged landscape.

For the next stage of the journey, to Durness, double back along the B801 to the Rhiconich junction and take the A838.

RHICONICH TO DURNESS

From Rhiconich, the A838 sheds a carriageway to become a narrow single-track road. Climbing towards Durness, it travels alongside the

deep gorge and rushing peaty cascades of the Allt an Easain Ghairbh. The landscape shakes off traces of civilisation to become lonelier and more epic.

The enormous bowl of Strath Dionard is dominated by the many summits of the Foinaven range. This wild terrain is heaven to those who seek the traditional Highland sporting pursuits of river fishing and stalking. In the distance are the peaks of Beinn Spionnaidh and Cranstackie. Here two young airmen lost their lives when their Mosquito plane crashed in 1943.

In such isolation, buildings become landmarks, milestones along the journey. Gualin Lodge is a former coaching inn built for the Duke of Sutherland in 1833. To protect the accommodation from view, the road was diverted behind it. The lodge encompasses a fish room and a deer larder. Across the valley a strikingly lonely farmhouse is surrounded by mountain grandeur.

The wayside water trough constructed in 1833 by surveyor Peter Lawson is a favourite landmark. A plaque notes his 'gratitude and respect

to the inhabitants of Durness and Eddrachillis for their hospitality while projecting this road'.

Emerging from the lonely hills, the A838 reaches the shallow shore at the Kyle of Durness, a beautiful sandy wedge between Cape Wrath and the scattered townships of Durness.

A minor road reaches the small pier at East Keoldale. Here a small seasonal pedestrian ferry transports passengers across the Kyle to visit Cape Wrath Lighthouse when the surrounding military range is not operational. The full expedition requires a minimum of three hours. The 10-minute ferry crossing connects with a minibus to cross rough terrain known as The Parph. The onward ride to the lighthouse takes an hour, bouncing along the rough tracks used by the military.

Robert Stevenson built the lighthouse in 1828. The beacon dominates the landscape and patrols the coast where surging waves slam Clo Mor, the highest sea cliff in Britain at 281 metres. While the tower is closed to the public, it is possible to have a very civilised cup of tea at the Ozone Cafe in the complex of lighthouse buildings. Visitors have around an hour to explore before the minibus bounces back through the military firing range to meet the ferry at the slipway.

Durness village is 16 kilometres east of Cape Wrath. The Ministry of Defence posts advance notice of the operating hours and restrictions on the bombardment range at Durness Post Office and Tourist Information Centre. The Kyle of Durness ferry service timetable is also available from the Tourist Information Centre.

This epic far-north coastline is fringed with enormous golden sand beaches. The journey to discover them begins at the minor road to

Curiosity

The golden eagles of Foinaven

Golden eagles have made Foinaven their kingdom. The majestic raptors, with a wingspan of up to 2.34 metres, scour lonely ridges where deflected wind aids their flight. They are known in Gaelic as *fior eun*, the 'true bird'. Before persecution in the 19th and 20th centuries, golden eagles were more widespread throughout the UK. As their numbers declined critically, the importance of their habitat and their protection in the wild landscape of Scotland have become increasingly significant.

White-tailed sea eagles also suffered persecution and illegal killing, especially on Victorian sporting estates where they were regarded as competitors for fish. The birds were extinct in the UK by 1916. In Wester Ross, the population has been revived by the introduction of birds from Norway between 2007 and 2013 and the enforcement of legal protection. The magnificent raptors are the UK's largest bird of prey, known also as fishing eagles and romantically in Gaelic as *iolaire suil na greine*, the 'eagle with the sunlit eye'.

Sea eagles snatch fish from the surface of the water with their talons. They do not plunge dive. Their staple food is fish however they will also scavenge carrion from dead sheep and lambs. Where sea eagles play a part in livestock losses, rural communities seek to find a balance between farming and wildlife, appreciating the benefits of both.

Balnakeil from Durness village. Before reaching the shore, the lane passes a colourful arts village in the cabins of a former Nuclear Early Warning station. Impressive Balnakeil House stands at the shore, opposite ruins of the parish church founded in 722 by St Maelrubha. A beach car park overlooks the fantastic bay where powerful breakers pound vast sands. It is often overcrowded by motorhomes in high summer and best avoided if possible. Cycling and walking to the beach along lovely lanes and coastal footpaths is a delight.

Among the memorials in the seashore burial ground is a grand design dedicated to Rob Donn ('Brown-haired' Robert) MacKay (1714–88) a native of Strathmore. Donn was a cattle drover whose spoken poems and songs entertained the communities he visited. Unable to read or write, Donn was a Gaelic-speaking contemporary of Robert Burns, widely regarded as the national poet of Scotland. A discovery trail of nine interpretive panels celebrates Rob Donn in the far north Highland places that are significant in his work.

Durness Golf Club, the most north-westerly course on mainland Britain, is a short walk from the burial ground. Sea views are stupendous. Spectacular greens are specially cared for within a European Special Area of Conservation. Visitors are most welcome.

A coastal walk of over eight kilometres from Balnakeil Beach to Faraid Head through one of the largest dune systems in Scotland is a favourite. Allow around two hours for the uplifting ramble in magnificent scenery to the sound of surging surf. The sight of Highland cattle roaming the sand dunes is especially memorable.

Beauty Spot

The Kyle and the long-finned pilot whales

At low water, the Kyle of Durness is especially magnificent. Sandbanks are revealed and wading birds feeding in gullies by the shore. Picnic benches make good observation posts. A standing stone engraved with a traditional Celtic knot pattern commemorates the millennium.

In July 2011 a wildlife tragedy unfolded here when a pod of around 70 long-finned pilot whales entered the shallow waters of the Kyle. Rigid inflatable boats and a team of Royal Navy divers from the Northern Diving Group failed to herd the creatures away and prevent a mass stranding. Pilot whales live in strong social groups. When one of the pod is sick, injured or lost, the rest will follow. As the tide receded, adult whales and young calves were mired deep on sandbanks, unable to escape. The Whale and Dolphin Conservation (WDC) charity mobilised a specially trained rapid response team. Heroic efforts saved many of the struggling creatures. Tragically 19 of the pod died.

Cape Wrath, to the west of the Kyle, is the largest live bombing range in Europe. In 2015 an investigation published by the Department for Environment, Food and Rural Affairs (Defra), found the detonation of four underwater explosives to have been a 'likely influence' in the mass stranding.

In the 24 hours prior to the stranding, the Royal Navy detonated three 1,000-lb bombs in the sea. A further 250-lb bomb was exploded after the stranding began.

Any plastic rubbish collected from the beach can be dropped into the collection barrel organised by the community at Balnakeil car park.

The Vikings who sailed from the north to invade Scotland referred to the territory as 'the southern lands', hence the historic county name of Sutherland. In the dunes of Balnakeil, the Norse people buried an adolescent boy who was around 13 years old. In 1991, a fierce storm brought strong winds that shifted the sands around him. Holidaymakers discovered the burial site. Among the boy's grave goods were a sword, a comb made of antler and an iron fishhook.

After a bracing walk on the dunes of Faraid Head, a mug of luxuriously

Curiosity

John Lennon's Durness summer holidays

John Lennon, singer, songwriter and one of the Fab Four Beatles holidayed in the far north Highlands. He was nine years old when he first left Liverpool to stay with his aunt in the hamlet of Sangomore. Inspired by the wild landscape, he wrote poetry and spent long daylight hours walking, fishing and playing with his cousins on the immense local beaches.

The community of Durness remembers these special times fondly. A memorial at the village hall celebrates the holidays of a boy who became an icon. Stone slabs in the John Lennon garden are incised with lyrics from The Beatles' nostalgic song 'In My Life'.

indulgent hot chocolate at Cocoa Mountain cafe in Balnakeil Craft village is a delicious treat.

Durness village centre is a modest gathering of services including a filling station, an excellent grocery store and post office, a comfortable hotel and a bunkhouse. Further businesses are scattered along the coast.

A fantastically situated cliff-top campsite enjoys huge sea views and Durness youth hostel offers much character in colourful vintage wooden huts. Wherever you stay in Durness, there is the strong possibility of spectacular starry nights and perhaps even the magic of the Northern Lights.

The A838 travels west to Sango Sands, a vast and smooth golden shore spiked with a smattering of jagged sea-stack fangs. Durness Visitor Information Centre is beside the cliff-top beach car park. Pop in for information about local walks, events and accommodation. Outside, a circle of boulders is a neat geology lesson to illustrate the ancient landscape. Each specimen of rock is named and aged.

GEODHA SMOO TO LOCH HOPE

The A838 follows the coast to Geodha Smoo, a steep-sided narrow inlet. Here the action of seawater and freshwater has created an enormous chamber with a gaping entrance 40 metres wide. If only the rocky walls of Smoo cave could share the stories of those who have used this place for shelter . . . Archaeologists have discovered traces of Stone Age people. Vikings may have repaired their ships here. The mouth of the cave can be explored freely. A seasonal guided tour explores geology deeper inside the chamber.

Spectacular Ceannabeinne Beach has an unusual addition. The zip wire that reaches from one cliff top to another divides local opinion. Some appreciate the opportunity to whizz across above the sands while others fear the spread of amusement park attractions in this unspoiled landscape.

From Rispond, the road turns inland around Loch Eriboll. The long shore is imprinted with Bronze Age activity. Discover hut circles, mysterious souterrains and burnt mounds in which rocks were heated to warm water. The mounds may also have served as baths, sweat lodges and saunas.

A minor road leads to Portnancon Pier and fishing station. The disbanded Heilam ferry sailed from here to Ard Neakie.

The deep fjord of Loch Eriboll is a historic refuge for vessels fleeing violent weather in the turbulent Pentland Firth. While waiting for the storm to pass, sailors on shore leave traditionally amused themselves by climbing into the hills to spell out the name of their ship in large rocks. Some of these names are still visible, though many of the stones are sinking into the ground and traces of this extraordinary history are disappearing. The isolated sea loch became a rendezvous for German submarine crews to give themselves up at the end of World War II. Historian David Hird recounts events in his book *The Grey Wolves of Eriboll*. More than 30 U-boats, previously tasked with destroying Allied convoy ships, surfaced under black flags of surrender.

The small township of Laid sprang up after farming families were ousted from Eriboll across the loch to make way for more profitable

Beauty Spot

Rispond

From the A838 a minor road slopes to the shore at Rispond harbour. Here a stone jetty, built in 1788, is surrounded by a handful of historic buildings associated with fishing. The harbour that exported Scottish wool to the Low Countries also claims a curious historic first – sailing boats from Rispond introduced St Petersburg to prized Scottish herrings. Close by the lovely harbour is a small beach of pinkish sand.

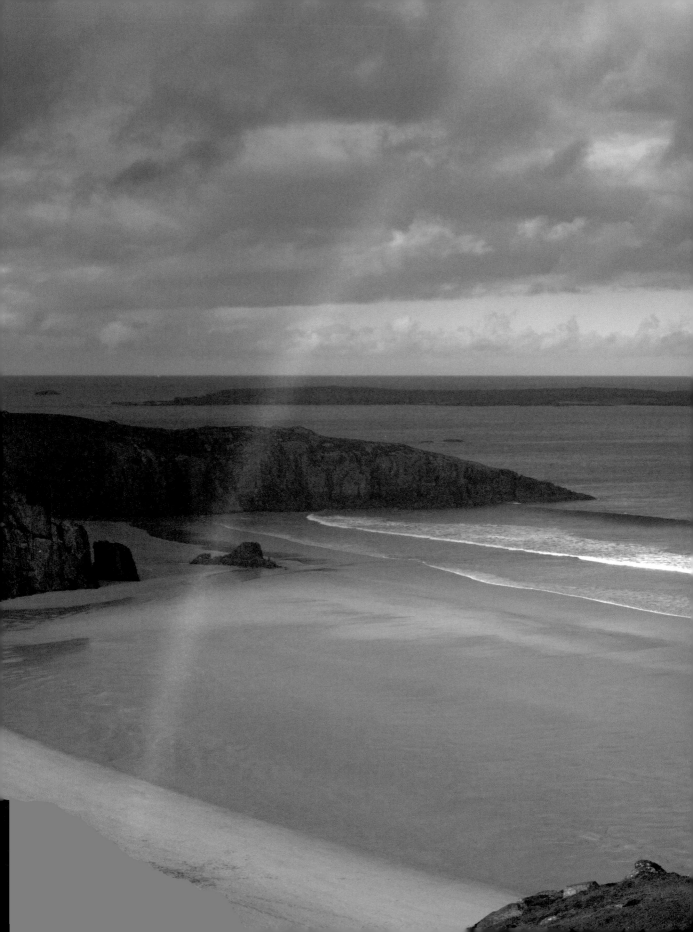

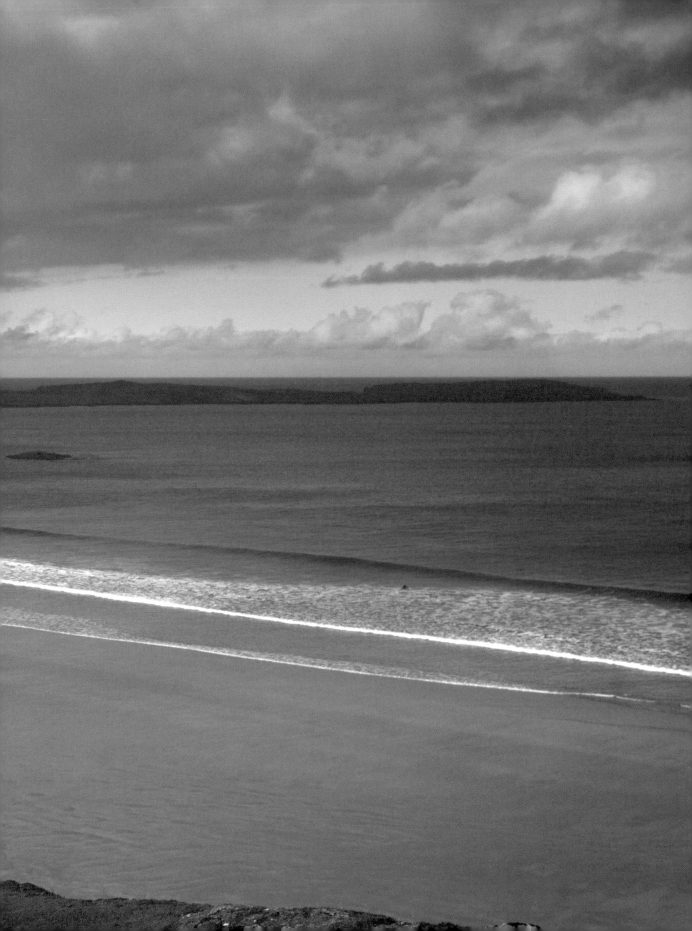

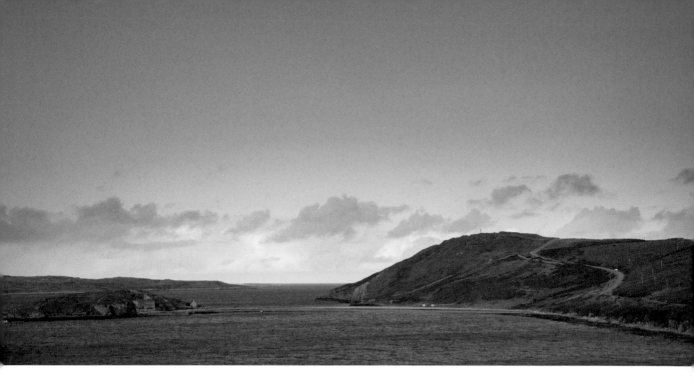

sheep grazing during the Highland Clearances. From Laid there are spectacular views to Ben Hope and the cliffs and sea stacks of Whiten Head, where Tom Patey, the pioneering climber and Ullapool doctor, tragically fell to his death in 1970.

At Laid, shapely iron gates and curious ceramics announce the sculpture croft of Danish artist Lotte Glob. Lotte's creative expression is inventive and playful. When her croft and studio are open, visitors are welcome to explore the magical landscape around her house on stilts. Lotte has made paths through sylvan glades to visit reflecting pools. Her weirdly wonderful ceramic installations crown heathery hillocks. Some sway and whistle in the wind. With a lifelong passion for planting native trees, Lotte is a woman on a mission to re-forest the exposed west shore of Loch Eriboll. The flourishing young woodland brings shelter and wildlife to her door. The achievement is extraordinary and life affirming.

The road skirts the loch shore to reach pastureland at Eriboll farm. Lush fields are something of a novelty in this rugged landscape. Derelict lime works at Ard Neakie appear to be on an island yet closer inspection reveals the distinctive headland is connected to the shore by a sandy spit. A hillside lay-by makes a good stopping place for an impressive view across the sea loch and into the far north mountains. Ships' names spelled out in rock above Laid and Portnancon are clearly visible. Turning east, the road crosses the bridge over the River Hope, where a minor road leads to a mysterious broch.

DETOUR: *The path to Ben Hope and Dun Dornaigil broch*

The minor road travelling south along the shore of Loch Hope leads to Muiseal. From here, a walking route of 7.5 kilometres ascends to the peak of isolated Ben Hope, the most northerly Munro. The climb is steep. Many walkers allow around six hours to make the journey. Summit views are worth it. The far north coast, lochs and mountains are magnificent. The historic Moine Path also departs from this minor road. The route over rough peat land was an important highway for local people and their animals.

Remains of the mysterious Dun Dornaigil broch tower are on the riverbank a little further south along the road. The large triangular sandstone lintel above its doorway appears to be a status symbol similar to that of Clachtoll beach broch. The tallest remnant of the broch's drystone wall stands some seven metres high. The imposing structure would have been twice as lofty when originally built.

ACROSS A' MHOINE TO THE KYLE OF TONGUE

Sections of an old road are occasionally apparent as the A838 crosses the barren peat moss landscape of A' Mhoine or The Moine. A stark ruin beside a section of the old highway is a lonely landmark. Moine House was built expressly as a place of shelter for travellers battling their way across bleak terrain. A resident family extended warm hospitality to weary guests. Appropriately, the refuge is close by the township of Hope. A stone tablet dated 1830 celebrates the building of the highway across 'the deep and dangerous morass of the Moin [*sic*]'. Surveyor Peter Lawson – the same man who gifted the landmark water trough to locals in Strath Dionard – is credited with the construction of the road and Moine House. Weathered words are barely visible. Moine House is fading fast.

The 'deep and dangerous' landscape of The Moine may be put to extraordinary use in future. Highlands and Islands Enterprise and the UK Space Agency are considering a 21st-century European vertical launch centre for commercial satellites.

On the approach to the Kyle of Tongue, a minor road to the right

invites discovery of the shore of the Kyle of Tongue. A road to the left leads to the North Atlantic and the wonderfully named Rabbit Islands. Both routes are worth exploring, and the lanes are lovely for cycling. My preference is to visit the coast first and explore the shore of the Kyle in a circuit from Tongue.

DETOUR: *Islands of rabbits and seals*

The minor road that connects the crofting community of Melness to the A838 offers fantastic views of Tongue Bay and the snaking causeway across the Kyle, backed by the mountain grandeur of Ben Loyal.

The Melness community swelled in the early 1800s as Lord Reay cleared families from Strathmore on his Hope estate to make way for commercial sheep farming. Many of the population drifted to these coastal fringes. From the huge sandy beach at Midtown, the road journeys around the headland, closely hugging the shore with views towards islands associated with animals. The seascape is spectacular on a moody day. Surging waves lick at jagged island edges. Ever shifting light dances across grassy green tops. The effect is spellbinding.

The Rabbit Islands are riddled with sandy burrows. The bunnies were introduced in 1790 to provide meat for the laird. Eilean nan Ron or 'Island of the Seals' takes its name from a large resident colony of grey seals. Following the Sutherland Clearances, a small group of uprooted families began new lives on Eilean nan Ron in 1820. The population flourished and a schoolhouse was built. During summer months, the men of working age left the island for seasonal work on herring fishing boats along the east coast. Women took care of the crofts and became expert rowers, skilfully handling boats around the precarious rocks encircling the island. Mainlanders communicated with islanders by smoke signals. One puff meant that someone needed a boat to fetch them. Two puffs of smoke indicated an important telegram had arrived. By 1938 the population had dwindled to three families, and in December of that year they too abandoned their homes.

In 1950 new residents joined the island seals. Virologist Sir Christopher Andrewes of the Common Cold Research Unit dispatched a dozen volunteers to stay in isolation for ten weeks before exposure to people

infected with colds. None of the twelve succumbed to the illness. Now only seals and seabirds remain. In winter, Greenland barnacle geese come to stay a while.

At Talmine, the road splits into a web of routes around the bay. A lane reaches the well-stocked village stores where freshly made German bread and Shetland beer are on sale. Outdoors, a picnic bench enjoys a great sea view. A lower road drops steeply to the beach campsite beside the wreck of *The Reaper*. The fishing boat caught fire while at Rispond Pier. Local man Billy MacKay brought the burned-out vessel to Talmine with the intention of restoring it. Sadly he died before achieving his mission. *The Reaper* has been largely reduced to a skeleton embedded in the sand. Talmine harbour has an awkwardly steep slipway more like a ski slope. Launching and landing is a feat. The haven is offered protection by a curiously long wall that extends beyond the shore to a small island.

A bracing coastal walk from Talmine leads to the natural harbour at Port Vasgo, from where stone and slate were shipped. Kestrels nest on cliffs ledges. Pools of purple Scottish primroses bloom between May and August. These rare and hardy flowers enjoy legal protection. Beyond a handful of crofts at Strathan lie the sands of Achininver. Dive-bombing skuas are regular visitors in summer.

The spectacular Kyle of Tongue causeway is a highlight of this far north Highland odyssey. The snaking short cut opened in 1971. Previously vehicles took the minor road that loops around the shore. A pedestrian ferry operated until 1953. A rise in vehicle ownership killed off the rowing-boat service. From the west shore, an 18-span bridge carries the roadway to low-lying Tongue Island. Here a mid-Kyle parking place with picnic benches makes an excellent wildlife observation post. The awe-inspiring view to Ben Loyal, 'the queen of Scottish mountains', is truly regal.

Melness croft houses are pegged out across the hillside like fresh white laundry. Stately trees and high grey walls enclose the elegant buildings of Tongue House and farm on the opposite shore. At low tide, tractors trundle across the sands to service the French-owned Pacific oyster farm that extends into the Kyle.

STAGE SIX
Tongue to Portskerra and Melvich

Strathy
Point

Eilean nan
Ron

Rabbit
Islands

Kirtomy
Point

Ardmore
Point

Portskerra

Farr
Point

Skerray

Armadale

Melvich

Torrisdale Bay

A836

A897

Torrisdale

BETTYHILL

Coldbackie

Borgie

Kyle of Tongue

A836

TONGUE

FLOW COUNTRY

Lochan
Hakel

Ben Loyal

N

0 5 km

0 5 miles

Forsinard

Legend

—·—·— Main route

—··—··— Detour

EASTWARDS FROM TONGUE ON THE A836

The Kyle of Tongue causeway reaches the east shore beside an imposing and cosy youth hostel that was formerly a grand shooting lodge. Over several generations, my family has stayed here. The lulling swash of the sea and the haunting moan of seals live long in the memory. We have picnicked in the seashore garden and crept out of bed to watch late-night entertainment provided by the merry dancers of the aurora borealis.

The hostel's gracious neighbour is Tongue House, a handsome mansion built for Lord Reay in 1678. A boathouse stands beside the pier from where Millicent, Duchess of Sutherland, often sailed to Eilean nan Ron in the 1880s. To communicate with the Gaelic-speaking islanders, she occasionally invited a translator. The eventful jaunts delighted her.

Though Tongue appears to be an unassuming village, there is much history to discover. Curiously, the main road through the village traces the outline of a tongue, as if to keep the theme going. A junction with the A836 connects traffic with Altnaharra and Lairg inland. The few businesses in the village have a long tradition of service to the local community, especially Burr's store.

The Tongue Hotel is another former sporting lodge of wood-panelled splendour. Vintage taxidermy trophies adorn walls and shelves. Beady-eyed Highland creatures are forever trapped in glass cases. The Falcon Bar is on the ground floor. The Brass Tap drinking den is in the basement. Water for whisky is piped from the eponymous tap on the bar.

The Ben Loyal Hotel in the heart of the village has morphed from post office and shop to bakery and accommodation over the years. The Ben, as it is known, is another friendly place to meet locals.

Curiosity

Burr's of Tongue

The village store is a lynchpin of great importance to a remote Highland community dispersed across a wide area. Burr's of Tongue is no exception. This grocery shop has provided service and entertainment over generations. Not much has happened in Tongue without Burr's being part of it.

Among its many incarnations have been Burr's bakery, tearoom, delivery service, garage, fire brigade, removal service and even a plush coach that made regular trips from the village to Thurso for weekend entertainments. The ride was fondly known as 'the picture bus'. Although no longer in the family, the esteemed emporium retains the name. A shiny working cash register from Burr's original store is among the most popular exhibits at the community-run Strathnaver Museum near Bettyhill.

DETOUR: *Time travels*

The minor road looping the south end of the Kyle is a time-travelling adventure. The first curiosity is a fenced-off memorial celebrating Ewen Robertson (1842–95), a fisherman known as 'the bard of the Clearances'. Robertson's Gaelic verse vividly recounts historic upheaval across the Highlands. The narrow road winds through birch, gorse and rowan. A gateway indicates Ribgill Farm and the popular path to majestic Ben Loyal. The 'queen of Scottish mountains' is clearly crowned by four peaks when viewed from the north. From the summit, walkers and climbers enjoy heady views of Ben Hope, the Flow Country, the Pentland Firth and the islands of Orkney.

In the waters of Lochan Hakel there is much mystery. It is thought that the pool may take its name from a Norwegian king, Haakon. Much of northern Scotland remained under Norwegian rule for many centuries until the Treaty of Perth in 1266. According to local legend, the crumbling remains of a stone building on the islet known as Grianan are the king's hunting lodge.

Beauty Spot

Castle Varrich

Hilltop Castle Varrich stands sentinel above the Kyle of Tongue. To visit the small square tower, follow the footpath from the village across the Rhian Burn. A staircase within the ruined castle rises to a new viewing platform. Island and mountain vistas are magnificent. The age and origins of the stumpy fortress are unknown though it is associated with the chiefs of Clan MacKay. Whoever resided here enjoyed dominant views of the community below.

Allow around an hour for the walk to the castle and back.

According to local legend, gold coins may lurk in the peaty depths of the lochan. In April 1746, the day after the Battle of Culloden, a sloop carrying funds to boost Bonnie Prince Charlie's rebellion was shipwrecked near Tongue. Hotly pursued by the British navy, the crew and 120 soldiers abandoned ship and fled. They stashed the fighting fund of gold coins in Lochan Hakel, though government forces later discovered the treasure. But did they find it all . . .?

On the loch shore, opposite the islet, a large rock is marked with Bronze Age cup-and-ring incisions whose meaning has been lost through the centuries. Beside the road a boulder beneath a birch tree has more of these mysterious markings.

The road continues around the loch to the remains of Dun Mhaigh broch. The builders of the dry-stone structure are unknown. The inhabitants and the purpose of the 2,000-year-old tower remain a mystery.

Leaving Tongue, the A836 skirts around Ben Tongue and Watch Hill to pass Coldbackie Beach. Surfers often enjoy powerful waves here. A side road slips to the shore through croft pastures. Chickens roam around tractors and jumbled fish boxes.

At Scullomie, a stone pier connects with an islet to create an unusual harbour. The ingenious construction is a listed protected building. A rough track discovers the deserted village of Slettel, a post-Clearance

settlement abandoned in the 1950s. From here, a further walk of approximately 1.5 kilometres crosses the moor to Skerray Bay. The route visits secret rocky inlets with views to the abandoned houses of Eilean nan Ron.

DETOUR: *Scattered hamlets around Skerray*

The sensation of leaving the A836 to explore lanes around Skerray Bay is like tumbling into a rabbit warren. Inviting burrows shoot off in all directions. Skerray means 'between the rocks and the sea'. There is much rock and plenty of sea in this lovely patch. The setting is lush and sandy too. A detailed map is essential. Signposts are few. Phone and satnav signals are poor. Walking and cycling are magical.

On the shore of Skerray harbour, clinker-built boats patiently await their return to sea. A poignant memorial plaque near stacked lobster creels remembers Hector MacKay and John Anderson, fishers lost at sea in 1973. The glassless windows of a derelict bake-house peer to an island known as Neave or Coomb. A secret artist has created a magical

seashore gallery in the dilapidated building. Her vibrant seascapes hang in tumbledown surroundings whipped by salt-laden wind and spray.

The warren of lanes connects scattered hamlets and secret beaches. Lamigo Cove is as enchanting as it sounds. The shore is reached by footpath only and it feels like the kind of place you might find a merman crooning softly to his lover by the light of the moon. Fishers reach their boats by means of a rough concrete pier that straddles rocks to the sea. Over the hill, Port an t-Strathain is another heavenly hideaway. In the community hub of Achtoty, the buildings of Jimson's Croft have been restored with respect for tradition. A mini heritage centre and post office nestle under the long low roof of thatch weighted with rocks.

Skerray Free Church is one of my favourite far-north buildings. Gothic windows, rust and peeling paint lend a storybook air. The characterful prefabricated corrugated iron building was a triumphant solution to meeting the need for a place of worship in a remote rural township with poor access roads and minimum funds. The church arrived by

sea in 1905, complete with a diagram of how to construct the numbered sections. Set back from the road beside the old post office and the war memorial, it was sited at the heart of the community. Sadly, the building is no longer fit for purpose. I hope it receives the protection it deserves. Apparently, Prince Albert admired these prefabricated creations too. A handsome corrugated iron building made in Manchester stands in the grounds of Balmoral Castle. Dispatched to the Highlands, it served as a temporary ballroom.

Before returning to the A838, the road passes the shore of Torrisdale Bay, where a vast apron of golden sand lies between the peaty estuaries of the Borgie and Naver rivers. Powerful waves attract surfers.

AROUND BETTYHILL

The Forestry Commission developed Borgie Glen in 1920. Woodland trails lead visitors to The Unknown, a skeleton sculpture over two metres high. The artwork created by Kenny Hunter surveys the glen in silent acknowledgement of human habitation over millennia.

The A836 swoops across the River Naver and climbs to Bettyhill. Some believe the village takes its name from Elizabeth, the first Duchess of Sutherland, while others suggest the Betty in question was the local innkeeper. The derelict buildings of Navermouth salmon fishing station stand on the east shore of the river. Here the catch was gutted, washed, boiled, salted, packed in tins and shipped. An ice house is built into the hill. Sweep-net fishing on the River Naver ended in 1992 due to dwindling stocks of salmon.

The landscape of Bettyhill is etched with traces of early human habitation. Look out for prehistoric hut circles on the River Naver shore and the remains of a dry-stone broch tower on the hill above.

The Strathnaver Museum is in the former parish church of St Columba beside the dunes of Farr Beach. In the burial ground to the west of the building, the ninth- or tenth-century Farr Stone is decorated with spirals and birds with intertwined necks. The heritage

Beauty Spot

Farr Bay views

Discover a beautifully situated picnic bench on cliffs above a secret cove on Farr Bay. The seascape is spectacular. Surging waves crash at the foot of high cliffs extending along the coast to Farr Point. The hideaway beauty spot is reached from a small car park just past Mackenzie Crescent in Bettyhill. The evening romance of the amber sun dropping gently into the ocean is magical.

centre documents the brutal Highland Clearances of Strathnaver. Exhibitions trace Gaelic and Norse influences throughout the area. The MacKay Room welcomes clan members from around the world. The wooden hull of a shipwrecked boat is among eclectic treasures. Canny crofters recycled it as a roof truss. A fishing boat buoy transpires to be the leathery body of a dog. An innocent looking pulpit proves to be the place where, in 1814, Reverend David Mackenzie was obliged to read eviction notices to his congregation at the behest of the Countess of Sutherland and the Marquess of Stafford.

The Strathnaver Trail departs from the museum. The history adventure visits 29 destinations in the valley of the River Naver. Maps and guides are available from the museum.

Curiosity

Surfers and great yellow bumblebees

Powerful autumn and winter waves attract cold-water surfers in thick wetsuits to Farr beach. A wildflower paradise near the Strathnaver Museum attracts rare great yellow bumblebees.

Supported by a local crofter, pupils from Farr High School worked with Scottish Natural Heritage to create a pollen-rich patch of vetch, scabious and knapweed. Burrowing great yellow bumblebees have lost much of their natural habitat due to intensive farming methods. Happily, they are joined in the reserve by other bee species, creating quite a buzz.

BETTYHILL TO MELVICH BAY

As the A836 approaches Caithness, the coast becomes increasingly ragged. A series of sharp and exposed headlands – Farr Point, Kirtomy Point, Ardmore Point, Strathy Point, Red Point, Brims Ness, Spear Head and Holborn Head – projects into the sea. Fierce wind and wave action sculpts spiked sea stacks and jagged islets. Sheltered bays are few. Rocky clefts make precarious harbours for crofters who supplement their income by fishing. At Kirtomy, a low concrete pier affords access to deeper water.

Armadale township overlooks the bay where the large team of sheep-dogs from Armadale Farm enjoy time off in the surf. On the headland, the crumbling houses of Poulouriscaig resound to sea breezes whipping around the walls. This community was renowned for the hum of ceilidh gatherings that extended long into the night. In Scots Gaelic, to ceilidh is to go visiting. The traditional ceilidh gathering of friends and neighbours is often accompanied by songs, music and poetry. Windswept Poulouriscaig was abandoned voluntarily in the 1940s. Villagers resettled

Curiosity

The whales and dolphins of Strathy Point

The first Scottish lighthouse built as an all-electric station crowns the headland at Strathy Point. Illuminated in 1958, the tower ceased operation in March 2012. Changes to shipping lanes made the beacon redundant. The cliff-top lighthouse is not open to the public. However, Strathy Point is an important shore watch site where seasonal 10-minute whale, dolphin and porpoise surveys are carried out by volunteer teams trained by the Whale and Dolphin Conservation (WDC) charity. Conservationists have been able to identify and name individual cetaceans making annual visits to these deep waters. The lighthouse headland is a 15-minute walk from a small car park at Totegan. Further around the coast, Strathy Beach is perfect for picnics, swimming and surfing.

Beauty Spot

Marie Curie Cancer Care Field of Hope

Beside a large lay-by, between Strathy and Melvich, a walled enclosure frames a beautiful early spring sight. In 2007, pupils of Melvich Primary School planted 2,000 daffodil bulbs on common grazing land. The mass planting took place on 7 November, Marie Curie's birthday. The dancing daffodils are an uplifting sight on the windswept moor overlooking Strathy Point, Dunnet Head and the Orkney Islands.

by the shore. To ceilidh and perhaps picnic at the deserted township, allow around two hours for a walk of six kilometres from Armadale on a rough track.

The townships of Portskerra and Melvich are closely connected. While Melvich extends along the A836 to the Halladale River, Portskerra reaches out to sea. Paths through dunes lead to Melvich beach. Winter waves are often good for surfing. At Portskerra the Drownings Memorial honours a total of 26 fisherman 'who perished within sight of their homes' in three separate incidents. A memorial on the hill beyond Portskerra old harbour honours shipwrecked mariners whose bodies came ashore when the *Snow Admiral* foundered in 1842.

In remote Highland communities, storytelling formed bonds that kept traditions alive and held people together. True and fanciful tales, woven with colour, were passed from one generation to the next. The tradition continues in Portskerra, where the annual storytelling festival entertains adults and children alike. Scottish artist and storyteller Alex Patience has also created inspirational audio walk kits. Exploring the village with the stories and traditions of local people is a wonderful way to connect. I highly recommend it. The audio story kits are available to borrow from the West End Stores in Portskerra and the Halladale Inn in Melvich.

Melvich Bay was previously known as Bighouse Bay. A former fishing station is among a cluster of historic buildings on the shore. Imposing Bighouse mansion is the former seat of the MacKay lairds. A salmon weathervane atop the garden pavilion is a neat salute to the king of fish in the Halladale River.

DETOUR: *The Flow Country*

Before continuing to Thurso, consider a detour to discover the globally significant peat land of Strath Halladale within the great north Flow Country. Precious peat lands cover only 3 per cent of the world's land area yet they hold almost 30 per cent of all terrestrial carbon. The Forsinain Trail is a 6.5-kilometre circular walk in the Forsinard Flows Nature Reserve, which is in the care of the RSPB. Created by the Peatlands Partnership, the trail passes through Forestry Commission Scotland woodlands and along the banks of the privately owned Halladale salmon river. Alternatively, the RSPB visitor centre at Forsinard offers guided tours of the weirdly wonderful landscape between April and October.

The blanket bogs of the Flow Country extend across 400,000 hectares and store more than three times the amount of carbon found in all of Britain's woodlands. The largely flat landscape, patterned with myriad pools that host wildlife in miniature, is like a Persian carpet. Dragonflies, newts, frogs and many more tiny creatures exist in a watery world of sphagnum moss. In autumn the moss turns wine red, apple green and sunshine yellow.

Between April and July, greenshanks, golden plovers and dunlins visit the reserve. Fields are planted with crops to attract breeding birds, especially reed buntings and skylarks. At Loch Bad a Bhothain, red-throated divers breed on a floating nest raft disguised as an island.

Boardwalks cross the watery landscape to reach a timber-clad viewing tower. From here the vast expanse of the pool systems is astonishing. On sunny days they become wonderful mirrors. The experience of the Flow Country is exceptional. There are few places like it.

STAGE SEVEN

Portskerra and Melvich to Wick

THE COAST
AROUND DOUNREAY

Leaving the small communities of Portskerra and Melvich, the A836 approaches Thurso, the most northerly town on the British mainland. For generations, this area of the far north coast was associated with nuclear power. Dounreay nuclear power development site was established in 1955. The famous golf ball dome housed the

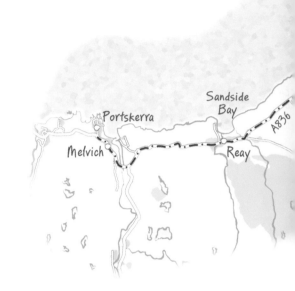

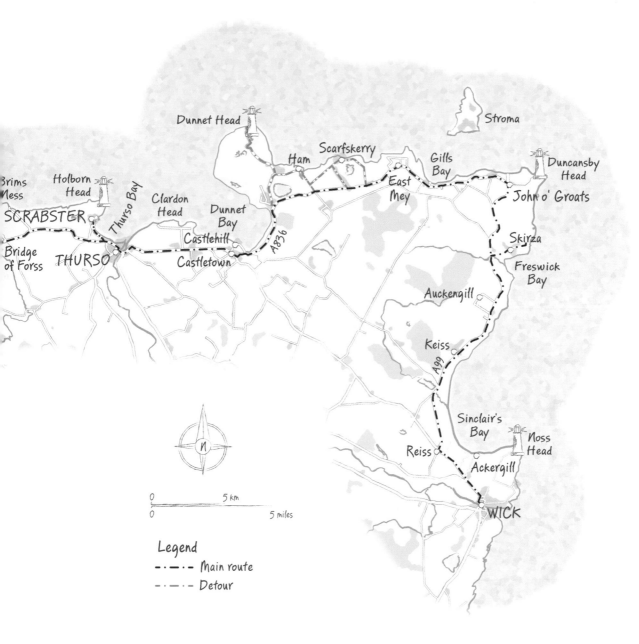

UK's only Prototype Fast Reactor (PFR) and symbolised the arrival of a new era. Wholly different employment opportunities were available to the offspring of traditional crofting families in Caithness, Sutherland, Orkney and the Shetland Islands. The nuclear research centre recruited young apprentices, though jobs were not guaranteed.

One of the most striking views of the Dounreay site is from Fresgoe harbour on Sandside Bay. Built in 1830, the harbour is attractive and

155

Curiosity

The most northerly golf course in mainland Britain

Panoramic views of the Pentland Firth and the North Atlantic Ocean are visible from every hole on the 18-hole links course designed by James Braid, at Reay Golf Club. Apparently, the sixth hole was Braid's personal favourite. Visiting golfers are welcome and invited simply to turn up and play. Clubs may be hired by prior arrangement. The club is normally open throughout the winter months however players should beware of what locals call the lazy wind, one that goes through you rather than around you!

impressively designed to withstand the pounding waves of the Pentland Firth. The very narrow entrance shelters fishing boats from the fury of the sea. Caithness flagstones are set vertically in the walls so that water drains away quickly. Among the quayside buildings is a former salmon bothy. An ice house is buried in the dunes. The proximity of this pretty harbour to its nuclear neighbour is striking. Ironically the older and still active little port has outlived the fast reactor.

Dounreay is undergoing the most complex nuclear site closure project in Europe. The UK Atomic Energy Authority monitors Sandside Beach regularly. Radioactive contamination, in the form of metallic particles, which cannot be identified by the human eye, has been found on the shore. According to Dounreay.com:

Used fuel from the reactors on site and other research reactors in Britain and abroad was recycled in the site's reprocessing facilities.

The swarf produced during the procedure was discharged from fuel ponds with the water and were released to sea.

It is not known how many particles were released but extensive research suggests that the bulk were released between 1958 and 1984.

The most hazardous fragments are located close to an old discharge point on the seabed. Their disintegration is believed to be the source of smaller, less hazardous particles detected on local beaches since the early 1980s.

Dounreay Particles Advisory Group suggests that 'the probability of the most frequent beach-users . . . coming into contact with a relevant particle is one in 80 million'.

At the end of a long drive, Sandside House is the last in a chain of the north-coast seashore mansions that stretches from Balnakeil to Tongue and Sandside Bay. The 15th-century estate overlooking the Pentland Firth to the Orkney island of Hoy was the stomping ground of the Lords of the Isles.

TO SCRABSTER AND HOLBORN HEAD

From Bridge of Forss on the A836 there are views of the Water of Forss and a beautifully restored corn mill. Woodland and cascades surround the elegant Georgian buildings of Forrs House Hotel. Here there are riverside walks to the sea. At the shore, St Mary's Chapel enjoys a romantic situation with lovely views of Crosskirk Bay. The attractive 12th-century ruin has witnessed dramatic changes across the surrounding farmland through the centuries, most recently the closure of a US naval communications base and the arrival of wind turbines. Previously known as 'the atom town', Thurso has been rebranded as 'the energy town'. Offshore wind farms and marine energy are among the new opportunities.

The icy waters of Thurso Bay host the annual Scottish National Surfing Championships. Among the hotspots is Brims Ness. The huge North Atlantic swell crashes on flagstone reefs. Foreshore slabs of Caithness stone make a great viewing platform for surfing spectators. At Brims Port, farm buildings conceal a 16th-century castle.

The best months to surf this far-north coast are between September and May. In high summer, the sea tends to be too flat. Winter swell is powerful and consistent. It is not unusual for surfers to be having the time of their lives on seriously big waves in falling snow. A hooded 6-millimetre thick wetsuit, gloves and boots are essential. Local advice is never to surf alone. Many of the north coast's most powerful waves are reef breaks, suitable for experienced surfers only. If in doubt, don't go out.

Scrabster harbour in Thurso Bay is a historic gateway to Shetland, Orkney, the Faroe Islands and Scandinavian ports too. Close to northern fishing grounds, the deep-water anchorage has an industrial-scale chilled fish market with a 2,000-box capacity alongside facilities serving the oil, gas and renewable sectors. Built in 1841, the harbour was an immediate success. In 1862 a lighthouse was erected at Holborn Head to protect the increasing volume of traffic in the fishing lanes. The port is busy and colourful. Plump resident seals scavenge around fishing boats and loll comically on slipways. Here they are safe from pods of hunting orcas that regularly visit this coast from Iceland with their young. Orcas are the largest member of the dolphin family. The best

months to observe them are between April and July, although they are occasionally seen at other times. The sea watch findings of volunteer citizen scientists stationed at Strathy Point and Holborn Head contribute enormously to the appreciation and protection of whales and dolphins in UK waters.

On the Scrabster quayside, the former Victorian ice house has been converted into the Captain's Galley Seafood Restaurant. Only seasonal fish from healthy stocks are on the menu. The listed building retains the stone walls, the barrel-vaulted ceiling and the chute where chunks of ice from ponds on Holborn Head were loaded. Wrapped in straw, the ice preserved wild salmon caught by fishers working from the bothy next door.

The coastal scenery of Holborn Head is awesome. Immense red sandstone cliffs extend to Dunnet Head, the furthest point north on the British mainland. Views to the island of Hoy, the Old Man of Hoy sea stack and the Clett Rock sea stack are wonderful. Yet this wind-blasted promontory is perilous. Geos are deep inlets in cliff faces caused by erosion. Gloups are collapsed sea caves that often become fierce blowholes. At all times, children should be supervised and dogs kept on leads.

THURSO, THE ENERGY TOWN

Much of Thurso town centre was laid out by Sir John Sinclair of Ulbster (1754–1835), an energetic man renowned for compiling the *First [Old] Statistical Account of Scotland*, an 18th-century census in 21 volumes. In 1798 he developed Thurso on a grid plan. Among the features introduced were buildings with rounded corners at road junctions to provide clear views of approaching traffic. A town centre statue shows Sir John wearing the striking uniform he designed for the Rothesay and Caithness Fencibles. The regiment he

Curiosity

Things Va, Alexander Smith and the Wolf Burn

Experts believe the Vikings recycled the site of an Iron Age broch to create a parliament at Things Va. The meeting place, just outside Thurso, is reached from a lay-by on the A836. A farm track leads to the huge grassy mound.

The Thurso welcome sign proclaims the town as the birthplace of Sir William Alexander Smith, who founded the Boys' Brigade in 1883. The brigade is one of the largest Christian youth organisations in the UK and the Republic of Ireland. 'Sure and Steadfast' is their motto. Sir William Alexander Smith was born in 1854 at Pennyland House, now a bed-and-breakfast establishment.

Award-winning Wolfburn whisky is produced in an unassuming modern warehouse at Henderson Park. The spirit takes its name from the Wolf Burn that flows nearby. The first bottling of single malt was released to acclaim in March 2016.

raised in 1794 was popularly known as the Caithness Highlanders. The costume consisted of a red regimental jacket with short tartan trews. Sir John did not choose a kilt for his regiment. The trews had a band of yellow silk down the side seam and at the hem. Red-and-white checked stockings completed the look.

Caithness Horizons Museum is an excellent place to discover the area and its changing way of life. Elaborately carved Pictish stones are among exhibits that span millennia. The standing stones are beautifully lit and presented. The relocated control room of the Dounreay Materials Testing Reactor looks as if it may have come straight from the set of a vintage sci-fi movie. The museum's friendly tearoom is good for time-travelling pit-stops.

In nearby Grove Lane, Tall Tales Bookshop is an inviting place to rummage for second-hand volumes and vinyl records. On ochre-coloured exterior walls, large slates are incised with phrases in the local dialect. 'Id's a foosum day' reads one – *foosum* means 'dirty' or 'mucky'.

From Thurso beach there are views of ferries sailing between Scrabster and Orkney. Victoria Walk was created in 1882. The cliff-top path to Burnside is enduringly popular. Uninterrupted sea views, bracing salty breezes and seats along the way ensure its longevity. The elegant ruins of St Peter's 12th-century church stand beside the hulks of old

Curiosity

22 hours and 134,846 cups of tea

Thurso station opened on the Far North Line in 1844. The smart black buffers mark the very end of the most northerly railway to the most northerly town in mainland Britain. It all feels a little unsung and hardly features in tourist information. Yet this station has many stories to tell. During World War I, a Royal Navy train, known ironically as 'the Jellicoe Express', made Britain's longest railway journey between Euston Station and Thurso. Named after the First Sea Lord, Admiral Sir John Jellicoe, the train ran daily from 1917. The epic journey took 22 hours. Conditions were dreadful. The train carried 600 service personnel and their kit bags, tightly packed like sardines. Refreshments were served on station platforms along the way.

From Thurso, passengers sailed to Orkney and the naval base at Scapa Flow. Saluting wartime spirit and hospitality, a brass plaque at Dingwall station, much further down the line, reads: 'This station was used as a tea stall for soldiers and sailors from 20 September 1913 to 12 April 1919 in connection with the Ross and Cromarty Red Cross Society, during which period 134,846 men were supplied with tea.'

The Jellicoe Line served Scapa Flow again during World War II. In 2017, the Far North Line made a new connection with the sea. Over 1,000 rails for the track were delivered by ship to Scrabster harbour. This option was preferred to road transport because it reduced the carbon footprint of the renewal project.

boats on the quayside at Thurso harbour. Local surfers meet at Cafe Tempest where the cheese scones are legendary. A mysterious artwork on a large white wall nearby is in the style of Banksy. A small girl loses her red heart-shaped balloon in the wind. The same image appeared on London's South Bank with the words 'There Is Always Hope'.

A mural at Tollemache House on Thurso High Street is by the artist Caziel – born Kazimierz Józef Zielenkiewicz (1906–88). The bold abstract was commissioned in 1963 for the offices of the Atomic Energy Commission. The artist was an associate of Picasso. His work reflects the town's avant-garde aspirations. The Swanson Art Gallery, within the town's elegant 18th-century public library, enjoys touring exhibitions throughout the year. The privately owned ruins of 17th-century Thurso Castle are across the River Thurso from the town centre. Here too is Thurso East, a cold-water surfing wave of world renown. Inland, there are gentle walks on the riverside known as The Mall.

CASTLETOWN TO THE CASTLE OF MEY

Leaving Thurso, the A836 passes Clardon Head, where Harold's Tower Mausoleum appears like a stone-built bouncy castle. According to legend, Earl Harold the Younger was killed in battle and buried on this land in 1196. Sir John Sinclair built the family mausoleum in 1780. A weather-worn plaque reads: 'The burial place of the Sinclairs of Ulbster'.

However, after his death in Edinburgh in 1835, Sir John was buried at Holyrood Abbey.

Wartime antitank blocks were installed around the Caithness shore to protect against invasion. Extensive remains of the concrete defences are still visible at Murkle. The beach is a popular surf spot, and there's good fishing from rocks known as The Spur. White cowrie shells found here are known locally as 'groatie buckies'. These little treasures are believed to bring much good luck.

Along the coast, Castletown is known as 'the flagstone village'. Here, estate owner James Traill built homes for families employed at his quarry and harbour. The labour was dangerous. Caithness flagstone was raised using hand levers. Many workers lost fingers and toes. Self-guided visitor trails from Castlehill heritage centre explore the attractive harbour and the flagstone works. Coastal views to Dunnet Head are magnificent. For an easy supper on the shore, Castletown village fish-and-chip shop is much acclaimed by Caithness locals.

From Castletown, the A836 sweeps around Dunnet Bay, where the beach is backed by dunes. The long curving strand and driving winds provide perfect conditions for the sand yachts that race here. There are good waves too, especially for beginner surfers. The Seadrift-Dunnet Visitor Centre is open seasonally. Call in for information about safe walking routes on unfenced sea cliffs and the best places to watch wildlife.

Near the beach, Dunnet Bay Distillers use locally foraged botanicals to handcraft small batches of Holy Grass vodka, Rock Rose gin and Rock Rose Navy Strength gin. The award-winning spirits are sold in distinctive white ceramic bottles sealed with wax.

The route now follows the A836 as it

Curiosity

Castlehill Dark Skies

In far north mainland Britain, the sun does not set until around half past ten on midsummer evenings. Daylight lingers for another hour. The experience is magical. When darkness falls, there is little light pollution. The starry heavens are spectacular. Castlehill Heritage Centre is a Dark Sky Discovery Site. Amateur and professional astronomers gather to share their passion. Members of the public are invited to join in and experience lively star-gazing nights by the sea.

Beauty Spot

Dunnet Forest

The Forestry Commission established Dunnet Forest as an experiment. Trees struggle to thrive on the exposed coast of Caithness. Blasting winds are laden with salt. The mature forest is now community owned. Woodland trails are popular with walkers, horse riders and mountain bikers. An impressive turf-roofed log cabin is decorated with Celtic knot patterns. This shelter is a gathering place for forest events.

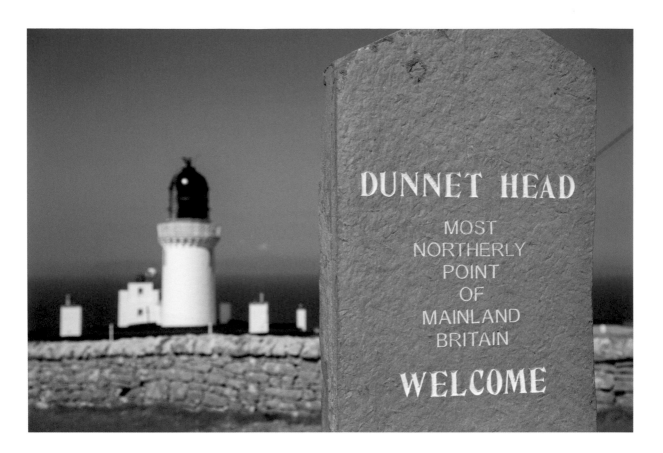

heads for the Castle of Mey, yet two possible detours – one around the peninsula of Dunnet Head and the other along the coast – beckon.

DETOUR: *Exploring Dunnet Head peninsula*

On this coast of all things most northerly, the B855 claims the title of most northerly B road in mainland Britain. The far-flung highway travels to the most northerly outpost of mainland Britain at Dunnet Head.

The lovely harbour at Brough is along the way. Brough township is scattered around the cove where local children have traditionally learned to swim. The attractive stone pier was built as a landing place to service the construction of Dunnet Head Lighthouse. The beacon became operational in 1831. On the shore, a restored salmon fishers' bothy hosts community gatherings and enjoys views to the Clett of Brough and Little Clett sea stacks in the bay.

The road snakes onward to Dunnet Head – famously further north than Moscow and Stavanger. Buildings are few. This modest headland quietly and deliberately shuns commercial development. Here, the

attractions are natural. There's no windsock but the strong ropes tethering the wooden cabin of the RSPB information point to the ground are an indication of the ferocity of the gales that rip around the peninsula. Spectacularly sheer cliffs rise 100 metres from the crashing sea. Guillemots, puffins, razorbills, fulmars and kittiwakes are among the noisy breeding seabirds that inhabit the rocky ledges. Though the lighthouse tower is not open to the public, the engine room is a seasonal gallery exhibiting the work of Caithness artists.

The tip of the most northerly point of the British mainland is an especially exhilarating experience on a calm sunny day. Jaw-dropping views are humbling. Vertiginous sea cliffs rise above the churning Pentland Firth. The Orkney Islands are clearly visible. However, do not explore this outpost in the cold sea mist known as 'haar' or in high winds and fog. Much of the cliff top is unfenced with a sheer drop below. The lighthouse beacon's four flashes every 30 seconds reassure seafarers in these murky and treacherous conditions.

The road to Dwarwick Pier offers the opportunity to visit Mary-Ann's Cottage. The whitewashed dwelling is a time capsule – as pretty as a picture-book illustration. Country flowers grow in the garden. A stack of cut and dried peats stands by the door. All is homely, as if Mary-Ann has just popped out to borrow a cup of sugar from a neighbour. In fact, Mary-Ann left her cottage in 1990 on her 93rd birthday. She settled into a nursing home where she lived until the eve of her 99th birthday. The Caithness Heritage Trust fulfilled her hope that the croft, built by her grandfather in the 1850s, might be shown to future generations. Her Majesty Queen Elizabeth the Queen Mother officially opened the cottage to the public in August 1993. She was Mary-Ann's royal neighbour at the Castle of Mey. The characterful cottage is open seasonally.

At sleepy Dwarwick pier, a picnic bench on a grassy knoll makes a lovely lunch spot with views to the golden swathe of Dunnet beach. A large slate set in the harbour wall commemorates a grand family holiday. In 1955 the Royal Yacht *Britannia* moored here. Her Majesty Queen Elizabeth and the Duke of Edinburgh came ashore with their children Prince Charles and Princess Anne. The family visited the Queen Mother at the Castle of Mey.

Dwarwick House or the House of the Northern Gate dominates

the hill. In 1952 the Queen Mother stayed here with friends. She became entranced by views of Barrogill Castle and acquired the deteriorating fortress. She reinstated the original name 'the Castle of Mey' and began a programme of restoration. Her beloved castle and gardens are open to the public seasonally.

From Dwarwick pier, a walk of 800 metres along cliff-top tracks reaches Peedie Sands, a romantic hideaway. The sheltered beach is exposed at low water only. From Dwarwick, there is a brief return to the A836 towards John o' Groats. Soon there is the opportunity of a further coastal detour.

DETOUR: *The great girnal and the small harbours*

The historic grain store in the small settlement of Ham is unmissable. The huge early18th-century building known as 'the great girnal' dominates the landscape. From here, the grain harvest produced on Caithness farms was exported to expanding cities throughout Britain and beyond.

Sadly, the extraordinary building is in terrible disrepair. The small harbour that served it at Wester Haven is in poor condition too. It is hard to imagine losing this magnificent agricultural architecture. Local people hope the great girnal might be revived as an arts centre to serve the wider community.

In the small community of Scarfskerry, homes and boats line up along the shore as if biding their time to jump into the sea. Tagged the furthest-north hamlet on mainland Britain, the settlement takes its name from the Old Norse words *scarf*, meaning 'cormorant', and *sker*, meaning 'sea rock'. A small rocky inlet is known as The Haven. A historic rowing boat ferry service crossed from here to Melsetter on the island of Hoy.

In 1818 William Daniell (1769–1837) made a series of artworks featuring castles along the Caithness coast as part of his Voyage around Great Britain project. The adventurous artist hired the small Scarfskerry open boat ferry to visit Orkney. The crossing of the Pentland Firth took three hours. His work was exhibited at the Royal Academy and the British Institution. Daniell became a Royal Academician in 1822. Much

of his coastal series is at the Tate Britain Gallery in London. However, his illustration of Scarfskerry is in the Carnegie Library in Wick.

Breeding waders visit the shallow Loch of Mey in summer. Observe them from the bird hide on the shore. Whooper swans and Greenland white-fronted geese are winter visitors.

From Harrow harbour, Caithness flagstone was exported to building projects around the world. A horse-drawn tramway transported the cargo to the shore. A small plaque on the harbour wall celebrates the restoration of the haven as part of a job creation scheme. In 1979, legendary guitarist Jimmy Page of Led Zeppelin performed the opening ceremony.

The minor road from Harrow continues along the shore to the Castle of Mey.

THE CASTLE OF MEY TO JOHN O' GROATS

The Castle of Mey is a famous link in the great chain of historic fortresses around the Caithness coast. Some are beautifully restored – others are not long for this world.

Following the death of her husband King George VI, the 16th-century castle became a retreat and a restoration project for Queen Elizabeth the Queen Mother. She visited often between October 1955 and October 2001. The romantic fortress and walled gardens are open to the public seasonally. Much of the interior remains furnished with her personal belongings.

From East Mey, a track over rough ground leads to St John's Point. Allow around an hour for a bracing walk to discover the rocky promontory. The seascape of the restless Pentland Firth is spectacular. Dramatic, vertiginous cliffs indicate the far north edge of mainland Britain. The Tower of the Men of Mey sea stack defies surging swell. The uninhabited pastoral island of Stroma is two kilometres offshore. The Orkney Islands are some 16 kilometres away. A little further west around the coast, the hideaway cove of Scotland's Haven is reached by a scramble down steep slopes. From Gills Bay a regular catamaran ferry service sails to St Margaret's Hope on South Ronaldsay. The village, known locally as The Hope, is the third largest settlement in Orkney after Kirkwall and

Stromness. The catamaran crossing of an hour is the quickest route by car to Orkney. The service is weather dependent.

The iconic fingerpost at John o' Groats displays distances to destinations worldwide. Few visitors resist the opportunity of a selfie. Many heroic fund-raising expeditions end here, having set off from Land's End in Cornwall, 1,407 kilometres away. The vast car park beside the small harbour often swarms with coach parties. The great throng comes as a shock after a journey through thinly populated landscape. I can't help but wonder what Jan de Groot would make of it all. The Dutchman established a ferry service to Orkney during the reign of James IV (1488–1513). Since then, the fortunes of John o' Groats have sometimes been as turbulent as the waters of the Pentland Firth. Rebranding has achieved renewed interest in the destination.

Many people come to John o' Groats to sail away. A 40-minute seasonal passenger ferry service lands at Burwick on South Ronaldsay. Wildlife cruises explore the coast. The Inn at John o' Groats was built in 1875. A makeover reveals Norse-style timber extensions in primary colours. Farm and coffee shops are new neighbours. A wildflower patch is planted to attract rare great yellow bumblebees. In eco lodges, guests enjoy glass walls with immense sea views.

Curiosity

The Pentland Firth

The Pentland Firth is a 27-kilometre tidal channel with some of the fastest and most dangerous currents in the world. Two tides a day funnel through the strait from the Atlantic Ocean to the North Sea and back again. The water travels at up to 12 knots. The surge creates powerful eddies, whirlpools and standing waves, even on a calm day.

Mariners describe the Pentland Firth as 'Hell's Mouth'. Perilous tidal races are known by name – the Merry Men of Mey, the Swilkie, the Duncansby Bore, the Bore of Huna and the Wells of Tuftalie.

Nomadic Boulders is a magnificent environmental art installation by Louise Scullion and Matthew Dalziel. The work references the powerful wave action of the Pentland Firth, which bowls mighty rocks around the seabed. Bronze ribs carry huge sandstone boulders as if ready to lob them. The ribs hint also at whalebones.

This tourist hotspot has many quirky aspects. During World War II, sand extracted from the dunes and

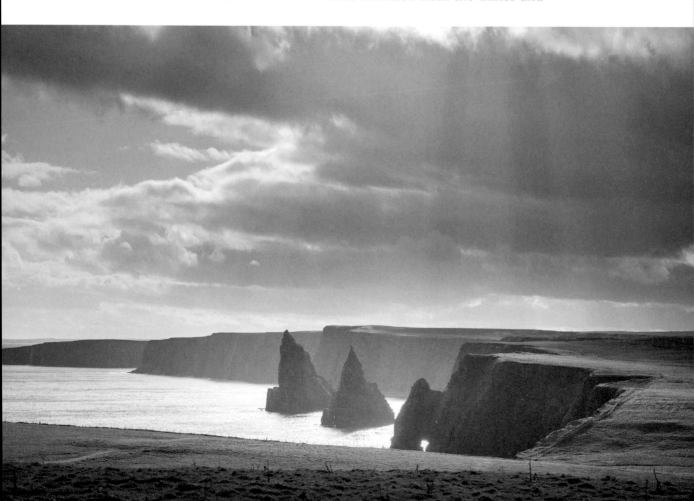

beaches of John o' Groats was distributed as a soil improver. The Dig for Victory campaign urged the nation to grow fruit and vegetables wherever possible. The local post office is the only place in the UK to issue the John o' Groats postmark. This is either hand franked or printed by a rare Krag franking machine, much admired by those in the know.

Jan de Groot is buried at Canisbay Church, where several graveyard sculptures are by Caithness farmer, archaeologist and artist John Nicholson (1858–1934). His work is celebrated in the Caithness Broch Centre, to be discovered a little further south on this route.

JOHN O' GROATS TO SINCLAIR'S BAY

From John o' Groats, a coastal footpath reaches the sandy shore of Sannick Bay. Here, a romantic mystery artist has been at work on a rocky reef. A line of Spanish verse by Chilean poet Pablo Neruda is carved beautifully in the rock. The verse comes from *Las Piedras del Cielo* or *The Stones of the Sky*, published in 1970. As if by magic, the beautiful verse and lettering is visible only for around an hour at low tide.

The A836 ends at John o' Groats and this journey continues on the A99. Soon, a minor road leads to Duncansby Head, where a stout lighthouse, built in 1924, alerts shipping to this treacherous coast. From the lighthouse car park, a coastal walk of around an hour discovers extraordinary scenery. The track crosses fields to visit the Geo of Sclaites, a long and foreboding gully with steep vertical sides. The route continues to the thrilling edge of sheer cliffs. Here, the extraordinary Stacks of Duncansby rise some 50 metres out of the sea like the snapping fangs of a submerged monster.

Seabirds reel on the wind. Their cries bounce off the rocks. Mighty swell rolls and smashes over the savage stacks. The scene is magnificent, but in high winds and low visibility this dangerous ravaged coast is to be avoided.

A curious artwork stands on the seashore

Beauty Spot

Skirza

The haven of Skirza on Freswick Bay is among my favourite Caithness places due to the sheer audacity of a teeny harbour at the end of a remote road off the A99. The very emptiness of it all is strangely atmospheric though, when the swell is right, Freswick Bay is a magnet for experienced surfers.

beside privately owned Freswick Castle. Landscape artist Roger Feldman has created a stone enclosure called *Ekko*. Inviting curves make this a place to enter and be still. The experience is that of being protected yet open to nature. Further south, around the bay, the spectacularly precarious remains of Bucholie Castle fight for survival on a high, narrow peninsula washed by engulfing waves. They are losing the battle.

Iron Age broch towers are uniquely Scottish. Around half of the country's 500 known broch sites are in Caithness. Discover the mystery of the circular drystone towers at Caithness Broch Centre in Auckengill. The museum hosts the collection of John Nicholson. The local farmer, artist and archaeologist was passionate about brochs. Nybster broch is signposted from the A99. A path through fields reaches the coastal site. Bizarrely, John Nicholson and landowner Sir Francis Tress Barry helped themselves to stones from the ancient building to construct their own monument, Mervyn's Tower, at the heart of the ruin. For good measure, they added some ugly sculptures. The tower was summarily repositioned away from the ancient site as part of a job creation scheme in the 1980s.

The curious zigzag form of the low pier on the shingle shore at Auckengill appeals to me much more than Mervyn's rehashed monstrosity. A mysterious contemporary artist has been at work. Low tide reveals incised runes on a rock slab below the cliff to the north of the harbour.

Old Keiss Castle is spectacular and precarious. Standing three storeys high, with an attic, the fortress teeters on Tang Head. In sunshine, the ruin casts long shadows on the shore. In 1755 a new neighbour replaced the 16th-century castle built by the Earl of Caithness. The striking and distinctly different pair of fortresses keep each other company in the relative isolation of Sinclair's Bay.

The A99 continues to the village of Keiss. Buildings around the harbour come as a surprise after all the lonely piers further north along the coast. There's something about Keiss harbour that feels as if it was built with love. Distinctive vertical stonework prevents the sea swell from raising and carrying off the stone, as it might if it were laid horizontally. Cobbles on the pier provide a sure grip. The imposing warehouse provided ample space to salt and barrel the herring catch alongside the store

Curiosity

The genius of James Bremner

James Bremner (1784–1856) was born in the seashore hamlet of Stain, just south of Keiss. Trained in the shipyards of Greenock, he became an acclaimed naval architect and a famous raiser of wrecked ships. Bremner rescued over 200 ships in his career, including the SS *Great Britain*. Between 1845 and 1854 the iron-hulled vessel, designed by Isambard Kingdom Brunel, was the largest passenger liner in the world. The ship made transatlantic voyages between Bristol and New York. When the mighty hulk ran aground at Dundrum Bay in Northern Ireland in 1847, ship raiser James Bremner went to the rescue. The SS *Great Britain* is now a visitor attraction at the Great Western Dockyard in Bristol.

Multi-talented Bremner also built harbours at Keiss, Portsoy, Sarclet and Castlehill. He engineered the breakwater at Wick, where he had shipyard. From Bremner's harbour at Keiss, a gentle coastal walk of 15 minutes reaches the old and new the castles of Keiss. The route passes the remains of two brochs and the wonderfully named Lobster Rocks on the shore below.

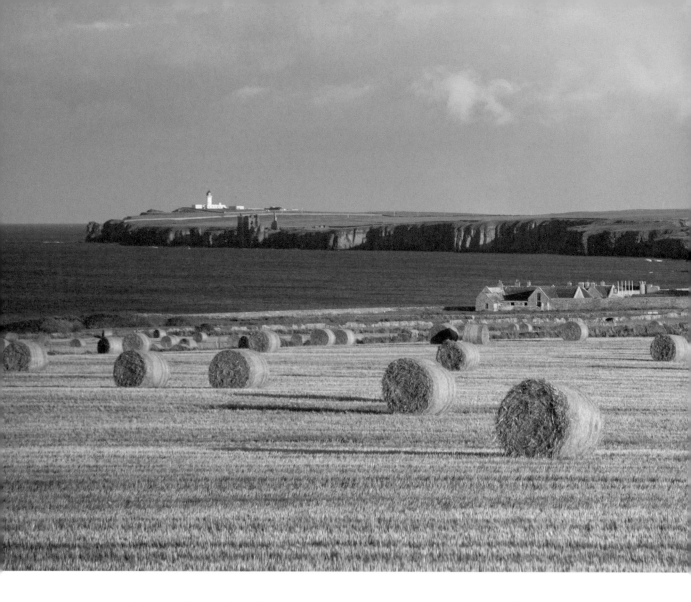

of nets and gear. Local man James Bremner was the architect of this haven for the herring and salmon fishers who were his friends.

The A99 sweeps around the curve of Sinclair's Bay yet it is impossible to appreciate the vast sands without visiting the shore. There are several gateways to the beach. A favourite is the lane to Wick Golf Club at Reiss. Established in 1870, the links course has spectacular views across Sinclair Bay to Noss Head and the Orkney Islands. The beach car park provides easy access and is popular with surfers. The immense crescent of sand, backed by grassy dunes, seems to stretch away forever and forever and forever. It is a wonderfully romantic place to see the Northern Lights.

Ackergill Tower Hotel stands at the south end of Sinclair's Bay. The

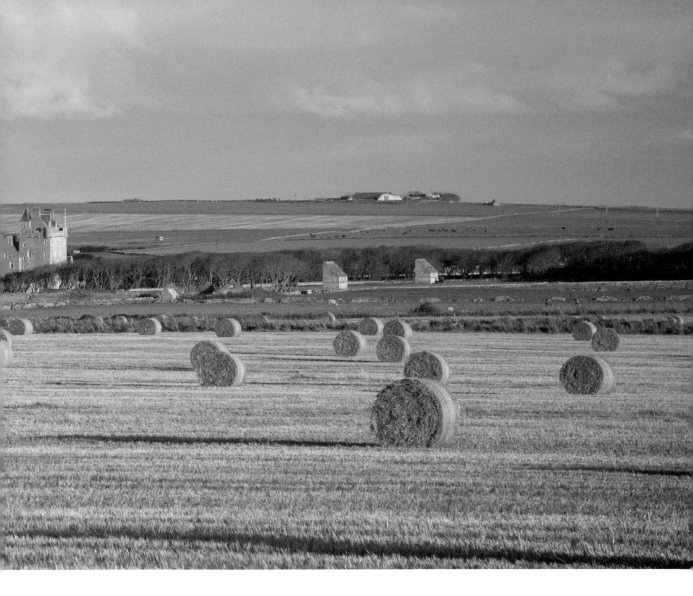

15th-century fairytale castle is the UK's most northerly Category A listed building, complete with a walled seashore garden and a tragic ghost.

Further south, the small harbour at Ackergill was traditionally a landing place for passengers and goods when poor weather prevented access to the harbour at Wick. The A99 passes Wick Airport and the Nucleus, which holds archives for the civil nuclear industry and for Caithness.

Next stop is the fascinating town known in the mid 19th century as Herringopolis – Wick.

STAGE EIGHT
Wick to Helmsdale

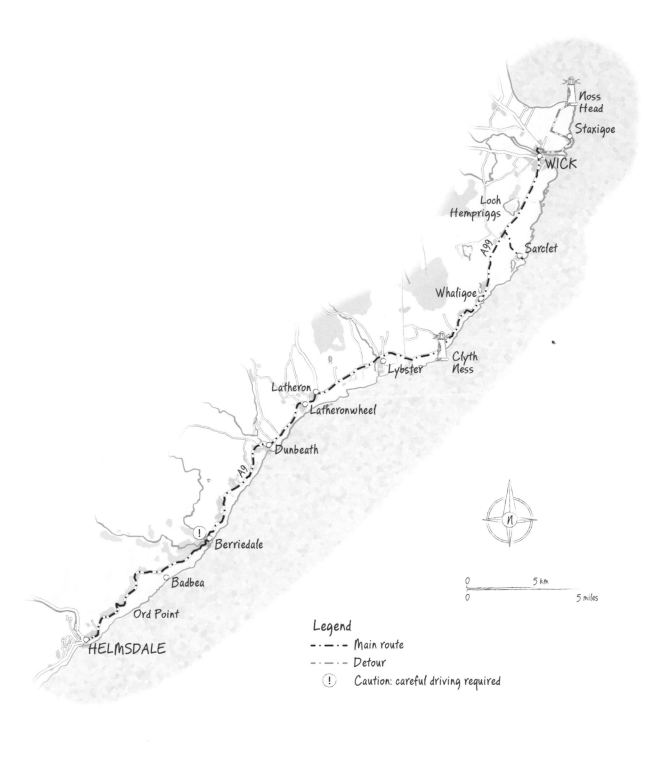

Noss
Head

Staxigoe

WICK

Loch
Hempriggs

A99

Sarclet

Whaligoe

Clyth
Ness

Lybster

Latheron

Latheronwheel

Dunbeath

A9

(!) Berriedale

Badbea

Ord Point

HELMSDALE

Legend
- ∙ — ∙ — Main route
- ∙ — ∙ — Detour
(!) Caution: careful driving required

0 5 km
0 5 miles

N

WICK – HERRINGOPOLIS

Wonderful Wick is full of surprises. Making time to stay a while and discover them properly is hugely rewarding. The name of the sea town comes from the Old Norse *vik* meaning 'bay' or 'inlet'. Vikings sailed their longboats to these shores between 800 and 1066. They established important trade links and settled locally. Tests by researchers at Living DNA and the University of Strathclyde reveal that Caithness men have the third highest percentage of Scandinavian ancestry in the UK. Shetland and Orkney are the front-runners. Wick was shaped by the economic and social impact of the Highland Clearances in the 19th century. Estate owners ousted tenant farmers from fertile land and replaced them with more lucrative sheep. Evicted families desperately sought new opportunities. Some drifted to poor and previously

undesirable land by the sea. Others emigrated or moved south. Many looked for work in developing industrial cities. The risk of depopulation across the Highlands was soon apparent.

The British Fisheries Society proposed purpose-built fishing villages to regenerate the Highland economy. The society's governor, Sir William Pulteney, backed Thomas Telford to deliver the scheme. The engineer won the commission and scoured the coast for sites with outstanding potential. Land on the south bank of the River Wick met his requirements. Telford named the area Pulteneytown in honour of his patron. Plans were laid in 1803. Telford's task was to develop the infrastructure for a fully operational self-sufficient fishing community within 20 years.

The mission was accomplished and Pulteneytown prospered. Wick invited a new community of professional fishers to purpose-built housing, a remodelled harbour and land set aside to gut, cure and pack herring in barrels.

The herring season peaked between late July and mid September. Fishing took place at night. During the day, the fleet remained in the harbour. Hundreds of women worked along the quayside. Nimbly and expertly they gutted and salted the catch. Herring deteriorates quickly and speed is of the essence. Barrels of the highly prized 'silver darlings' were distributed throughout Britain by train and shipped to Ireland, the West Indies, Germany, Russia and Eastern Europe. As Manchester became Cottonopolis, Wick became Herringopolis, the largest herring fishing port in Europe. By the 1860s over 1,000 boats sailed in daily pursuit of the seasonal shoals. The harbour was further expanded to cope with demand. However, failure to conserve fish stocks led to decline in the industry and a catastrophic dip in fortunes.

A stroll around historic Pulteneytown is fascinating. Streets are named after Telford and other luminaries involved in developing the planned community. Fishing boats are depicted in Caithness stone lintels above the doorways of neat terraced houses. Popular sayings in the local dialect – like 'A new broom can sweep clean . . . but 'e owld broom kens aal 'e coarners' – grace the walls.

Wick's wonderful volunteer-run Heritage Centre adds hugely to the experience of this friendly town. Be warned – delving into this treasure trove is not something to rush. Among the eclectic exhibits are full-size boats and anchors, an extraordinary photography collection, a

sequence of period room sets, an unusual wedding cake and a huge lighthouse lens. The great gathering of workers for the herring-fishing season is celebrated in words and images. An exhibition note reads, '1,500 lassies and men walked to Wick from the County of Sutherland. For some the journey was 130 miles and took 7 days to complete. They had no shelter and had to sleep in the open air.' The Heritage Centre's steeply terraced cottage garden enjoys views across the rooftops to the harbour heart of Herringopolis.

There's history at your feet on the pavements around the Heritage Centre. The names of historic local businesses are incised in Caithness flagstone. A horse illustrates the slab of James Wares, the town saddler in 1880.

Artist L.S. Lowry (1887–1976) took a holiday from Cottonopolis to paint the streets of Herringopolis. He depicted local people on the *Steps at Wick* in 1937. This steep staircase connects the residential area of Pulteneytown with the harbour below. The historic fishers' route to their boats and the sea is known locally as the Blackstairs. Many of the steps are engraved with local dialect fishing terms. They climb to Blackstairs Fish Shop where only fish landed locally by Scottish boats is sold. The staircase is also where Blackstairs Highland Wear makes and hires kilts and sells Highland dress accessories.

Fishy mosaics and rowing boats abound in Bank Row memorial garden at the foot of the Blackstairs. This is the site of the first daylight air raid of World War II on mainland Britain. Fifteen people died when two bombs were dropped on 1 July 1940. Eight children were among the victims. The memorial garden also honours a woman and two children who died when enemy aircraft dropped explosives on Hill Avenue.

The Pulteney distillery, built by Thomas Telford, is still in business. Old Pulteney maritime malt is renowned for its salty tang. However, production has not been continuous. In May 1922 the Temperance Society achieved prohibition and Wick was dry for 25 years. To many this comes as a surprise. Prohibition was more famously enforced in the United States for a much shorter period between 1920 and 1933.

Curiosity

The Johnston Collection of photography 1863–1975

Few towns have ever been brought to life in the way the Johnston Collection of photography reveals Wick. Over three generations, the family of professional photographers captured townspeople and visitors at work, at play and on ceremonial occasions. Between 1863 and 1975, the prolific dynasty made 100,000 plate glass negatives. Half of them survive. The Wick Society holds the extraordinary social record in trust. A selection of the evocative images is on display at the Heritage Centre.

Old Pulteney Distillery was mothballed in 1930 and reopened in 1951. Manager Malcolm Waring is poetic when he speaks of the creative process: 'Whisky is made with the senses. It's about sight and smell. It's about taste and feeling. It's not textbook. It's Caithness in a glass.' The unusual shape of Old Pulteney single malt bottles is inspired by the distillery's squat stills. The story goes that the copper vessels were too tall for the still house so, among other modifications, the tops were sliced off. See the quirky stills on a distillery tour.

Another of Wick's quirks is the shortest street in the world. Ebenezer Place measures 2.06 metres and its only doorway is for No. 1 Bistro at Mackays Hotel.

The Old Man of Wick Castle was constructed in the 1100s, when the kings of Norway held power in northern Scotland. Little of the stronghold remains yet the coastal location is spectacular. For centuries, the ruin has served mariners as a landmark. The fortress perches on a narrow promontory between two deep and daunting geos. The dramatic headland is a great picnic spot on a calm sunny day.

Wick's elegant Pilot House commands an impressive harbour view

from the south bank of the river. The landmark was built in 1908 to serve seafarers. Inside, there's a warm welcome and more local history. The cosy pavilion seats 10 people. This is a favourite place to meet local 'Wickers' over a cup of tea. The neighbouring monument was erected in 1803 by public subscription. The grey granite obelisk commemorates the genius of James Bremner, maritime architect and raiser of wrecked ships.

Wick's attractive former herring mart stands by fishermen's sheds on the quayside. Here, crews showed samples of their catch to curers and kipperers in the hope of securing a good sale.

A small art collection in Wick Town Hall is associated with local

Beauty Spot

The Trinkie

The Trinkie is a fantastic tidal swimming pool in the rocky foreshore near the Old Man of Wick Castle. In the local dialect, trinkie means 'trench'. A team of dedicated volunteers care for this giant saltwater bath, removing litter, refreshing paintwork and scraping away slippery seaweed with garden hoes. On bright summer days, a bracing swim followed by a picnic flask of reviving hot soup is great fun. The town boasts a further tidal pool at Blackrock shore on the north bank of the River Wick.

maritime history. Look out for portraits of Thomas Telford and James Bremner. St Fergus Gallery stages local and touring art exhibitions. The venue is named after the town's patron saint. Discover rich maritime connections and artwork in St Fergus Church. A favourite stained glass window donated by the local grocer portrays St Peter, the fisherman.

Before leaving Wick on the A99 south, consider a detour to the castle, lighthouse and fishing inlets of Noss Head.

DETOUR: *Staxigoe harbour, Noss Head Lighthouse and Castle Sinclair Girnigoe*

Prior to the development of Wick harbour and Pulteneytown, a much smaller herring fleet fished from Staxigoe harbour. The historic barometer and weather vane that helped crews decide whether or not to set sail in the challenging North Sea remains in situ on the quayside.

The white tower of Noss Head Lighthouse rises starkly above the flat landscape. The beacon has been in service since 1849 and, although closed to the public, scenic headland walks around it are especially popular with bird and sea watchers. Upright stone flags, traditionally used as field boundaries in Caithness, enclose a picnic site at the nearby car park. From here, a way-marked path crosses summer fields of wild flowers and ground-nesting birds. To protect both, dogs must be kept on leads. The track reaches a mismatched pair of ruins at the fortress of Castle Sinclair Girnigoe. Though this thrilling cliff-top location is just a 10-minute walk from the car park, precarious uneven ground with steep drops to the sea demands suitably sturdy footwear for safety. The site is open to visitors between May and September. At sunset on a warm evening, this romantic spot is spellbinding.

TOWARDS SARCLET HAVEN AND WHALIGOE STEPS

Leaving Wick, the A99 passes Loch Hempriggs. Here, Thomas Telford engineered the ingenious mill lade or channel to carry fresh water to the corn mill, brewery, distillery and harbour at Pulteneytown. The

lade, lined with Caithness stone, is still in use and is easily visible on a tour of Pulteney Distillery.

A minor road off the A99 reaches sleepy Sarclet. Peering from the cliff top to the shore, it is difficult to imagine the throng of boats and industry that made this one of the most important 19th-century herring fishing stations. Little evidence remains, and seals have reclaimed Sarclet Bay.

The Yarrows Archaeological Trail discovers Caithness prehistory. The way-marked circular walk of four kilometres requires around two hours. However, several sites are within easy reach and can be visited in less time. There is much to chose from – a broch, a standing stone, a cairn, hut circles and a round house. Suitable footwear is advised for this moorland site.

The largely flat landscape of Caithness is strikingly different to the mountain scenery of the west coast, where fishing communities grew around sea lochs. Access from the Caithness cliff-tops to east-coast fishing grounds was more challenging, often requiring daredevil ingenuity. The harbour at Whaligoe Steps is an unforgettable example of that.

When scoping potential locations for east-coast harbours, Thomas Telford refused to consider Whaligoe Steps. The engineer pronounced it a dreadful place. And, indeed, it is pretty scary. Whaligoe Steps is to harbours what the Bealach na Ba is to hill roads.

The deep narrow inlet is a dramatic amphitheatre. The cry of seabirds bounces off the cliff face and carries on the wind. Perilously steep steps zigzag down and down to the surging North Sea. The scene is reminiscent of M.C. Escher's surreal artwork. One can only imagine the supreme fitness and death-defying agility of the fisherwomen who climbed more than 300 steps with weighty nets and baskets of herring.

The catch was cured with salt and packed in barrels produced by the cliff-top cooperage. Bound for export, the preserved fishy cargo was loaded on to schooners from a platform at the bottom of the steps. Unable to sail into the narrow geo, or inlet, the receiving ships were held fast on the waves by ropes lashed to iron fixings in the cliff.

Beauty Spot

The Bink

A visit to Whaligoe Steps requires wearing sensible footwear. The steep staircase is without a guardrail. The perilous steps can be slippery in all weathers and they are not suitable for young children or dogs.

A platform at the bottom of the steps is known as 'the Bink'. Take a picnic lunch and blanket to enjoy this extraordinary spot but, if you have vertigo, don't even think about it. There's a great seasonal cafe at the top.

MYSTERIOUS PREHISTORIC SITES
ON THE WAY TO LYBSTER

The A99 leaves Whaligoe Steps and travels south through a series of extraordinary prehistory sites. The first is the Cairn o' Get, a Neolithic chamber some 5,000 years old. The site is signposted from the main road, and a trail of black-and-white posts leads from the car park over rough ground to the burial place. Allow round 10 minutes for the time-travelling walk.

The Hill of Many Stanes is a Caithness mystery. At this ancient site, 22 rows of 200 stones stud a sloping hill. The tallest 'stane' or stone is around a metre high. This weird arrangement may be some 4,000 years old. The eerie massed ranks are associated perhaps with ritual and solar or lunar cycles. Whatever their purpose, the stanes are not telling.

The red-and-white striped tower of redundant Clyth Ness Lighthouse peeps into view as the A99 continues south along the coast towards the Grey Cairns of Camster. The astonishing cairns are yet more examples of weirdly wonderful Caithness expressed in stone. An unrelentingly straight minor road across a bleak moor reaches the ancient site. The landscape feels lonely until the pair of immense grey mounds appears

on the scene like misguided whales beached on peat. The cairns are of Neolithic origin though they have been reconstructed in modern times. A dark, narrow passageway invites visitors to crawl through time into the sacred burial chamber of ancient ancestors. Whatever your belief, the experience is extraordinary.

LYBSTER TO DUNBEATH

Lybster village is reached from a curiously named crossroads on the A99. The intersection of Quatre Bras remembers a battle in Belgium on 16 June 1815, two days before the epic Battle of Waterloo. Scottish Highland regiments were among the Allied forces involved in the strategic Battle of Quatre Bras south of Brussels. Their determined efforts prevented Napoleon's army advancing further north. The road into Lybster village is as wide as a Parisian

Curiosity

The Coffee Pot and the ticket office

When the route of the Lybster and Wick Light Railway crossed Lybster golf course in 1903, the club decided to relocate. The new rural line served east-coast fishing ports and a steam engine, known fondly as 'the Coffee Pot', became a popular sight. But, to the alarm of residents, sparks carried on the wind and ignited thatched roofs. Slate replacements were swiftly installed. In 1926, the golf club returned to the site of the original nine-hole course bisected by the railway. The railway closed to passengers in 1944 and, in 1970, the station buildings became the clubhouse. In celebration of its railway links, the Lybster Golf Club's quirky emblem is the Coffee Pot steam engine.

boulevard yet it narrows and twists steeply down to the harbour. Lybster was the third largest herring port in Scotland after Wick and Fraserburgh. The imposing haven that once accommodated the great fleet now serves a handful of boats landing crab and lobster.

Waterlines Heritage Centre is in a restored quayside warehouse. Visit to discover the history of the herring boom, a boat-building exhibition and the curious local game of knotty, a variation of the sport of shinty. Remote-controlled cameras broadcast seabird activity on the cliff, and the plain and simple fresh crab rolls in the cafe are legendary.

A path climbs steeply from the harbour to Swiney Hill viewpoint. The dramatic ruin of 13th-century Forse Castle can be seen three kilometres to the south.

Artist Jenny Mackenzie Ross creates intriguing ceramic sculptures and attractive studio pottery inspired by the Caithness landscape. Her Northshore workshop and exhibition space are in a lovingly restored oatmeal mill beside the A99.

Almost opposite the pottery, across the A99, a gatehouse stands sentinel at the end of the long driveway to Forse House. The country mansion was built in 1753. Discover Forse of Nature arts and crafts workshops, a walled garden, a cafe and accommodation too. Walks and cycle trails explore Rumster Forest. Brochs, cairns and standing stones are scattered throughout the wider surrounding landscape.

The A99 reaches the ends of its journey and the A9 takes over just before Latheron. Here, the village's former church houses the Clan Gunn Heritage Centre and Museum. A little further south, Dunbeath is the birthplace of one of the clan's famous sons. Author Neil M. Gunn (1891–1973) is among the most influential Scottish writers of the early 20th century. But first there's Latheronwheel harbour to discover. The sleepy haven is especially lovely on calm days out of season. The lulling sound of the sea shifting the shingle shore is deeply hypnotic and restful.

Laidhay Croft Museum celebrates traditional rural life in a long, low 200-year-old farm building. The impressive rush thatch roof is renowned. Among the exhibits is a traditional Caithness chair designed with a low seat to avoid peat smoke from the fire. The chairs were often made of driftwood and a small rail to the front was perfect for drying wet socks. In an adjacent building, the Laidhay Tearoom serves home baking.

In fields at Tormore, beside the A9, the gable end of a distictive whitewashed farmhouse supports ivy clipped to form a romantic green heart from the ground to the roof. Home is where the heart is.

The road to Dunbeath sweeps underneath the A9 flyover. Discover Dunbeath Heritage Centre in the former village school. Here a permanent exhibition celebrates the work of Neil Gunn. The writer's father was a skipper and his mother was a domestic servant. The countryside of Dunbeath Strath was his boyhood playground. Among places that made the greatest impression on him was Dunbeath broch, situated on a wooded promontory at the confluence of Dunbeath Water and the Houstry Burn. A riverside path from the village visits the Iron Age site. When young Gunn summoned his courage to enter the darkness

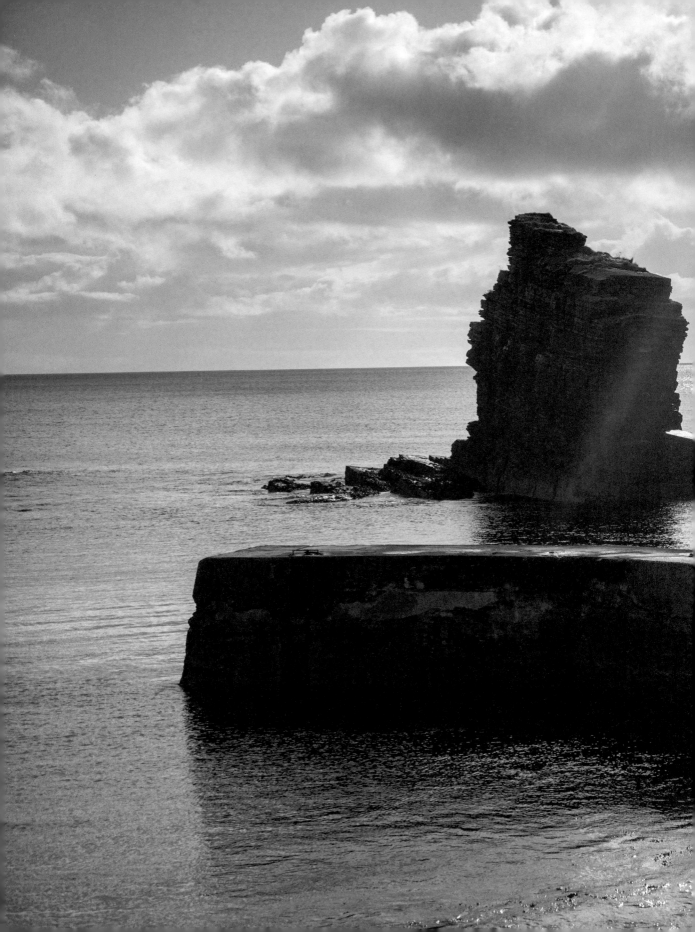

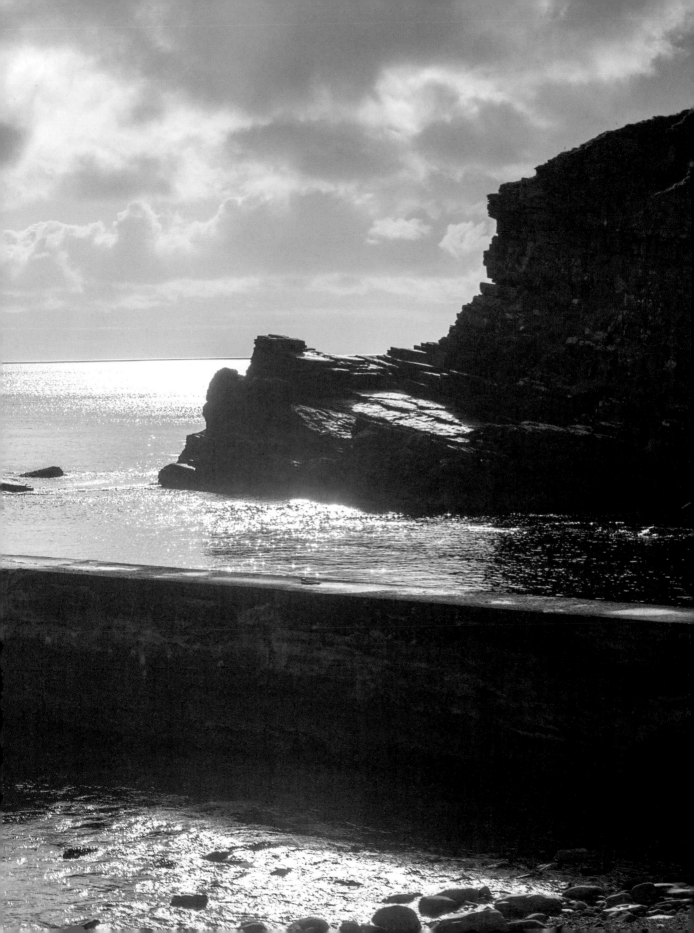

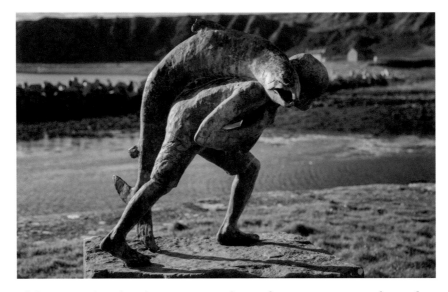

of the inner chamber, he experienced a tingling connection with another world and time beyond his comprehension. The powerful sense of journeying stayed with him and influenced his writing deeply.

Gunn's novel *Highland River* (1937) opens with a famous scene in Scottish literature. Nine-year-old Kenn is woken early one morning by his mother. She sends him to fetch fresh water. As the boy sets off reluctantly, he little imagines the extraordinary encounter ahead. Peering into the river, he sees a living salmon for the first time in his life. Kenn decides to conquer the creature and a frantic battle ensues. Celtic lore attributes the king of fish with extraordinary knowledge. The boy is ultimately victorious yet the respect he learns is immense. The novel traces Kenn's journey to adulthood and his experience of surviving World War I. His ultimate quest for peace and better understanding of himself is mirrored by his search for the source of the Highland river where he discovered the salmon.

Dunbeath Castle looms starkly on a cliff edge. The late 17th-century building surveys the North Sea with commanding views of the harbour too. The castle is privately owned. Sheltered gardens within the high walls open to the public one day a year.

Beauty Spot

Beside the Water of Dunbeath

A magnificent bronze sculpture by Alex Main stands beside the fishers' storehouse at Dunbeath harbour. The artwork commemorates the centenary of author Neil Gunn's birth. Skinny Kenn and the huge weighty salmon of knowledge are beautifully observed. To read the opening pages of *Highland River* in the exact spot envisaged by Gunn is a very special experience.

TOWARDS BERRIEDALE, BADBEA
AND ORD POINT

From Dunbeath, the A9 snakes into Berriedale. A local road reaches the wooded estate of privately owned Langwell House. The gardens are open to the public once a year. The surrounding estate buildings host small businesses. Jewellery maker Patricia Niemann is at the Old Post Office House. The River Bothy is a friendly tearoom and deli. From the bothy, it is a short walk to the shore where the Langwell Water and Berriedale Water meet the North Sea. A springy pedestrian suspension bridge leads to a romantic row of fishers' cottages sympathetically restored by the Landmark Trust. The herring fishing station later became a salmon fishing station, sending the catch to London. On the cliff top above, a pair of follies, known as 'the Duke's Candlesticks', guide boats to the harbour.

The A9 climbs out of Berriedale to the bleak heights of Badbea clearance village. The deserted township is accessed easily from a lay-by on the carriageway travelling south. A short path leads to the imposing Cairn of Remembrance erected in 1911 by David Sutherland of New Zealand. His father, Alexander Sutherland, was born in Badbea in 1806 and emigrated to New Zealand in 1839. The weathered remains of the township built by Clearance families are overgrown with gorse and bracken.

Views to the Moray Firth are magnificent, yet this is an inhospitable hill. Fierce wind spits salt and cold sea mists and fog disorientate. Badbea was not a welcoming place to put down new roots. The people lived in fear of losing their children and animals over the cliff. Both had to be tethered. Ultimately, most of the community abandoned Scotland. Many emigrated to New Zealand.

On the granite heights of Ord Point, the counties of Caithness and Sutherland meet once more along a boundary line. A curious flat-topped landscape feature jutting into the sea is known locally as the Green Table. Through the centuries, unfortunate souls have lost their lives in fearsome incidents, raging storms and deep snowdrifts on rough tracks across the Ord. The arrival of the smooth A9 carriageway has changed all of that, though it is still best to cross with care! The onward journey to Helmsdale continues in Sutherland.

STAGE NINE

Helmsdale to the Black Isle

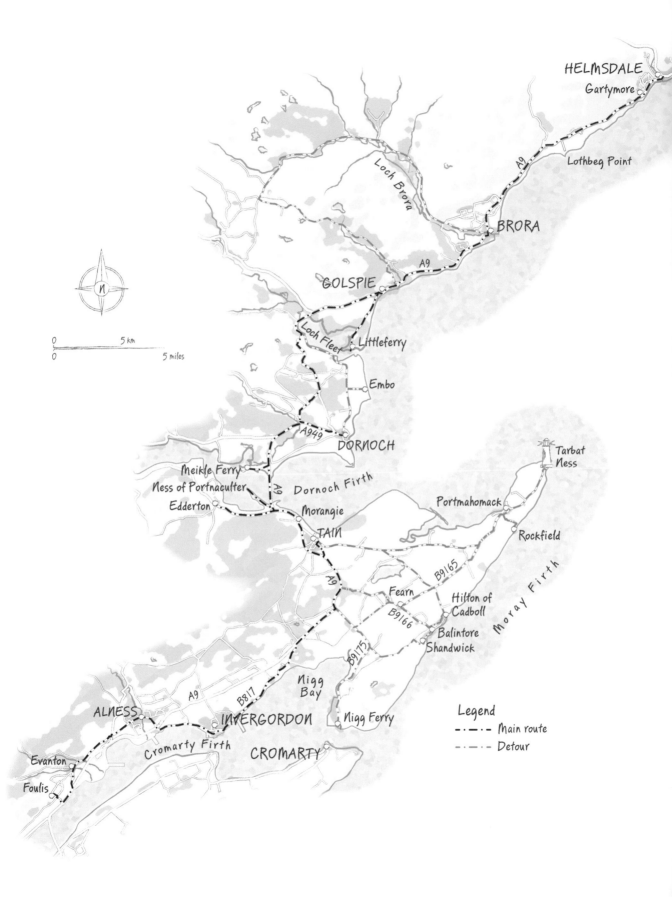

AROUND HELMSDALE

Crossing the Ord Burn that marks the county boundary between Caithness and Sutherland, the A9 descends to the shelter of Helmsdale. The coastal village was built to accommodate crofting families ousted from straths inland. It is thought around 15,000 people were cleared from the 1st Duke of Sutherland's estates in the 19th century. In 1816 the duke's land factor Patrick Sellar was accused of burning a croft in Strathnaver while an elderly woman was inside. He faced trial for arson and culpable homicide. Sellar was acquitted but left his post as the duke's factor.

At Helmsdale shore, *The Emigrants* statue portrays a Clearance family leaving Scotland. A father and son look to sea. A mother cradles her baby and turns to look back at the glen. Canadian businessman Dennis Macleod commissioned Gerald Laing's poignant artwork. A twin statue known as *The Exiles* stands on the shore of the Red River in Winnipeg, Canada. The plinth is inscribed with 'Selkirk Settlers 1813'. Thomas Douglas, the 5th Earl of Selkirk, bought land in Canada as part of a colonising scheme. His prospectus invited immigrants to populate land where Metis communities lived and worked as fur traders, free traders and buffalo hunters.

In Helmsdale, new land agreements are creating historic change. In 2017 the local community secured funds to accept an offer of first refusal on 3,000 acres on the Sutherland estate. The opportunity was backed by private finance from the Scottish Land Fund, which supports communities to become more resilient and sustainable through the ownership and management of land and land assets.

Timespan Museum and Arts Centre celebrates Helmsdale landscape, history and community. The museum cafe has outdoor seating on the riverbank. Here you may catch sight of the local otter. Large rock specimens in the Timespan geology garden have a combined age of around 16 million years.

Thomas Telford's bridge spans the river known by two names – the Helmsdale and the Ullie. Confusingly, the river valley is known as

Strath Ullie rather than Strath Helmsdale. A further twist is that Strath Ullie is also known as Strath of Kildonan.

Helmsdale's war memorial clock marks time on the south bank of the river. The elegant 1924 tower serves as a landmark for fishing vessels. In the still of the day or night, the chime of the Westminster quarters is sweetly haunting. The melody, inspired by Handel's *Messiah*, was made popular by Big Ben in the Elizabeth Tower (formerly the Clock Tower) of the Houses of Parliament in London. A 19th-century ice house is built into the hill below Helmsdale's handsome time-keeper. Here fishers chilled salmon on slabs of ice hacked from frozen ponds. In mild winters, ice was imported from Norway.

The river flowing through the village is still renowned for Atlantic salmon. Along the banks are picnic benches and walks into the strath. The railway line runs close to livestock in pastureland and the need for good fencing is apparent. Passenger safety and the suffering of animals straying on to the line are local concerns.

Upstream a small sign at Baile an Or remembers a big event in 1868. When a local man returned from gold prospecting in Australia, he was astonished to find flecks of the precious metal in the river at home. News of his discovery prompted a Highland gold rush. Hopeful prospectors worked from shanty sheds and a temporary tented community of around 500 sprang up along the banks of the Suisgill Burn. The extraordinary township on the Duke of Sutherland's estate became known as Baile an Or which means 'Village of Gold'. The Duke introduced regulations, including licences and a 10 per cent Crown levy on all gold finds. By January 1870 the stampede was over. Huts were burned and the site was cleared.

Gold panning has been reintroduced on restricted sections of the river and visitors are welcome to try their hand. A permit is required and only approved equipment may be used in order to protect the

Curiosity

Helmsdale station

The Far North Line is wonderfully scenic and Helmsdale station is an important community asset. The vision and tender loving care of volunteers from the village and beyond have transformed what was a declining listed building into an atmospheric destination.

The former station house is available to let as a holiday home. The old waiting room is now a bedroom. Any surplus funds earned from the venture are redistributed among charities and good causes in the area. The award-winning station operates a cycle hire partnership. Folding bikes are available for easy onward train travel. An attractive signal box is unusually situated on the platform. The station's photographic dark room is used by university art students and is available to hire by the public. Visit the original first-class waiting room for information about the historic 1871 building and a self-service book exchange.

natural landscape. The Timespan Museum and Arts Centre in Helms-dale issues all the necessary documents and provides essential infor-mation. The museum also has approved gold-panning kits for hire.

GARTYMORE CROFTING TOWNSHIP TO BRORA

At Gartymore, a monument cairn, erected in 1981, marks the centenary of the founding of the inaugural branch of the Highland Land League. The league campaigned to prevent further estate clearances of tenant farmers and secured the Crofting Act of 1886. The historic act estab-lished the Crofting Commission and defined a crofting parish and crofter. The inscription on the plaque reads:

> IN MEMORY OF THE HIGHLAND
> HEROES OF THE LAND LEAGUE
> "They laid the foundations
> that we might build thereon"
> Gartymore 1881–1981

From Helmsdale, the A9 travels south enjoying fantastic sea views and closely accompanied by the Far North Line. Together they pass the sands of Portgower and the striking architecture of the Gothic church at Lothmore, built in 1822. The design was inspired by Kintore Church in Aberdeenshire at the request of the Duchess of Sutherland. Sadly, the elegant and redundant building is now at risk of ruin.

At Crakaig, there is a designated naturist beach on the shore to the west of Lothbeg Point. The nearby campsite hosts occasional naturist events. Cycling and walking trails discover peaceful Glen Loth with scenic views over the Helmsdale River.

The name Brora is synonymous with a luxury cashmere company, the Clynelish distillery, a historic golf course laid out by James Braid in 1891 and Brora Rangers Football Club. The part-time professional team is known as 'the Cattachs', a traditional name for people from Sutherland. The village's intriguing industrial history is discovered at Brora Heritage Centre and on a self-guided walking tour of around an hour.

In the early 19th century, the Duke of Sutherland invested heavily in Brora's developing industry. Few traces remain. Many sites have been landscaped since closure. The most northerly coalfield in the UK is at Brora. Mining began in the late 16th century and the deep pit was over 400 years old when it closed in the 1970s. Colliery buildings were demolished in 1987. Brora brickworks also closed in the 1970s. The clay pit became a recreation ground. During the Cold War, the government operated a secret military listening post in the village. The service closed in 1986.

Curiosity

The wolf, the hen and the duke

Victor Cavendish-Bentinck, the 9th Duke of Portland (1897–1990), occasionally marked curious sites with memorial stones. A stone he erected in 1924 stands beside the A9 near Lothbeg. Here the last wolf of Sutherland allegedly met its demise at the hands of a hunter called Polson in 1700. According to legend, Polson was hunting with his son and his son's friend. Upon discovery of a lair, Polson instructed the young men to dispatch the cubs in the absence of the she wolf. He hid in the cave awaiting her return. As she entered the den, Polson grabbed her by the tail and killed her.

The extermination of wolves in Britain was caused by deforestation and by wolf hunts. Often there was a bounty on the head of each animal destroyed. The possible reintroduction of wolves is a hot topic in the Highlands.

Another of the duke's marker stones is at the Grey Hen's Well, where the villagers of Badbea drew fresh water. Stories abound as to the identity of the grey hen – she may have been a bird, she may have been a woman.

Frank Stapleton acquired Hunter's of Brora woollen mill in 1990. Economic downturn caused the historic business to close 18 months later. However, Frank's daughter, Victoria, was inspired by her work there and went on to found a mail order Scottish cashmere and tweed business. She named the company Brora.

Beauty Spot

Brora shore

The Brora shore offers gentle coastal walking and lovely picnic spots with huge sea views. From the public car park on the east bank of the River Brora, there are walks along the vast sands to Dalchalm. Brora Fishermen's Hall is on the south bank of the river. Here locals laid out a five-hole golf course. They named it 'the other Gleneagles'. Unlike its prestigious neighbour, the roughly fashioned course was free to play.

Coastal erosion has ravaged Brora's shoreline saltpans. The historic industry began in 1598 and developed through the centuries. Briny seawater was boiled in pans over fires made with local coal. The evaporating liquid produced valuable salty residue. Waste from the fires was cast on the shore. Traces of the industry remain faintly visible in the dunes.

Discover magnificent views and curious seals on an exhilarating seashore ramble of 11 kilometres between Brora and Golspie. Explore Carn Liath broch along the way. Many walkers carefully time their trip to return to Brora by train or bus.

Before leaving Brora, it is tempting to stop for a hedonistic retro and vintage fix at Pandora's Emporium. Lesley Graham expertly curates clothing and accessories collections. Her stylish shop window is a work of art.

DETOUR: *A circular tour inland*

An especially lovely circular tour travels quiet roads alongside the River Brora. The route discovers inland beaches at Loch Brora and the distinctive hill of Carroll Rock. In Strath Brora, the turbines of Kilbraur wind farm spike the skyline. Electricity generated by the rotating blades powers around 27,000 homes.

The return to Brora by road is through Dunrobin Glen. Alternatively, many cyclists take the train from Golspie station.

Curiosity

The Mannie on the Hill

A gargantuan statue of George Granville Leveson-Gower, 1st Duke of Sutherland, dominates Beinn a Bhragaidh, or Ben Bhraggie, hill at Golspie. The Mannie, as it is known by locals, stands 30 metres high. He dwarfs mere mortals. The astonishing monument was sculpted by Sir Francis Chantrey and erected in 1837, four years after the death of the duke. Though funded by subscription from the duke's tenants, attempts have since been made to dynamite it. The colossus is tainted by the duke's role in the Highland Clearances. Local opinion is divided. Some want rid of the monument. Others regard it as a reminder of wounds to be healed.

A further gargantuan statue of the first Duke of Sutherland towers above the treetops of his Trentham Estate in Staffordshire. This too was funded by subscription.

TOWARDS GOLSPIE AND LOCH FLEET

The broch tower of Carn Liath is an unusual Iron Age site with evidence of a village around it. To visit by car, stop at the parking place on the inland side of the A9 then walk in the opposite direction of the broch to reach the safest place to cross the busy highway.

At the gateway of Golspie, the waters of the Big Burn power one of the last waterwheel mills in Scotland. Golspie Mill returned to service in 1992 after extensive restoration. The grindstones produce award-winning flours and meals. A Golspie speciality is peasemeal. The nutritious flour, made from roasted yellow field peas, has been used since Roman times. Produce from Golspie Mill is available online by mail order and through stockists.

Golspie Drill Hall was built in 1892. No longer in service, the distinctive timber building has a corrugated iron roof topped by a flamboyant pagoda. Inside, a small armoury provided safe storage of guns.

The Golspie Inn was established in 1808. The magnificent monkey-

Beauty Spot

The Big Burn

Allow an hour or so to discover the Big Burn that powers Golspie Mill. A three-kilometre walk explores a deeply wooded gorge where wooden bridges span waterfalls. The cascades are especially powerful after rain. The ground can be slippery underfoot. Walking boots are recommended.

The way-marked path leads to a peaceful skating pond. Woodland reflections make this a popular picnic spot.

puzzle tree beside it is a local landmark. The 1861 post box in the wall of the hostelry is the oldest in Scotland.

While the Mannie on the Hill is a reminder of the 1st Duke of Sutherland, the fountain of Fountain Road commemorates the 1st Duchess. Charles Barry, architect of the Houses of Parliament, designed the elaborate monument.

In 1845 Barry was invited to remodel Dunrobin Castle. The transformation was extraordinary. What emerged would not look out of place among the chateaux of the Loire Valley. The gardens of the Palace of Versailles inspired the immaculate and unexpected seashore parterre. During World War I, the castle

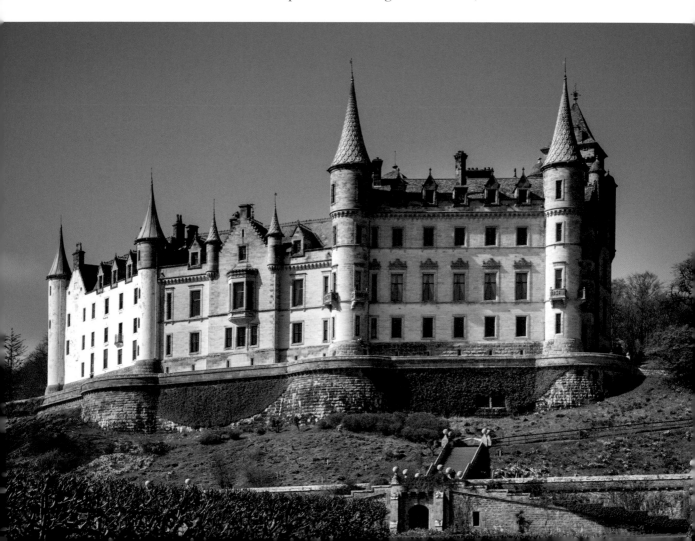

served as a naval hospital. In 1915 a fire ripped through the interior and sailors from Royal Navy vessels moored offshore came to the rescue of their colleagues. Their action prevented the inferno destroying the building entirely.

In 1965 the castle became a very grand boarding school. It offered outdoor pursuits and promised to be 'character-building'. Pupils lived and learned among opulent furnishings. Lessons were conducted amid tiger skins, silk tapestries and the heads of beasts shot on safari. This extraordinary education came to an end with the economic downturn of the 1970s. Dunrobin Castle welcomes visitors and it is no mean feat to see it all on one visit. The range of buildings is fascinating.

The 3rd Duke of Sutherland built a private railway from Dunrobin to Helmsdale. His pretty station house is in the English Arts and Crafts style. Trains on the Far North Line stop at the station and the service is increased in summer.

A museum within the castle grounds houses an extraordinary collection. African artefacts mingle with local Pictish stones and exotic hunting trophies. For animal lovers, the safari souvenirs can be hard to stomach. Hundreds of endangered species hang from the walls with frozen stares. The floor standing head and neck of a giraffe is especially disconcerting. The creature's lifeless eyes are haunting. Falconry displays in the grounds are informative and impressive. Woodland paths from the castle grounds lead to the statue of the 1st Duke of Sutherland. The castle tearoom provides sustenance for the expedition. On the hills, over 18 kilometres of Highland Wildcat mountain bike trails has been constructed and is managed by the local community.

The North of Scotland Kart Club track is in pinewoods by Loch Fleet. Racing takes place between March and October. Golspie Golf Club is nearby. The course, designed by James Braid, offers a combination of heath-land, woodland, parkland and links golf.

Off the A9, a long lane leads through Balblair Wood to the peaceful shore at Littleferry. This was the site of an important battle on 15 April 1746, the day before the Battle of Culloden. Scottish forces from the MacKay and Sutherland Clans, loyal to the British government, defeated Scottish forces from the Mackenzie, Mackinnon and Gregor Clans supporting the Jacobite rebellion. Many lives were lost in the waters of Loch Fleet as combatants attempted to swim to safety.

The National Nature Reserve around Loch Fleet's tidal basin offers the opportunity to observe fishing ospreys, playful otters and grey and common seals hauled out on sandbanks. The coastal mudflats and saline lagoons also attract breeding wetland birds. Strong currents caused many ferry tragedies. In 1816 the opening of an earth embankment designed by Thomas Telford provided a safer route. The Mound connects to a stone bridge with self-regulating sluice gates. Briny water is prevented from flowing upstream while the freshwater of the River Fleet enters the sea as the tide recedes. Protected alderwoods thrive in the trapped silt.

DETOUR: *To Coul Links and Embo*

A web of minor roads explores the shore of Loch Fleet north of Dornoch. Alternatively, the A949 reaches the county town of Sutherland directly from the A9. Coul Links is part of an area designated as a Site of Special Scientific Interest (SSSI). It is noted for wild beauty and a rare fly, *Botanophila fonsecai*, unique to the area. The vast sands of Embo are twinned with Kaunakakai in Maui County, Hawaii. Starfish and jellyfish frequent the beach. Marine Conservation Society advice is not to touch any stranded creatures with bare hands. Beware of stinging tentacles and keep your face well clear. Seek medical advice if stung. Embo's friendly community shop serves the seashore village and holidaymakers at Grannie's Heilan Hame Holiday Park. Locally grown seasonal vegetables are often available but sadly not hula skirts – there's not much call for them. There is, however, much tropical colour in Embo's glorious sunrise skies.

DORNOCH

Dornoch lives and breathes golf. The Royal Dornoch Golf Club is situated spectacularly on the curving golden shore of the Moray Firth. International golfers make pilgrimages to experience the Championship Course and the Struie Course, which originally opened for ladies only in 1899.

The town's grassy rural airfield is beside the beach. Walkers and dogs can be taken by surprise when a plane performs a safe low pass to make its presence known before completing the circuit to land. Dornoch's impressive former courthouse has been renamed the Carnegie Courthouse after Andrew and Louise Carnegie. Scottish-American Andrew Carnegie (1835–1919) was a steel industry magnate with a passion for philanthropy. In 1898 the industrialist acquired Skibo estate and castle and commissioned a multi-million-pound refurbishment. Among the guests who came to stay at the grand pile were Woodrow Wilson, Helen Keller, Rudyard Kipling and Herbert Asquith. Skibo Castle is now the exclusive members-only Carnegie Club.

When Andrew Carnegie retired at the age of 66 in 1901, he was the world's richest man. As a believer in the 'Gospel of wealth', he had no doubt that prosperous people in society were morally obligated to combat inequality. By 1911 the philanthropist had given away 90 per cent of the fortune made by his workers and investments.

The Carnegie Courthouse is a vibrant hub. Artist Sandy Noble has created a magnificent mural in the elegant cafe. Everyone in the imaginary courtroom crowd of 62 people enjoys a connection with Dornoch. Many are famous faces. The Carnegie Courthouse is a wonderful opportunity to indulge. Enjoy tastings in the Whisky Cellars and luxurious treatments at the Aspen Spa.

Dornoch Castle Hotel was originally the bishop's palace. The chic accommodation is renowned for its annual whisky festival and outstanding selection of rare, vintage and eye-wateringly expensive spirits kept under lock and key in the cosy bar. An onsite distillery produces gin and whisky. Opposite the former palace is the town's compact cathedral, founded by St Gilbert in the 13th century.

CROSSING THE DORNOCH FIRTH TO MEDIEVAL TAIN

Dornoch Firth Bridge carries the A9 over the water. Before making the crossing, there is an opportunity to see the spectacular 21-span bridge from Meikle Ferry slipway. The peaceful quay is the site of a tragedy that occurred on a calm summer's day in July 1809. Excited crowds

205

bound for the Tain fair were crammed on to a ferry. The boat was low in the water and capsized when it was hit by a wave. Over 90 people died. Few local families were unaffected by the loss. Soon after, a new crossing was built at Bonar Bridge. Meikle Ferry continued to operate until 1957, and in 1991 the Dornoch Firth Bridge opened. On the south side of the firth, Ferry Point at the Ness of Portnaculter is a favourite local picnic spot.

Things are done differently at Balblair Distillery in Edderton – whisky bottles are labelled not with the traditional age statement but instead with a date, like wine. This indicates the year the spirit was laid down. The distillery features in the 2012 film *The Angels' Share* (directed by Ken Loach) and in Ian Rankin's crime novel *Standing in Another Man's Grave* (2012). Distillery tours are available and are best booked in advance.

Two carved stones in Edderton village form part of the Pictish Trail, which starts at Inverness Museum. The Picts were the descendants of indigenous Iron Age tribes. The Romans called them the *Picti*, the 'painted people', but it is not known what they called themselves. The stones they carved are symbolic and enigmatic. Discover the Clach Biorach in a field near the Balblair Distillery. The mysterious monument, three metres high, may be aligned intentionally with a stone circle nearby. Pictish horsemen are carved on the Edderton Cross Slab stone, which stands in the churchyard of Old Edderton Church.

Curiosity

The tragedy of Janet Horne

In 1722, Janet Horne was put on trial in Dornoch for turning her daughter into a pony so that she could ride to the devil. Accused of witchcraft and nervously struggling to recite the Lord's Prayer in a packed courtroom, Janet and her daughter were declared guilty. Her daughter escaped but Janet was taken prisoner. On a terrible day in 1727, she was smothered in tar, paraded through the town and burned alive in a barrel of oil.

Janet was the last woman to be tried and executed for witchcraft in Britain. In Carnaig Street, a stone incised with the date 1722 stands in remembrance of the mother and daughter, who both had health complications. The monument is a stark reminder of outrageous accusations that led to the execution of many hundreds of innocent women and men accused of witchcraft.

TAIN

Tain is Scotland's oldest royal burgh, founded by charter in 1066. Tain Through Time is a great way to discover the area. The independent, volunteer-run museum is located in the serene grounds of St Duthac's

Curiosity

Tarlogie spring water

Glenmorangie Distillery is on the shore of the outer Dornoch Firth. However, the distillery was originally sited at Tarlogie, west of Tain. Whisky was distilled using the hard mineral-rich water of the natural spring that supplied Morangie farmhouse. Although the distillery outgrew the farmhouse, the spring water remains fundamental to the spirit's distinctive taste. The spring can be visited as part of the distillery tour. At Glenmorangie, a spiral stone sculpture by American artist Dan Snow represents the important relationship whisky has with the surrounding landscape that flavours it.

Church. King James IV of Scotland made at least 18 pilgrimages to the shrine of St Duthac between 1493 and his death in 1513. An exhibition reveals all the razzamatazz associated with the monarch's trip to the Highlands.

Among Tain's attractive buildings is the turreted 18th-century tolbooth, which served as a prison and the collection point for tolls and taxes. The fancy French Gothic appearance of the Royal Hotel built in 1872 is the work of local architects Maitland and Sons, who also built Glenmorangie Distillery in 1888.

While in town, a visit to the Made in Tain shop is an opportunity to support a social enterprise where handmade items are lovingly produced by a learning organisation set up by and for young people with support needs.

The studio and gallery of Northcoast Glass is not a glassblowing exhibition yet visitors are welcome to observe the creative team of Brodie Nairn and Nichola Burns at work. Visits are also possible by prior arrangement. Tain Pottery at Aldie also welcomes visitors to observe potters and artists at work.

From Tain there is the opportunity of a detour to the attractive coast of the Tarbat Ness Peninsula. Alternatively take the A9 to Invergordon.

DETOUR: *The intriguing Tarbat Ness peninsula*

The flat pastureland of the Tarbat Ness peninsula is riddled with lovely lanes. A detailed map is essential if you do not wish to get lost. Here are some of the highlights.

From Tain, a country road time travels through the derelict buildings and runways of RAF Tain to reach the sheltered shore of Portmahomack. This heavenly spot is extra special because the east-coast, horseshoe-shaped bay faces west. Watching the setting sun while dining on the waterfront is a romantic treat. The sands are perfect for making sand-

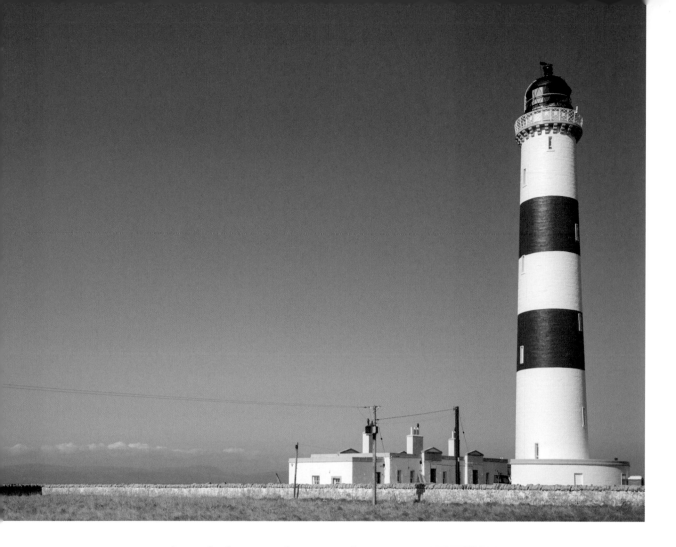

castles and a favourite destination for picnic rides with ponies from the stables of Highlands Unbridled. The centre at Fendom caters for all abilities from novice to experienced riders. Portmahomack's 19th-century harbour, built by Thomas Telford, is known as The Port. At the quayside, former warehouses with distinctive crow steps have been converted into attractive homes. A coastal walk of five kilometres reaches the red-and-white striped lighthouse of Tarbat Ness.

The Tarbat Discovery Centre explores local heritage, especially the Pictish culture. Rockfield village snuggles in the shelter of cliffs. A cozy cluster of whitewashed cottages

Beauty Spot

Tarbat Ness Lighthouse and headland

The club emblem of Portmahomack Golf Club is the slim, stripy, red-and-white tower of Tarbat Ness Lighthouse, the third tallest Scottish lighthouse after Skerryvore and North Ronaldsay. The impressive beacon, designed by Robert Stevenson, has been operational since 1830. According to local folklore, Tarbat Ness headland was the meeting place of a witches' coven. The rugged location is outstanding with no trace of witches but plenty of walkers and birdwatchers. Views to the coast of Caithness are spectacular. Manx and sooty shearwaters and arctic and pomarine skuas are regular visitors. The resident dolphins of the Moray Firth are often seen here too. Sheltered nooks make wonderful picnic spots.

built by fishers overlooks grassy greens that extend to the sea. Here they baited their lines.

Ballone Castle overlooks the shore. Built in 1590, the fortress fell into desperate ruin only to be saved four hundred years later by the vision of Annie and Lachlan Stewart who lived in a wooden hut while renovation took place. Annie is the inspiration behind ANTA Scotland Ltd, a prestigious company designing and manufacturing luxury interior textiles and stoneware made in Scotland. Lachlan is a renowned architect. The ANTA factory shop and a small cafe are at Fearn.

Extraordinary Pictish stones and the Seaboard Sculpture Trail to Nigg Bay

An intricately carved Pictish stone discovered at Hilton of Cadboll has been removed to the National Museum of Scotland in Edinburgh. However, sculptor Barry Grove painstakingly created an astonishing replica, which he hand carved over four years. The exquisite artwork stands four metres high. The original decorative hunting scene is faithfully reproduced and patterns from the beautiful stone are incorporated in the brand emblem of Glenmorangie whisky. Illuminated by night, the Cadboll replica is magical.

There are five further artworks on the Seaboard Sculpture Trail

through the villages of Hilton, Balintore and Shandwick. They represent themes inspired by traditional coastal communities – faith, folklore, fortitude, fishing and the four corners of the earth. The Balintore mermaid is perhaps the best known. She basks on a pink granite erratic rock deposited in the Ice Age. I especially like the sculpture of three powerful salmon swimming on the shore. Both the mermaid and salmon are the work of Stephen Hayward. A further Pictish artwork stands in a hilltop farm field overlooking the sea. The Shandwick Stone features an elephant, and the huge transparent case that protects the mysterious monument lends a further air of wonder.

The Cromarty Ferry is known also as the Nigg Ferry. This crossing at the narrows of the Cromarty Firth is a historic route used by pilgrims travelling to Tain. The vessel carries three cars and twelve passengers. However, the service can be disrupted by tides, poor weather and technical difficulties. My advice is to check whether it is operational.

Tidal mud flats, salt marsh and wet grassland around Nigg Bay teem with birdlife. In winter, pink-footed geese, wigeons, whooper swans and pintails flock to the RSPB reserve. The din of this great gathering resounds atmospherically, especially two or three hours before high tide. A bird hide is accessed from the B9175.

From the reserve, it is possible to remain on smaller roads to rejoin the main route to Invergordon.

INVERGORDON TO FOULIS

The natural deep-water harbour at Invergordon is considered to be among the finest in Europe. Docks and fabrication shops traditionally served the Royal Navy and built some of the most complex structures in the North Sea oil and gas fields through the 1970s and '80s. New construction projects at Nigg Energy Park produce offshore wind turbines. The seashore town is dwarfed by monumentally huge platforms and rigs in the bay. The extraordinary sight is sensational. Many of the colossal structures have mesmeric beauty. Invergordon Museum explores the history of the port. Exhibitions recount the dramatic events of a naval mutiny over pay and celebrate the contribution of Polish soldiers who helped defend Scotland and made it their home at the end of World War II.

The Natal Garden remembers a World War I tragedy. On the evening of 30 December 1915, sailors, civilians and children were gathered aboard the Royal Navy cruiser HMS *Natal* for a Christmas film party. Ammunition aboard the ship exploded mysteriously and the vessel capsized within five minutes. At the time, the government and the Admiralty concealed the loss of 421 lives in the freezing waters of the Cromarty Firth. The site is now an official war grave. Those who died are remembered at the garden.

Much of Invergordon's heritage and community life is expressed in a series of fantastically imaginative artworks around the town, including the station platform. The murals especially delight passengers from the cruise ships that visit the port in season. Another Invergordon delight is the regular sight of dolphins leaping on the bow waves of large ships entering the Cromarty Firth.

Alness, the largest town in the county of Ross-shire, boasts a heritage centre, two distilleries and a huge monument on the hillside above. Teaninich Distillery produces malt whisky for Diageo's blends. Without a traditional mash tun, in which starches from crushed grains are converted into sugar for fermentation, the distillery uses a hammer mill and mash filter – the only one operational in a Scottish malt ditillery.

The Admiralty requisitioned Dalmore Distillery during World War I. The maturing whisky was moved out to other distillery warehouses and American service personnel moved in. They shipped landmines

from the distillery's long pier in the Cromarty Firth, hence the nickname the Yankee Pier. The single malt from Dalmore is branded with the image of a distinctive royal stag that has 12 antler points or tines – six on each antler.

Atop the heights of Fyrish Hill (Cnoc Fhaoighris), an extraordinary arched monument commissioned by General Sir Hector Munro (1726–1806) is reminiscent of an Indian fort. Sir Hector's successful military campaigns in India appear to have inspired the huge folly. The project provided employment to local people at a time of famine and economic hardship. Footpaths to the monument are signposted from a car park on the minor road off the B9176 Struie Road. Allow a couple of hours for the walk of six kilometres over a steady steep climb. Panoramic summit views look east to Cromarty and west to Ben Wyvis.

In Evanton, the Highland Deephaven Industrial Park is the site of a former airfield. The base was built in 1922 to support and accommodate planes from the aircraft carriers of the Royal Navy's Home Fleet at Invergordon. Evanton airfield, known as Novar, closed in 1956. The A9 cuts through the site. Areas of the runway are still visible and some hangars remain in use by businesses on the industrial park.

Black Rock Gorge sounds like something from a David Lynch movie yet this dramatic chasm featured in the film version of *Harry Potter and the Goblet of Fire* (2005). The gorge is reached easily from the car park in Evanton village. The footpath crosses the River Glass, which tumbles through the deep canyon where the fire-breathing Hungarian Horntail pursued Harry. Allow a couple of hours to explore the lovely woods. There are no horntails, but midge repellent is advised.

For many regular travellers on the A9, a stop at The Storehouse of Foulis is a tradition. The historic former grain house, built in 1740, is situated at the water's edge. The cafe has tables at the shore. Seals are often seen from here.

STAGE TEN
The Black Isle to Inverness

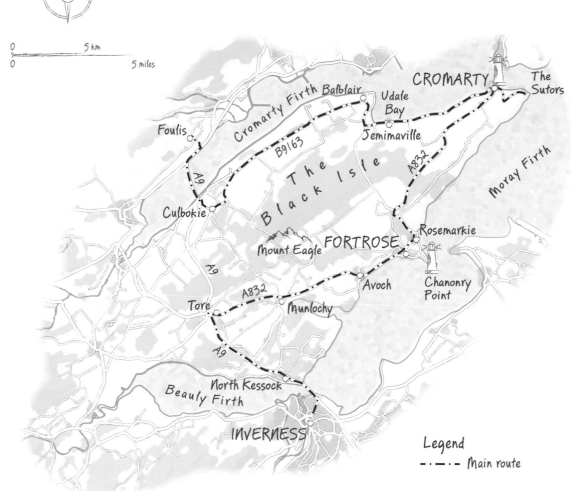

N

0 ____ 5 km
0 ____ 5 miles

Foulis

Cromarty Firth Balblair
Udale
Bay

CROMARTY

The Sutors

B9163
Jemimaville

A9

The
Black Isle

A832

Moray Firth

Culbokie

Mount Eagle

FORTROSE

Rosemarkie

Chanonry
Point

A9

A832

Avoch

Tore

Munlochy

A9

North Kessock

Beauly Firth

INVERNESS

Legend

–·–·– Main route

AROUND UDALE BAY

The waters of the Beauly Firth, the Cromarty Firth and the Moray Firth surround the Black Isle yet the name of this pastoral landscape is misleading. It is not an isle – it is a peninsula. Though in many ways it is a place apart. When white sheets of snow shroud surrounding high ground, the Black Isle often remains untouched. The maritime climate and low-lying landscape weave spells that keep cold air away, sometimes.

Mount Eagle, a peak of 255 metres, is the highest point. Birds are significant Black Isle residents and visitors. The muddy coast resounds to the clamour of wildfowl and waders. RSPB volunteers feed red kites daily at Tollie. Picnic trips in the company of gentle ponies from Black Isle Walking with Horses are an especially lovely way to discover local forests.

The B9163 traces the northern edge of the peninsula, passing through farmland to reach Udale Bay Nature Reserve. Here, an RSPB bird hide offers views of the shore. Among the highlights are curlews, geese, waders and ducks in winter, fishing ospreys in summer and widgeons feeding on eel grass in autumn. The high- and low-level observation windows of the hide make it possible for many to observe the spectacle.

On the Balblair shore, the Kirkmichael Heritage Centre celebrates the artistry of 500-year-old grave slabs. Yet there are unique and beautiful contemporary headstones too. Among those buried in the atmospheric graveyard is Elizabeth Jane Cameron (1910–76), a best-selling author who wrote as Jane Duncan. Readers are now rediscovering Jane Duncan's writing, especially her series *My Friends*, a huge publishing success in the 1960s. Her 19 semi-autographical novels portray Highland life in Scotland and colonial life in Jamaica. Her firsthand experience of the Highlands and the Caribbean spices her works. Jane Duncan novels unpeel and celebrate the lives of women. Her readers appreciate the insight.

In later life the famous author settled on the Black Isle and made Jemimaville her home. She ran a teashop and enjoyed the company of

her fans. The Udale croft, worked by her grandparents and known as 'The Colony', appears in her novels as 'Reachfar'. In 1975, the year before her death, Duncan published her autobiography, *Letter from Reachfar*. Curiously, on the author's Kirkmichael headstone, her pen name appears above her birth name.

CROMARTY

The B9163 coastal road continues to Cromarty, a historic harbour town with over 200 listed buildings. Many reflect a time of immense prosperity promoted by an ambitious 18th-century laird. George Ross bought Cromarty estate in 1768 and embarked on the creation of a new planned town. A harbour, built in 1784, soon became an important port, trading with Norway, Sweden, England and the Netherlands. Coal, iron, timber and gin were among the exports. Emigrants sailed for new lives in Canada, North America and Australia in the wake of the Highland Clearances.

Alongside a fish processing plant, a lace-making school, a hog yard, a pork curing operation, a shipbuilding yard and a brewery, George Ross built a hemp factory. Strong sacks and coarse bags made from imported Russian hemp were shipped to the West Indies where Scottish slave owners used forced labour to cultivate cotton, coffee and sugar.

In 1796 Scots owned almost 30 per cent of the estates in Jamaica. By 1817 they owned 32 per cent of the slaves and often imposed their names upon them. Campbell is the most common surname in Jamaica. Slaves were also forcibly renamed after Scottish towns and villages. Yet Scots were also among humanitarian campaigners whose protests achieved the Slavery Abolition Act passed by Parliament in Westminster in 1833.

Cromarty families who harvested the sea for their income lived in simple cottages on cobbled 'vennels' in Fishertown. The paraphernalia of nets, baited lines, barrels and baskets is long gone yet the seashore lanes retain much character. Fishertown windows protrude at curious angles, designed to keep an eye on the weather and the bay.

The National Trust for Scotland owns the birthplace of Hugh Miller (1802–1856). Visitors are invited to discover the thatched cottage and

Miller's ambitious rise to fame as a self-taught geologist and newspaper editor, among other roles. The endeavours of George Ross are explored in the fascinating Cromarty Courthouse Museum.

Two imposing headlands, known as The Sutors, dominate the horizon and guard the entrance to the deep water of the Cromarty Firth. Around these heights are the remains of World War I defences, lookout posts, gun emplacements, secret tunnels and underground bunkers. The grassy shore by Cromarty Lighthouse was a seaplane base during World War I.

Contemporary Cromarty is an intriguing place. Views of deep-water rigs and platforms in the firth are spectacular. Eco Venture boat trips ride the waves to discover resident bottlenose dolphins and other wildlife. The Royal Hotel is the traditional gathering place for the yachting community. Coffee lovers meet at the snug and funky Slaughterhouse Cafe on the shore, where a wood-burning stove is especially welcoming on chilly days. The Cromarty Arms hosts traditional music events on the second Friday of every month. The Black Isle Brewery produces organic beers from barley cultivated on the company farm. The Cromarty Brewing Company is a family enterprise upholding the local tradition of small-scale production.

The Emporium is a favourite bookshop den. Autographs are scrawled on the walls and freshly ground coffee is on tap. The old police station has been transformed into a cheese shop where produce from the Netherlands is a speciality. Just across the road, the Cromarty Bakery is considered to be among the best in the Highlands. There is also a branch at Fortrose. The Old Brewery, in the warehouse established by George Ross, is a contemporary arts centre. A white unicorn sculpture by the name of Urquhart resides at The Stables gallery.

Curiosity

National Unicorn Day

The unicorn has been a heraldic symbol of Scotland since the 12th century when it featured on the coat of arms used by William I, known also as William the Lion. The fantasy creature is the national animal of Scotland and National Unicorn Day is celebrated on 9 April.

ROSEMARKIE AND CHANONRY POINT

In Rosemarkie, Groam House Museum exhibits beautifully decorated Pictish stones dating from 700 AD and traditional Celtic artworks by George Bain (1881–1968).

The long sandy beach and resident dolphins attract visitors and traffic congestion can be chronic. Avoid this by hopping on the Dolphin Shuttle bus service that connects Rosemarkie and Fortrose with Chanonry Point. The bus stops near the village car parks. Or explore the coast on foot and on bicycle. Bikes, helmets and locks are available to hire in season from Rosemarkie Beach Cafe. The Dolphin Mile is a gentle ride or walk along the lovely shore. The coast is also the haunt of fossil hunters and they are politely requested to investigate loose stone on the beach rather than hammer at rock in situ.

The Black Isle features prominently in legend. The local Brahan Seer, who claimed to have second sight, was burned to death in a barrel of tar for his unsettling prophecies. At Chanonry Point, a stone marks the spot of his tragic demise though there is no evidence to support this story.

A powerful tidal race churns through a narrow gap just one kilometre wide between Chanonry Point and Fort George on the opposite shore. This is the hunting ground of bottlenose dolphins

Beauty Spot

The Fairy Glen

From Rosemarkie village, woodland paths explore the magically mossy Fairy Glen. Here there are colourful carpets of spring flowers and splashy cascades. A money tree bristles with coins – hopeful souls hammer them into the fallen trunk for good luck. According to tradition, local children would cast petals on the waterfall pool as a gift to the fairies. In return, the fairies ensured fresh water for the village.

chasing fish on the incoming tide. Yet the Moray Firth dolphins are seen at less crowded places around the Black Isle too. When walking or cycling it is always worth scanning the sea, especially on a calm day. You might well get a private show.

FORTROSE

At the heart of Fortrose is an imposing cathedral dedicated to St Peter and to St Boniface. Built in 1250, the red sandstone edifice is in a state of elegant ruin. Around the cathedral grounds, townspeople celebrate the St Boniface fair on the second Thursday in August. Performers and stallholders wear medieval dress. The fair is declared open for business by the town crier.

Hidden from the centre of town, Fortrose harbour is reached by narrow lanes. Thomas Telford designed the haven in 1817. An impressive wooden bench, featuring a carving of the harbour, stands by the shore in his honour. Look out for the boats of the local coastal rowing team. Two St Ayles skiffs are painted to reflect the landscape. Yellow represents the flowers of gorse bushes. A black stripe represents the Black Isle.

AVOCH

The Fortrose branch of the Highland Railway opened in 1894 and was in service for almost a century. The tracks have gone and the section between Fortrose and Avoch is a traffic-free four-kilometre walk. Allow around an hour and a half for the stroll. Many walkers treat themselves to a fish-and-chips picnic on the grassy shore of Seatown. The local 'chipper' is a highly regarded institution, renowned for its haggis suppers.

At the harbour, a colourful mosaic created

Curiosity

Munlochy clootie well

At first sight, it appears as if a tornado has blasted a disorderly jumble sale of clothing into the woodland at Munlochy. Garments dangle from branches and boughs around an ancient well attributed with healing powers. In pagan rituals, prayers are offered to the spirits of nature and 'cloots' or cloths are dipped in the sacred water dedicated to St Boniface. The cloots are then tied to trees around the site.

The sheer sprawl around the well is overwhelming. In places, it is almost impossible to see the wood for the cloots. Sadly, some visitors have tied items such as disposable nappies, sunglasses, baseball caps and plastic to the trees. It seems as if the essential spirit of this place is lost. In keeping with the history of the site and the intention to honour nature, the Forestry Commission urges the use of traditional cloots – strips of a biodegradable fabric like pure cotton.

Beauty Spot

Ormond Hill

Among the favourite walks of Black Isle residents is the ascent of Ormond Hill. The mound was the site of one of the Highlands' largest medieval castles. Here Andrew de Moray raised his standard on the hilltop to rally troops in support of his allegiance to Scottish freedom fighter William Wallace. The forces led by William Wallace defeated the troops of Edward I at the Battle of Stirling Bridge in 1297.

Oliver Cromwell destroyed the castle at Ormond Hill in the 17th century. The masonry was recycled to build his fort at Inverness. From the centre of Avoch, forest tracks lead to the important archaeological site at the summit. Views across the Black Isle and the Moray Firth are impressive. Allow around an hour and a half for the five-kilometre circular walk.

by the Avoch Brownies is one of a series of artworks around the Black Isle celebrating the ancient Celtic alphabet known as Ogham. Each of the tree and shrub species in the Ogham alphabet has specific energy and wisdom associated with it, which the druids used for learning. The Ogham apple tree symbol shown in the Avoch harbour mosaic is an expression of several beautiful energies including love, peace and creativity. A generous anonymous benefactor funded the beautiful *Silver Darlings* mosaic in Avoch community garden. The artwork portrays local dialect words woven around a scene of traditionally dressed fisher folk at work.

At the wonderfully named Lazy Corner, the fishermen of Avoch would gather to exchange news and smoke clay pipes. A weathered metal sculpture there represents the sails of a Zulu herring fishing boat. The roof of the nearby bus shelter is designed as an upturned hull.

The seashore village is the birthplace of Margaret MacDonald, who was a much-respected member of the royal household. 'Bobo', as she was known, was appointed nanny and later dresser to Queen Elizabeth II. She died at the age of 89 after 67 years of royal service.

JOURNEY'S END: NORTH KESSOCK AND THE KESSOCK BRIDGE

Before leaving the Black Isle and returning to Inverness, the final visit of this odyssey around the magical far north Highlands is to the peaceful North Kessock shore. From the 15th century, a ferry service connected Inverness with North Kessock and the mountains and islands beyond. Many early travellers were pilgrims making their way to the shrine of St Duthac at Tain. The historic ferry service became redundant in 1982 when the Kessock Bridge opened.

Crossing the bridge is a significant conclusion to this epic adventure. By way of celebration, consider spending time to reflect on your travels while appreciating the full span of the impressive structure from the shore of North Kessock. The kilometre-long structure is the work of Hellmut Homberg. His elegant cable-stayed design is engineered to withstand turbulent water, powerful wind and, unusually, seismic activity in response to the threat of the Great Glen Fault line. The geological feature extends more than 100 kilometres from the shores of the Black Isle and Inverness on the east coast of Scotland to Fort William and Loch Linnhe on the west.

The graceful crossing is especially magnificent when viewed from below and, if you are in luck, you may see dolphins too. They often hunt fish in the narrows. For many, the sight of dolphins in the wild is the beginning of a lifelong love affair. The Scottish Dolphin Centre is situated in a converted 18th-century salmon fishing station at Spey Bay near Fochabers. Here the WDC – the Whale and Dolphin Conservation charity – provides insight about the intelligent and sociable mammals that have made their home in Scottish waters. Another adventure for another day!

Alba gu brath!
Scotland forever!

List of Illustrations

Places to Visit and Useful Addresses

Note: Entries are listed alphabetically within each stage

Stage 1

Culloden Battlefield National Trust for Scotland Visitor Centre
Culloden Moor
www.nts.org.uk/visit/places/culloden
01463 796090

Dingwall and Highland Marts
Bailechaul Rd, Humberston,
Dingwall IV15 9TP
dingwallmart.co.uk
01349 863252

Glen Ord Distillery Visitor Centre
Muir of Ord IV6 7UJ
www.malts.com/en-gb/distilleries/glen-ord/
01463 872004

Glen Wyvis Distillery
1 Upper Dochcarty,
Dingwall IV15 9UF
www.glenwyvis.com
01349 862005

Inverness Museum and Art Gallery
Castle Wynd,
Inverness IV2 3EB
www.highlifehighland.com/
inverness-museum-and-art-gallery/
01463 237114

Lochcarron Food Centre & Filling Station
Main Street, Lochcarron,
Strathcarron IV54 8YD
www.lochcarronfoodcentre.com
01520 722209

Lochcarron Golf Club
Strathcarron IV54 8XQ
www.lochcarrongolfclub.co.uk
01520 722744

Lochcarron Weavers
Lochcarron IV54 8YH
www.lochcarron.co.uk
01520 722212

The Muir Hub
Great North Road,
Muir of Ord IV6 7UA
www.muiroford.org.uk/the-muir-hub/
01463 870 588

Tollie Red Kites Visitor Centre
Dingwall IV7 8HQ
www.rspb.org.uk/reserves-and-events/
reserves-a-z/tollie-red-kites/
01463 715000

Stage 2

Applecross Heritage Centre
Clachan, Applecross,
Strathcarron IV54 8ND
www.applecrossheritagecentre.org.uk
01520 744478

Applecross Inn
Shore St, Applecross,
Strathcarron IV54 8LR
www.applecross.uk.com/inn/
01520 744262

Applecross Walled Garden and The Potting Shed
Applecross,
Strathcarron IV54 8ND
www.applecrossgarden.co.uk
01520 744440

The Coalshed Gallery
Shore Street, Applecross,
Strathcarron IV54 8LR
01520 744206

Cuaig Croft Wools and Weavers
Cuaig, Applecross,
by Strathcarron IV54 8XU
www.croftwools.co.uk
01520 755260

Deer Museum
Achnasheen IV22 2EW
www.nts.org.uk/visit/places/torridon

Gille Brighde
The Old Schoolhouse,
Diabaig, Torridon,
Achnasheen IV22 2HE
www.gille-brighde.com
01445 790245

Kishorn Seafood Bar
Kishorn, Strathcarron IV54 8XA
www.kishornseafoodbar.co.uk
01520 733240

Nanny's
Shieldaig, Strathcarron IV54 8XN
www.nannysshieldaig.com
01520 755787

Torridon Stores and Cafe
Torridon, Achnasheen IV22 2EZ
www.torridonstoresandcafe.co.uk
01445 791400

Whistle Stop Cafe
Kinlochewe, Achnasheen IV22 2PF
www.facebook.com/Whistle-Stop-Cafe-Kinlochewe
01445 760423

Stage 3

Badachro Distillery
Aird Hill, Badachro IV21 2A
www.badachrodistillery.com
01445 741282

Beinn Eighe National Nature Reserve
Reserve Office, Anancaun,
Kinlochewe IV22 2PA
www.nature.scot/enjoying-outdoors/
places-visit/
scotlands-national-nature-reserves/
beinn-eighe-and-loch-maree-islands-
national-nature-reserve
01445 760254

Dundonnell Hotel
Garve IV23 2QR
www.dundonnellhotel.com
01854 633204

Gairloch Heritage Museum
Achtercairn, Gairloch IV21 2BP
www.gairlochheritagemuseum.org
01445 712287

Gairloch Sands Youth Hostel
Carn Dearg,
Gairloch IV21 2DJ
www.syha.org.uk/where-to-stay/highlands/
gairloch-sands.aspx
01445 712219

Inverewe Gardens
Poolewe, Achnasheen IV22 2LG
www.nts.org.uk/visit/places/inverewe
01445 712952

Isle of Ewe Smokehouse &
Fine Food Emporium
Ormiscaig, Aultbea,
Achnasheen IV22 2JJ
www.smokedbyewe.com
01445 731304

Kenneth Morrison Butchers
Strath, Gairloch IV21 2BZ
01445 712485

Kinlochewe Hotel
Kinlochewe, Achnasheen IV22 2PA
www.kinlochewehotel.co.uk
01445 760253

Leckmelm Shrubbery and Arboretum
Leckmelm, by Ullapool IV23 2RH
01845 612662

Loch Maree Hotel
Gairloch IV22 2HL
www.lochmareehotel.com
01445 760288

The Mountain Coffee Company
Gairloch IV21 2BZ
www.facebook.com/MountainCoffee.
Gairloch/
01445 712316

Old Inn
Flowerdale Glen, Gairloch IV21 2BD
www.theoldinn.net
01445 712006

Russian Arctic Convoy Museum
Birchburn, Aultbea,
Achnasheen IV22 2HZ
www.russianarcticconvoymuseum.org
01445 731137

Sail Mhor Croft Hostel
Dundonnell, Camusnagaul
IV23 2QT
www.sailmhor.co.uk
01854 633224

Shieldaig Lodge
Gairloch IV21 2AW
www.shieldaiglodge.com
01445 741333

Stage 4

An Cala Cafe and Bunkhouse
Culag Square, Lochinver IV27 4LE
www.ancalacafeandbunkhouse.co.uk
01571 844598

An Talla Solais
1 West Argyle St, Ullapool IV26 2UG
www.antallasolais.org
01854 612310

Assynt Aromas
Drumbeg IV27 4NW
www.assyntaromas.co.uk
01571 833263

The Caberfeidh
Main St, Lochinver IV27 4JZ
01571 844321

The Ceilidh Place
12–14 West Argyle St,
Ullapool IV26 2TY
www.theceilidhplace.com
01854 612103

Clare Hawley
Ardvar, Assynt IN27 4NJ
www.clarehawley.com

Crafts on the Croft
Polochaple, Culkein,
Drumbeg IV27 4NL
www.facebook.com/pg/craftsonthecroft/
01571 833245

Culag Hotel
The Pier, Lochinver IV27 4LQ
www.culaghotel.co.uk
01571 844270

Drumbeg Hotel
Drumbeg, nr Lochinver IV27 4NW
www.drumbeghotel.co.uk
01571 833236

Flossie's Beach Store
Clachtoll, Lochinver
www.facebook.com/flossiesbeachstore/
01571 855763

The Hector Heritage Quay
P.O. Box 2015 Pictou,
Nova Scotia B0K 1H0
www.shiphector.com
902-485-4371 (Canadian number)

Highland Stoneware
Baddidarroch, Lochinver IV27 4LP
www.highlandstoneware.com
01571 844376

Highland Stoneware
North Road, Ullapool IV26 2UN
www.highlandstoneware.com
01854 612980

Inver Lodge Hotel
Iolaire Rd, Lochinver IV27 4LU
www.inverlodge.com
01571 844496

Knockan Crag National Nature Reserve
Knockan Crag, Elphin, Lairg IV27 4HH
www.nature.scot/enjoying outdoors/
places-visit/scotlands-national-nature-
reserves/knockan-crag-national-nature-
reserve
01854 613418

Kylesku Hotel
Kylesku IV27 4HW
www.kyleskuhotel.co.uk
01971 502231

Living the Dream
Stoerhead Lighthouse,
Lochinver IV27 4JH
www.living-the-dream.org.uk
01571 855224

Loch a' Mhuilinn National Nature Reserve
off the A894
www.woodlandtrust.org.uk/visiting-
woods/wood/?woodId=27680&wood
Name=loch-a-mhuilinn-nnr
01571 844356

Lochinver Larder and Pie Shop
Main St, Lochinver IV27 4JY
www.piesbypost.co.uk
01571 844356

Loopallu music festival
www.www.loopallu.co.uk

The Macphail Centre
5 Mill St, Ullapool IV26 2UN
www.macphailcentre.com
01854 613336

New Broom Hub and Community Shop
28, Argyle Street,
Ullapool IV26 2UB
www.facebook.com/ULLAPOOLHUB/
01854 613879

North West Highlands Geopark
The Rock Stop, Unapool,
Kylesku IV27 4HW
www.nwhgeopark.com
01971 488765

Peet's Restaurant
Culag Road,
Lochinver IV27 4LE
www.peetsrestaurant.com
01571 844085

Rhue Art Gallery
Rhue, Ullapool IV26 2TJ
www.rhueart.co.uk
01854 612460

Rock Stop Cafe
The Rock Stop, Unapool,
Kylesku IV27 4HW
www.nwhgeopark.com
01971 488765

Seafood Shack
9 West Argyle St, Ullapool IV26 2TY
www.facebook.com/
theseafoodshackullapool/
07876 142623

Ullapool Museum
7 & 8 West Argyle St, Ullapool IV26 2TY
www.ullapoolmuseum.co.uk
01854 612987

Stage 5

Cocoa Mountain
Balnakeil Craft Village, Durness IV27 4PT
www.www.cocoamountain.co.uk
01971 511233

Durness Golf Club
Balnakeil, Durness, Lairg IV27 4PX
www.durnessgolfclub.org
01971 511364

Durness iCentre
Sango, Durness IV27 4PZ
www.visitscotland.com/info/services/
durness-icentre-p332891
01971 511368

Gualin Lodge
Gualin IV27 4SL
www.gualin-estate.com/Home.aspx
01328 823 233

Handa Island Nature Reserve
Handa Island
www.scottishwildlifetrust.org.uk/reserve/
handa-island/
07920 468572

Loch Clash Stopover
Loch Clash Pier,
Kinlochbervie IV27 4RR
www.klbcompany.wordpress.com
01971 521717

Lotte Glob
105, Laid, Lairg IV27 4UN
www.lotteglob792300328.wordpress.com

The Old School Restaurant and Rooms
Inshegra IV27 4RJ
www.oldschoolklb.co.uk
01971 521383

Rhiconich Hotel
Rhiconich IV27 4RN
www.rhiconichhotel.co.uk
01971 521224

Scourie Hotel
Scourie, Lairg IV27 4SX
www.scouriehotel.com
01971 502396

Shorehouse Seafood Restaurant
Tarbet IV27 4SS
www.shorehousetarbet.co.uk
01971 502251

Stage 6

Ben Loyal Hotel
Main Street, Tongue IV27 4XE
www.benloyal.co.uk
01847 611216

Burr's of Tongue (Spar shop)
Tongue IV27 4XF
www.spar.co.uk/store-locator/
lan02912-spar-tongue
01847 611202

Forsinard Flows Nature Reserve
RSPB Forsinard Flows,
Flows Field Centre,
Forsinard KW13 6YT
www.rspb.org.uk/reserves-and-
events/reserves-a-z/forsinard-flows

Halladale Inn and
North Coast Touring Park
Melvich, Thurso KW14 7YJ
www.thehalladaleinn.co.uk
01641 531282

Kyle of Tongue Hostel and Holiday Park
Tongue IV27 4XH
www.tonguehostelandholidaypark.co.uk
01847 611789

Strathnaver Museum
Clachan, Bettyhill, Thurso KW14 7SS
www.strathnavermuseum.org.uk
01641 521418

The Tongue Hotel
Tongue IV27 4XD
www.tonguehotel.co.uk
01847 611206

West End Stores
Melvich, Thurso KW14 7YL
01641 531219

Stage 7

Ackergill Tower Hotel
Ackergill, Wick KW1 4RG
www.ackergilltower.com
01955 603556

Cafe Tempest
Harbour Court, Thurso KW14 8DE
www.cafetempest.org
01847 892500

Caithness Horizons Museum
High St, Thurso KW14 8AJ
www.caithnesshorizonsmuseum.com
01847 896508

Castlehill Heritage Centre
Castletown, Thurso KW14 8TG
www.castletownheritage.co.uk
01847 821204

Castletown Chip Shop
MacKay St, Castletown, Thurso
KW14 8UQ
01847 821778

Dunnet Bay Distillers
Dunnet KW14 8XD
www.dunnetbaydistillers.co.uk
01847 851287

Forss House Hotel
Forss, Thurso KW14 7XY
www.forsshousehotel.co.uk
01847 861201

Mary-Ann's Cottage
Thurso KW14 8YD
www.caithness.org/community/museums/
maryanncottage/

Reay Golf Club
Club House, Reay,
Thurso KW14 7RE
www.reaygolfclub.co.uk
01847 811288

Seadrift-Dunnet Visitor Centre
Thurso KW14 8UT
www.highland.gov.uk/info/1457/
tourism_and_visitor_attractions/53/
visitor_centres/4
01847 821531

Tall Tales Bookshop
1a Grove Lane,
Thurso KW14 1AE
07900 284488

Stage 8

Clan Gunn Heritage Centre and Museum
Latheron KW5 6DN
www.clangunnsociety.org/heritage-centre/

Dunbeath Castle Gardens
Dunbeath KW6 6EE
www.dunbeath.co.uk

Dunbeath Heritage Centre
The Old School,
Dunbeath KW6 6ED
www.dunbeath-heritage.org.uk
01593 731233

Forse of Nature
Forse House, Latheron KW5 6DG
www.forseofnature.com
01593 741754

Jenny Mackenzie Ross
Northshore Pottery, Mill of Forse,
Latheron KW5 6DG
www.northshorepottery.co.uk
01593 741777

Laidhay Croft Museum and Tearoom
Dunbeath KW6 6EH
www.laidhay.co.uk
07563 702321

Lybster Golf Club
Main St, Lybster KW3 3BL
www.lybstergolfclub.co.uk
01593 721316

Mackays Hotel
Union Street, Wick KW1 5ED
www.mackayshotel.co.uk
01955 602323

Old Pulteney Distillery
Huddart St, Wick KW1 5BA
www.oldpulteney.com
01955 602371

Patricia Niemann Design
Old Post Office House,
Berriedale KW7 6HE
www.patbat.com
01593 751496

Pilot House
Smith Terrace, Wick KW1 5HD
www.facebook.com/Pilot-house-
1292699980848203/
01955 602992

The River Bothy
Berriedale KW7 6HE
www.clementineandclove.com
01593 751569

St Fergus Gallery
Sinclair Terrace, Wick KW1 5AB
www.highlifehighland.com/
st-fergus-gallery/
01955 603489

The Trinkie
(outdoor tidal swimming pool)
Wick KW1 5TN

Waterlines Heritage Centre
Lybster KW3 6DB
www.caithness.org/community/
museums/waterlines/
01593 721520

Wick Heritage Centre
18–27 Bank Row, Wick KW1 5EY
www.wickheritage.org
01955 605393

Stage 9

ANTA
Fearn, Tain IV20 1XW
www.anta.co.uk
01862 832477

Balblair Distillery
Edderton, Tain IV19 1LB
www.balblair.com
01862 821273

Carnegie Courthouse
Castle Street, Dornoch IV25 3SD
www.facebook.com/thecourthouse
cafedornoch/
01862 811632

Clynelish Distillery
Clynelish Rd, Brora KW9 6LR
www.malts.com/en-gb/distilleries/clynelish/
01408 623000

Coul Links
Dornoch Firth
www.scottishwildlifetrust.org.uk/
our-work/our-advocacy/
current-campaigns/coul-links/

Dalmore Distillery
Alness, IV17 0UT
www.thedalmore.com
01349 882362

Dornoch Castle Hotel
Castle Street, Dornoch IV25 3SD
www.dornochcastlehotel.com
01862 810216

Dunrobin Castle
Dunrobin, Golspie KW10 6SF
www.dunrobincastle.co.uk
01408 633177

Glenmorangie Distillery
Tain IV19 1PZ
www.glenmorangie.com
01862 892043

Golspie Golf Club
16 Ferry Rd, Golspie KW10 6ST
www.golspiegolfclub.co.uk
01408 633266

The Golspie Inn
Old Bank Rd, Golspie KW10 6RS
01408 633234

Golspie Mill
Mill House, Golspie KW10 6SF
www.golspiemill.co.uk

Grannie's Heilan Hame Holiday Park
Dornoch, Sutherland IV25 3QD
www.parkdeanholidays.co.uk/
scotland-holidays/grannies-heilan-hame/
grannies-heilan-hame-holiday-park.htm
01862 810383

Helmsdale Station
Helmsdale KW8 6HH
www.helmsdalestation.co.uk
01743 588654

Loch Fleet National Nature Reserve
Golspie, Dornoch IV25 3QG
www.nature.scot/enjoying-outdoors/
places-visit/scotlands-national-nature-
reserves/loch-fleet-national-nature-reserve
0300 067 6841

Made in Tain
24 Tower St, Tain IV19 1DY
www.madeintain.co.uk
01862 892221

Northcoast Glass
2 Chapel St, Tain IV19 1EL
www.northcoastglass.com
01862 893189

Pandora's Emporium
Victoria Rd, Brora KW9 6QN
www.pandorasofbrora.co.uk
01408 622562

Portmahomack Golf Club
Tarbatness Road, Portmahomack,
by Tain IV20 1YA
www.tarbatgolf.com
01862 871222

Royal Dornoch Golf Club
Golf Rd, Dornoch IV25 3LW
www.royaldornoch.com
01862 810219

Royal Hotel
High St, Tain IV19 1AB
www.royalhoteltain.co.uk
01862 892013

Storehouse of Foulis
Foulis Ferry, Evanton,
Dingwall IV16 9UX
www.thestorehouseathome.com
01349 830038

Tain Through Time
Tower St, Tain IV19 1DY
www.tainmuseum.org.uk
01862 894089

Tarbat Discovery Centre
Tarbatness Rd, Portmahomack,
Tain IV20 1YA
www.tarbat-discovery.co.uk
01862 871351

Teaninich Distillery
Riverside Dr, Alness IV17 0XD
scotchwhisky.com/whiskypedia/1899/
teaninich/
01349 885001

Timespan Museum and Arts Centre
Dunrobin St, Helmsdale KW8 6JA
www.timespan.org.uk
01431 821327

Stage 10

Black Isle Brewery
Munlochy IV8 8NZ
www.blackislebrewery.com
01463 811871

Cromarty Arms
Church St, Cromarty IV11 8XA
www.cromartyarms.com
01381 600230

Cromarty Bakery
8 Bank St, Cromarty IV11 8UY
49 High St, Fortrose IV10 8SU
www.spanglefish.com/CromartyBakery
Phone (Cromarty): 01381 600388
Phone (Fortrose): 01381 620055

Cromarty Brewing Company
Davidston, Cromarty IV11 8XD
www.cromartybrewing.com
01381 600440

The Emporium
11 High St, Cromarty IV11 8UZ
www.cromartyemporium.co.uk
01381 600551

Groam House Museum
High St, Rosemarkie IV10 8UF
www.groamhouse.org.uk
01381 620961

Harbour Fish & Chips
32 High St, Avoch IV9 8PT
01381 408402

Hugh Miller's Birthplace Cottage
and Museum
3 Church St,
Cromarty IV11 8XA
www.nts.org.uk/visit/places/
hugh-millers-birthplace
01381 600245

The Old Brewery
The Stables
Burnside Pl, Cromarty IV11 8XQ
www.cromartyartstrust.org.uk
01381 600354

Rosemarkie Beach Cafe
off Mill Road,,
Rosemarkie IV10 8UW
www.rosemarkiebeachcafe.info

The Royal Hotel
1 Marine Terrace,
Cromarty IV11 8YN
www.royalhotel-cromarty.co.uk
01381 600217

Slaughterhouse Cafe
Marine Terrace,
Cromarty IV11 8YN
07494 492695

Udale Bay Nature Reserve
Jemimaville, Dingwall IV7 8LU
www.rspb.org.uk/reserves-and-
events/reserves-a-z/udale-bay/
01463 715000

Index